FLORIDA MADE

FLORIDA MADE

THE 25 MOST IMPORTANT FIGURES WHO SHAPED THE STATE

GEORGE S. LEMIEUX & LAURA E. MIZE

THE
History
PRESS

Published by The History Press
Charleston, SC
www.historypress.com

Copyright © 2018 by George S. LeMieux and Laura E. Mize
All rights reserved

Front cover: Portrait of Henry Flagler. *Courtesy of the State Archives of Florida, Florida Memory*;
portrait of Carl Fisher. *Courtesy of the State Archives of Florida, Florida Memory*.
Back cover: Etching of Douglas Dummett. *Courtesy of Vera Zimmerman*.

First published 2018

Manufactured in the United States

ISBN 9781467140034

Library of Congress Control Number: 2017963231

In memory of my father, the "real George LeMieux." My love for Florida and its people I learned from him.
—G.S.L.

For Patrick and Cora Mize. Your smiles outshine the Florida sun.
—L.E.M.

CONTENTS

CONTENTS

ACKNOWLEDGEMENTS

I n formulating, researching and writing this book, we have benefited from the contributions of numerous talented and generous people who have blessed us with their time, talents and resources.

We are indebted to Palm Beach Atlantic University president William M.B. Fleming for his support and enthusiasm throughout this project and for introducing us to each other. All royalties from this book will be contributed to Palm Beach Atlantic University.

We also acknowledge the contributions of Governor Jeb Bush and Florida's commissioner of agriculture, Adam Putnam, who brainstormed with us in identifying the twenty-five shapers of Florida history highlighted in these pages. We also thank Doug Davidson of Bank of America, Boca Raton councilman Scott Singer and Maureen Jaeger for their helpful suggestions. Ms. Jaeger and Mike Marcil, longtime friends of Senator LeMieux, helped us review draft chapters.

Cristina James and Jackie Buck, assistants to Senator LeMieux, kept him organized throughout the project and were instrumental in compiling and sending our queries to publishing houses. Michael Boonstra helped us with fact checking. Carolyn Edds identified and collected many of the images in this book. Stephanie Handy formatted our manuscript and created the index. Kevin Leonard conducted research for us in Washington, D.C., at the Library of Congress.

We would be remiss not to recognize the staff of the Florida State Library and Archives, especially Anya C. Grosenbaugh, Hendry Miller and

Jacklyn Attaway, for digging up, scanning and copying hundreds of pages of historical images and documents between them.

The Florida Historical Society's director of educational resources, Ben DiBiase, offered nuanced perspective on several of the historical episodes covered in the book.

Ken Lundberg, Senator LeMieux's former communications director, conducted preliminary research for and wrote drafts of several chapters. The foundation he provided made this book a richer volume.

Becky Peeling at Palm Beach Atlantic University connected us with faculty who contributed their own expertise to our chapters. She and Vicki Pugh helped us formulate our marketing plans.

Our final thanks go to Arcadia Publishing and The History Press, including our editors, Amanda Irle and Hilary Parrish, and the rest of the fine team of editors and designers who helped make this book a reality. Thank you for seeing our vision and partnering with us to bring it to fruition.

INTRODUCTION

When we think of early America, images of the Pilgrims landing at Plymouth Rock in 1620 come to mind. If you really know your history, you might remember the first permanent English settlement in the Americas: Jamestown, founded in modern-day Virginia in 1607. A few among us might recall the "Lost Colony" of Roanoke, established in 1585 in present-day North Carolina.

All three of these early British colonies comport with our understanding of American history we know from elementary school: Puritans fleeing persecution in England colonized America, and the United States traces its historical roots to our brothers and sisters in Great Britain. After all, we celebrate the British story of our heritage every year at Thanksgiving.

If only it were true.

One hundred and seven years before the Pilgrims landed in modern-day Massachusetts, and 72 years before the English first arrived in the New World, Ponce de León set foot on La Florida on April 3, 1513.* As the prime minister of Spain noted at the 2010 National Prayer Breakfast, the first Judeo-Christian prayers offered in the New World were uttered not in English but in Spanish.

Founded in 1565, St. Augustine was the first, and is now the oldest, U.S. city established by Europeans. In the eyes of the Spanish crown,

* A thorough comparison of Spanish developments in Florida versus settlements by the British can be found in Michael Gannon's seminal work, *Florida: A Short History*, in the chapter titled "European Settlement."

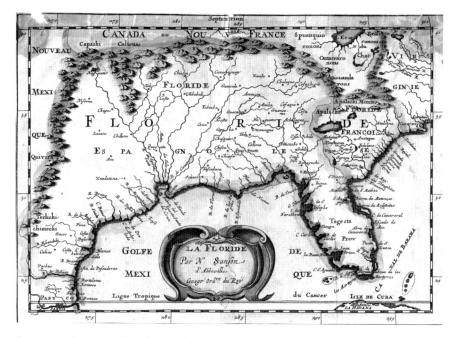

A seventeenth-century French map shows "La Floride" occupying most of what is now the southeastern United States. *By Nicolas Sanson, courtesy of Florida State University Strozier Library Special Collections.*

La Florida encompassed what we now call the American Southeast and spanned all the way from the islands recognized today as the Florida Keys to Newfoundland.[1]

The future Sunshine State shrank to fit within its modern borders only after a string of battles that took place while Florida was still a Spanish colony.[2] In 1819, Spain agreed to relinquish the land to the United States.

The population of Florida, like that of most of the other states below the Mason-Dixon line, grew slowly. At the turn of the twentieth century, Florida was home to only 528,000 people. Maine had more residents, and Georgia was four times more populous.[3] It was not until after the Second World War that Florida's population growth would skyrocket.

By midcentury, the Sunshine State's popularity took off. Starting in the 1950s, Florida was welcoming two to three million new Floridians each decade. As of the writing of this book, Florida is home to nearly twenty-one million people and has surpassed New York as the nation's third-most-populous state.

But these impressive numbers tell only a small part of Florida's story. There is much more to the Sunshine State than population growth.

Neighboring Central and South America and the Caribbean, Florida is the gateway to Latin America. For Europeans, it is a destination for business and pleasure. In the Western Hemisphere, only California outdoes Florida's fourteen ports as a center for transshipment and trade. The Sunshine State's collection of ports also makes it the cruise capital of the world.

And with Florida's never-ending coastline—no state in the continental United States has more—its warm climate and world-renowned tourist hotspots, it is little wonder the state draws more than 110 million visitors each year. Florida also boasts a population now as diverse as any other U.S. state. People from Cuba, Puerto Rico, Brazil, Greece, Canada, Germany, Colombia, Venezuela, Haiti, Great Britain, France, Vietnam and the Seminole and Miccosukee Indian tribes call Florida home, as do the old cowboys we know as "crackers."

How did all this come about? What has driven Florida's nearly 4,000 percent population growth since 1900? How did Florida become one of the most popular tourist destinations on earth, with Orlando alone setting a new record for itself by drawing sixty-eight million visitors in 2016?[4]

Behind every great story are great characters.

The story of the Sunshine State begs the question: Who built Florida? We vetted each candidate for our list of the twenty-five most significant people in Florida's development using this simple test: But for that person, would anyone else have made the same, or a similar, contribution? If that person had not contributed to Florida in the way he or she did, what would have happened? It is not enough that a person was the first to do something significant. The real question is: Absent his or her influence, how would Florida be different?

Join us as we sort through more than five hundred years of history. Some of our choices will surprise you. Quite a few may be unknown to you. A couple will be unpopular. Hopefully, they will spark conversation. Most of all, we hope you enjoy this story of America, from the place it started—the Sunshine State.

HENRY MORRISON FLAGLER

(JANUARY 2, 1830–MAY 20, 1913)

The most significant individual in Florida's history, he
connected Jacksonville to Key West and created Florida cities along the way.

The Sunshine State, the Conch Republic, the Treasure Coast, the Magic Kingdom, Crystal River, Honeymoon Island—monikers for the twenty-seventh U.S. state and its world-famous destinations convey images of an idyllic, almost enchanted subtropical paradise. In many ways, Florida has become just that. Theme parks, beaches bordered by luxury hotels and condominiums, clear blue waters, sprawling golf courses and retirement playgrounds drew just shy of 113 million visitors to the state in 2016.[5]

But the land settled and fought over by Spain, Great Britain and France looked much different. When Juan Ponce de León became the first European known to step foot on Florida soil in 1513, the Everglades occupied four thousand square miles, stretching from Lake Okeechobee to the peninsula's southern tip.[6] Uncontrolled mosquito swarms spread disease; there was no fully navigable inland waterway stretching along the east coast; and air conditioning, refrigeration and hurricane-resistant building codes would not be invented for hundreds of years. Native tribes occupied the untamed land.

Development crept along slowly for the next few centuries, as control of the land changed hands between Spain and Great Britain. Finally, the young United States took control. Florida became a U.S. territory in 1821, and the

Henry Flagler built resorts, infrastructure and railroads down Florida's east coast, laying the foundation for the tourism that today drives much of the state's economy. *Courtesy of the State Archives of Florida, Florida Memory.*

first U.S. census in Florida showed a state population of 34,730 in 1830.[7] Florida achieved statehood on March 3, 1845.

Thirty-three years later, a middle-aged, self-made businessman named Henry Morrison Flagler would make his first trip to the fledgling state with his wife, Mary Harkness Flagler. Flagler had tried his hand at everything from the grain business to distilling,[8] salt mining, railroads and, ultimately what he would become famous for, oil refining. In collaboration with his business partner John D. Rockefeller, Flagler created Standard Oil Company. It was, according to Thomas Graham, professor emeritus of history at Flagler College in St. Augustine, Florida, "the greatest corporation the world had ever seen."[9]

Standard Oil made Flagler one of the wealthiest men in America. A *San Francisco Call* article from 1901 pegged Flagler as America's sixth wealthiest man, while a 1905 *Washington Post* piece put him in twelfth place.[10] While he did not realize it upon his first visit, the Sunshine State would capture Flagler's imagination, and his riches, in a way no other place had. With his extravagant wealth and impeccable business sense, Flagler would soon embark on several decades' worth of development projects in Florida, creating a hotel and railroad empire that transformed the state. Without question, more than any other individual, Flagler laid the groundwork for the Florida we know today.

His first trip to Florida, in 1878, was for personal and practical reasons. His wife, Mary, had been diagnosed with tuberculosis,[11] and her doctor prescribed time in a warm climate. Jacksonville was the couple's temporary home that winter, but the sunshine did not cure Mary's ills. She died in 1881 at just forty-seven years of age.[12]

The tycoon's next trip to Florida came shortly after he married Ida Alice Shourds, his second wife, in 1883. By this point, railroad magnate Henry B. Plant was expanding into Florida and had formed the Plant Investment Company to fund his efforts. Flagler would become an investor.[13]

Flagler and Alice, as she was called, returned to Florida in the winter of 1884–85, and it was then that he apparently first began to contemplate doing business in Florida. During this trip, he stayed at the San Marco Hotel, which opened in St. Augustine in February 1885.[14]

An 1887 article in the *Jacksonville News-Herald* describes Flagler's pleasure in his stay at the San Marco and hinted at the start of his fascination with developing Florida: "But I liked the place and the climate, and it occurred to me very strongly that someone with sufficient means ought to provide accommodations for that class of people who are not sick, but who come

In 1888, Henry Flagler's extravagant Hotel Ponce De León opened, featuring steam heat and electric lights in the guest rooms. *Courtesy of the State Archives of Florida, Florida Memory.*

here to enjoy the climate, have plenty of money, but can find no satisfactory way of spending it."[15]

This was the beginning of his budding love affair with the peninsula, one that would hold his attention for the rest of his life and coax him to spend great sums of money. A letter written in 1902 to Mrs. Ellen Call Long—the daughter of a Florida governor—contains Flagler's own description of the decision to invest his money and efforts in improving Florida, as well as his movement down to South Florida. It almost seems as if his interest in the state was born of a simple fondness for it and a curiosity about its future:

> *I don't know that I can assign any particular reason for my first investment in this State; it was simply the outcome of a casual visit, and is merely an instance of the luck which has attended me throughout my life. My attention was first attracted to the upper East Coast, and later I realized the wonderful possibilities of this section, both as to the soil and climate,*

until the development of the present day is reached. What the future will be, no one can foretell, but I have unbounded faith in the resources of the State and its citizens.[16]

EXTRAVAGANCE AND EXPANSION

In the same year he visited the San Marco Hotel, Flagler began building his first Florida establishment, the Hotel Ponce de León in St. Augustine. It was a grand building in the Spanish Renaissance style, boasting 450 guest quarters, as well as decadent finishes and features throughout. Tourists could enjoy balconies, fountains, gardens and towers, plus technologies that were surely unexpected at the time the hotel opened in 1888: steam heat and electric lights in all the guest rooms.[17] In addition, the building was "the first major poured-in-place concrete building in the United States," according to the website of Flagler College, which now operates in the former hotel.[18] Building the hotel cost $2.5 million, an astonishing sum for the time.[19] His extravagance was attention-getting but proved not to be profitable, as the hotel ultimately lost money.[20]

"In the Hotel Ponce de León, Henry Flagler stepped up the quality many degrees to create one of the best hotels in the world," said Graham in a 2015 interview. "Now from there on down the coast, he never did something as architecturally important as that again."

Flagler's ambitions to make the Hotel Ponce de León a success extended beyond the hotel and its operations to his first Florida railroad venture. Thirty days after construction on the hotel began, he purchased the Jacksonville, St. Augustine and Halifax Railway, which he would continue down the coast.[21]

He went on to own three hotels in St. Augustine—the Hotel Cordova and the Hotel Alcazar being the other two—and to buy and build hotels down Florida's eastern coastline. He owned a hotel in Ormond Beach, two in what is now Palm Beach, one in Miami and one in Jacksonville. He also built Whitehall, his own magnificent private residence, in Palm Beach. Eventually, he would also own a Bahamian resort in Nassau.

The Building Blocks of Society

As his portfolio of Florida resorts expanded, so did his railroad holdings. The railroad brought life to sleepy little towns and helped to establish cities where none had existed previously. In addition to establishing luxury accommodations in and drawing people to frontier towns, Flagler personally plotted out infrastructure and municipal buildings, carefully designing new cities surrounding his resorts.

More than anywhere else in Florida, Flagler's efforts in South Florida were the defining influence that swept the region into a new age. The Palm Beach County Historical Society puts it this way: "Henry Flagler visited the Lake Worth area in 1892 finding a 'veritable paradise.' He bought land on both sides of the lake and built two hotels, established a town, and extended his railroad to south Florida, which signaled an end of the Pioneer Era."[22]

Following a brutal winter in 1895, Flagler stretched his rail line to Florida's largely undeveloped southeastern tip, some sixty miles down the coast. Fewer than one thousand people lived in the area at the time.* "Flagler's railroad, renamed the Florida East Coast Railway in 1895, reached Biscayne Bay by 1896," reports the Flagler Museum. "Flagler dredged a channel, built streets, instituted the first water and power systems, and financed the town's first newspaper, the Metropolis."[23]

In recognition of his contributions, the area's residents desired to name the town after their benefactor. He suggested, instead, "Mayaimi"—an old Indian moniker—and the city was so named. Four years later, the 1900 census recorded Dade County's population at 4,955, almost a six-fold increase from the previous tally. By the census of 1950, the population was one hundred times as large, at nearly half a million people.[24] Flagler's work right before the turn of the twentieth century laid the foundation for Miami to blossom into a world-class destination and gateway between the United States and Latin America in the coming decades.

Creating a Land Bridge

The crowning achievement of his Florida railroad empire was the Overseas Railroad, which connected the peninsula to Key West by rail. It was a feat of spectacular engineering, with most of the 156 miles of track being laid

* The story of what, or rather who, prompted Flagler to extend his railroad to present-day Miami is told in chapter 10.

over water.[25] Flagler began the project in 1905, after seeing the United States embrace the construction of the Panama Canal.

Key West "was far more developed at that point than, say, Miami was or Fort Myers or anything like that, so I think there were real economic reasons to build it up as sort of a gateway to the Caribbean," said Wes Borucki, a southern history expert and an associate professor at Palm Beach Atlantic University.[26]

Perhaps Flagler had in mind to build more resorts in the Keys or was motivated by an overall sense of competition with another Florida pioneer, Henry Plant.* Unlike in other parts of Florida, building a railroad through the Florida Keys would not have yielded large parcels of land for a railroad company, neither through land grants nor purchases from private landholders. This likely made the project unattractive to most railroad companies, Borucki believes.[27]

The project was completed in 1912. The following year, Flagler was injured when he fell down a set of stairs at his Palm Beach home. He never recovered and died in 1913, at age eighty-three. At the time, the tycoon was working on another railroad extension, this one intended to reach Lake Okeechobee. His goal was to facilitate agricultural development in the area.[28] Indeed, Flagler's railroads throughout Florida strengthened the state's agricultural industry. The tycoon established agriculture in Palm Beach County to supply his resorts. Today, the county is among the nation's top ten in the nation for agricultural production, with $20 billion in economic impact.[29]

* Plant's work in Florida may be cited as a rebuttal to the idea of Flagler as the state's most influential person. He also built luxury resorts and railroads that drew tourists and new residents. While Plant did much to develop Florida, particularly the west coast, he could not have done it without the aid of men like Flagler.

Plant's resources, though extensive, fell short of Flagler's funds. Flagler paid for his own work in Florida largely with his own funds. Another strike against Plant is that geography kept his empire from touching southeast Florida, where the state's most prominent city now lies. Several years before Flagler took his railroad to Miami, Plant explored the feasibility of a rail extension that would link the Gulf Coast city of Fort Myers to Miami. Such a connection would require building a railroad through the Everglades, a task that James E. Ingraham, Plant's surveyor, reported was not very practical. The Everglades Digital Library contains this account of the result of the survey expedition: "Ingraham was a member of the survey party that crossed the Everglades from Fort Myers to Miami in March 1892 in search of a possible railroad route for Henry B. Plant's railroad system. He caught Henry Flagler's attention when he reported that the east coast would serve as a more practicable route. Flagler immediately hired Ingraham and eventually placed him in charge of all land holdings." (Ruthanne Vogel, "Everglades Biographies: James Edmunson Ingraham," Reclaiming the Everglades: South Florida's Natural History, 1884 to 1934, Everglades Information Network & Digital Library at Florida International University Libraries, accessed September 14, 2015, everglades.fiu.edu/reclaim/bios/ingraham.htm.)

With the Everglades in his way, Plant never extended his rail line to southeast Florida. Plant's place in history is discussed in chapter 4.

"I think Flagler realized his string was running out," Graham said. "Going to Key West and going to Okeechobee City, that was going to be as much as he could do in his lifetime. And I don't know that he had any dream of anything beyond that. You can almost say once he ran out of Florida, his life came to an end."[30]

WHO ELSE BUT FLAGLER?

In recognizing Flagler as the single most important figure in Florida history, one must ask whether anyone else could or would have done for Florida what he did. Graham believes others could have pursued the same course of action but not necessarily that they would have done what Flagler did when he did it: "There is the Atlantic Coast Line Railroad that was right up the way that could've come down from Georgia, and the Sea Board Railroad could've come down. The thing is, I think you can say pretty clearly Flagler speeded up the process, because he went down to an area that was unpopulated and a railroad company that needed to make profits might've been reluctant to go into [an] undeveloped area. And so Flagler almost certainly speeded up the settlement of South Florida."[31]

Importantly, a delay in laying this foundation in South Florida might have meant the work was never done at all, or not completed until much later. Society-altering world events in the early twentieth century—such as World War I, which lasted from 1914 to 1918; the Great Depression from 1929 to 1939; and two devastating hurricanes that hit South Florida in 1926 and 1928—redirected resources, slowed or shut down business ventures and, for many, made leisure travel a low priority or impossibility. Building luxury resorts that drew wealthy tourists simply may not have been an important or prudent move in the face of these significant obstacles.

Without the resorts, railroads and towns Flagler had built along the entire length of the east coast, the state would surely have been less populated and less developed in the first half of the twentieth century. T.D. Allman, in his book *Finding Florida*, posits that development of high-end tourist destinations in Florida during the Gilded Age put the state on the map in a way that would not have happened otherwise.[32] Such development also had a hand, no doubt, in attracting the wealthy and talented Cubans who began fleeing their country in 1959 to escape Fidel Castro's regime. Most settled in

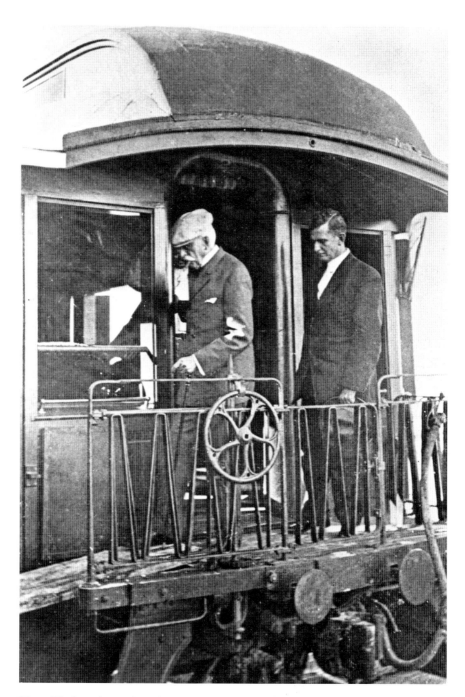

Henry Flagler exits a train arriving via his new railroad extension into Key West. *Courtesy of the State Archives of Florida, Florida Memory.*

Miami,[33] by then a respectable city thanks in large part to Flagler. Bringing with them their skills, customs, language, cuisine and work ethic, the Cuban exiles to Miami have transformed the city into a center of Latin American culture and helped further establish it as a trade hub.

But imagine if Miami—lacking the infrastructure and access Flagler had provided it—had still been an insignificant town in the 1950s, unable to support an influx of hundreds of thousands of Cubans. Many of these upper-class immigrants may have settled elsewhere, perhaps in New York or Tampa, and the city we know today as the vibrant, international focal point of Florida would not exist.

Today, southeast Florida has become an economic powerhouse boasting more than six million residents as the eighth largest metropolitan region in the United States. The state's population reached and exceeded twenty million in 2015.[34] Both these facts are due in large part to Flagler's aggressive development of the area starting just forty years after the Sunshine State was created. Henry Flagler had plentiful resources and ambition to match. He put both to work on Florida's east coast, building it up and earning Florida a prominent role in the nation, the Western Hemisphere and the world. If Florida has a founding father, it is, without a doubt, Henry Flagler.

WALTER ELIAS DISNEY

(DECEMBER 5, 1901–DECEMBER 15, 1966)

The architect of Central Florida tourism, his theme-park development made Orlando the nation's most-visited destination and launched an entertainment empire that is responsible for more than half of Florida's annual visitors.

I n his triumphs and his setbacks, and perhaps even in his death, Walter Elias Disney did more to mold the state of Florida than nearly anyone else. His influence, and that of the entertainment mecca he created, are so far-reaching in the Sunshine State that it seems only right to name him behind Henry Flagler as the second-most influential person in Florida's history.

Yet, the Walt Disney World we know today is much different than the one this creative genius initially proposed. The story of Florida's most famous tourist destination begins in Southern California. There, Disney became a household name with cartoons that sang and danced across cinema screens, capturing Americans' imaginations and lifting their spirits through the dark days of the first half of the twentieth century. There, too, he accomplished his goal of building a theme park that brought his cartoon characters off the screen and into real-life splendor in a more attractive, engaging way than anyone had previously seen.

"He came along in the '50s with his idea, [when] these things were kind of shady," said historian James C. Clark, a lecturer in the history department at the University of Central Florida and author of the book *Orlando, Florida: A Brief History.* "People associated them with carnivals and hucksters and

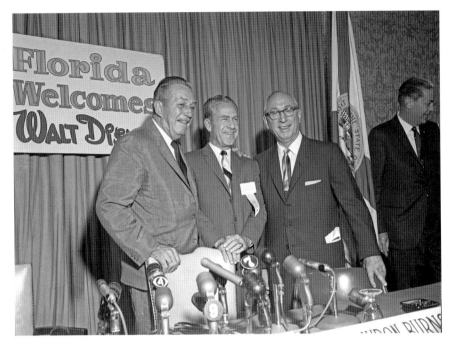

Left to right: Walt Disney, General William E. Potter and Roy Disney at a 1965 press conference announcing plans to build Walt Disney World in Florida. *Courtesy of the State Archives of Florida, Florida Memory.*

games of chance that you couldn't win, and so his vision was so far ahead of everybody else's."[35] Disney parks today still prioritize the atmosphere of cleanliness and wholesomeness that were pioneered with Disneyland.

But to Walt's view, all was not well with Disneyland. It wasn't the park itself that bothered him but all the touristy kitsch that had cropped up just outside its gates. This was marring the picture-perfect world Disney had imagined and brought to life.

There was also the fact that research had revealed that people living east of the Mississippi River made up only 2 percent of Disneyland patrons.[36] Disney set his sights firmly on expansion. Not expansion of Disneyland but, rather, the creation of a new attraction, thousands of miles away. A new venture closer to the nation's East Coast, and the two-thirds of the nation's population who lived east of the Mississippi,[37] would draw an audience that Disneyland, because of its West Coast location, simply could not attract.

Disney took great care in selecting the site for his eastward expansion. After much consideration, he took a flight in late 1963 with several trusted

advisors to scout possible locations. Potential sites included spots in or near St. Louis, Missouri; Secaucus, New Jersey; Niagara Falls, New York; Washington, D.C.; and three locations in Florida: Ocala, Palm Beach County and Orlando.[38]

In the years since that all-important tour, locations such as Miami, New Orleans and others have been falsely reported as runners-up in Disney's decision. At first, downtown St. Louis was the most intriguing site. Here, a five-story building would house a new indoor park of Disney's design, similar to attractions he had created for the 1964 World's Fair. There, a talking robot of Abraham Lincoln, the Carousel of Progress and the "It's a Small World" exhibit had been big draws.[39]

The St. Louis project plans were aimed at celebrating the city's 200th anniversary. Failure of that project, noted Neal Gabler, author of the definitive Disney biography *Walt Disney: The Triumph of the American Imagination*, may have been due to finances. Some people reported a dispute between Disney and the prominent Augustus Busch Jr., head of St. Louis–based Anheuser-Busch brewery, over Disney's plan not to sell liquor at his new property. Gabler, however, says reports of such a conflict were inaccurate and points instead to another possibility: that Disney had discovered a more favorable location.[40]

As he flew over Central Florida in a twin-engine propeller plane,[41] Disney saw a vast expanse of swampland crossed by the still-in-progress Interstate 4. Here, there was plenty of land available cheaply, enough for Disney to create a land buffer around his new attraction to mitigate the unsightly creep of motels and tourist traps that had surrounded Disneyland. Florida offered another advantage, comparative to all the other sites considered: mild winters, for year-round operation of Disney's new outdoor attractions. In addition, Florida already was well known as a popular tourist destination, although its reputation then pales in comparison to the spotlight the state enjoys today.

At the same time, the Sunshine State Parkway, now called the Florida Turnpike, was progressing up through the center of Florida and would cross I-4 near Orlando. Interstates 75 and 95, which today funnel people from the Eastern Seaboard and the Midwest straight down into the Sunshine State, not far from Orlando, were already in the works.[42]

The Disney family was not new to Florida, either. Walt's parents had married in Florida in 1888.[43] As a boy, he made many trips to the state to visit cousins and other relatives. Walt and his family were distantly related to industrialist Hamilton Disston, who purchased millions of acres of land

in Central Florida in 1881 and began some of the first efforts to drain significant portions of the Florida Everglades. Disston's "ancestors were French noblemen of the D'Isney clan," reports Michael Grunwald in *The Swamp: The Everglades, Florida, and the Politics of Paradise*. Today, Walt Disney World lies within the land Disston was contracted to drain.[44]

While Disney saw great potential for building his next project in Florida, he did not—unlike so many other entrepreneurs—want his attraction to be near the ocean. Perhaps this was why his discussions with insurance mogul John D. MacArthur, about potentially locating the enterprise on his land in northern Palm Beach County, failed. "As to why he didn't choose the coast, he told people he did not want to compete with a free attraction, meaning the beach," Clark said. "And so he narrowed it down, finally, to two sites: Ocala, where he had been often as a child when he came down to visit relatives, and Orlando."[45] Orlando, Disney announced before the return flight reached California, was the site.

Disney's work to acquire the ideal property for his expansion was cloaked in secrecy. He used aliases for the venture, such as "Project Future" and "Project X," even with his own executives.[46] Upon selecting the area between Kissimmee and Orlando, Disney knew that word of his interest in the region would drive up land prices exponentially. To avoid a land rush, he had a series of shell corporations established to quietly purchase large, contiguous chunks of land. For even greater secrecy, the real estate transactions involved numerous intermediaries between Disney and the person actually buying the land. In this way, even the buyer never knew on whose behalf he was purchasing.[47] All told, Disney's company purchased forty-three square miles of swampy Florida wilderness in Orange and Osceola Counties. It was plenty of room for all the amusement parks one could wish to build.

Disney eventually had to show his cards, after an intrepid *Orlando Sentinel-Star* reporter pinpointed him as the person most likely responsible for these large-scale land purchases in Central Florida. The company publicly announced its plans in a November 15, 1965 press conference. Describing the endeavor as a "labor of love," Disney announced "a whole new world of entertainment" to be built in Florida and committed $100 million to "get the show on the road."[48] Florida governor Haydon Burns predicted that November 15 would now be known as "the most significant day in the history of Florida."[49]

But the Florida project Walt Disney envisioned was not to be centered on a theme park. Rather, it would be a utopian workshop of a city.

"EXPERIMENTAL PROTOTYPE COMMUNITY OF TOMORROW"

By Walt Disney's description, a place called EPCOT—Experimental Prototype Community of Tomorrow—was to be the centerpiece of Walt Disney World, not the Magic Kingdom. It would not be the Epcot park we know today, but something much grander and with a loftier purpose than entertaining. Disney imagined a model city adjacent to the theme park, one that would set a new ideal for city planning and draw visitors from around the globe. He described this vision for Walt Disney World in a 1966 video presentation designed to educate Florida politicians about his plans. "E.P.C.O.T. will take its cue from the new ideas and new technologies that are now emerging from the creative centers of American industry," he explained. "It will be a community of tomorrow that will never be completed."[50]

Seemingly, nothing was missing from Disney's blueprint for Epcot. His design was for a city in the shape of a wheel. It was to be three miles in diameter and comprise five thousand acres.[51] There would be a convention center and hotel in the middle, towering thirty stories tall, surrounded by concentric rings holding offices, shops, restaurants, theaters, high-rise apartment buildings, green space and, finally, a suburban environment with homes for Epcot's families. People would travel the city mostly by walking and via electronic transport, the PeopleMover.

A high-speed monorail would connect Epcot to the other parts of Walt Disney World and an industrial park. A multi-level underground transportation hub would accommodate cars and large trucks and offer parking. Epcot's urban core, a commercial center spanning fifty acres, would be protected from unpleasant weather by a massive dome.[52] Disney even envisioned himself and his wife, Lilly, taking in his creation from a bench in downtown Epcot during their golden years.[53]

Disney believed that by 1980, some 20,000 people would live in Epcot, and that its population eventually might reach 100,000.[54] Most of the working residents would be employed in a one-thousand-acre industrial park he planned to build just a short distance outside the city, still within Walt Disney World's borders. Here, he saw Disney employees and the brightest minds of American corporations collaborating to develop new technologies and solutions to the problems faced by people living in cities around the world. Visitors to Walt Disney World could tour these facilities and watch the work unfold. In his video presentation, which was filmed

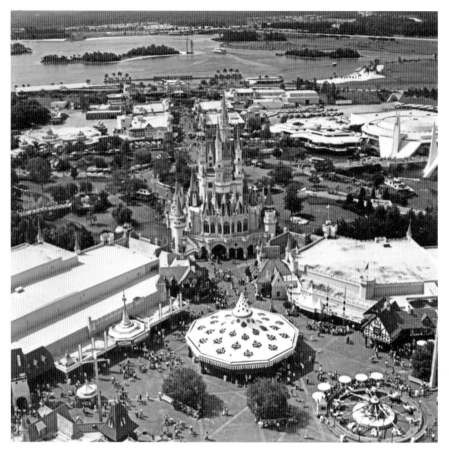

A 1976 aerial view of the Magic Kingdom, with Cinderella's Castle at center. *Courtesy of the State Archives of Florida, Florida Memory.*

as poor health began to plague him, Disney made clear that he hoped the model of Epcot—including its design and function as a breeding ground for practical solutions to civic problems—would be replicated in other locations, many times over.[55]

Along with Epcot, the industrial park and the transit systems, Disney also described a theme park area for Walt Disney World, one that would include hotels and motels and be five times larger than Anaheim's Disneyland. Additional features would include the "airport of the future" and an entrance complex. He knew Epcot was a lofty idea and called on American industry to help his company achieve it. Disney sought innovative partners for the project and paid visits to Westinghouse, RCA and General Electric.[56]

Walt stated that he believed Epcot ultimately would become the most visited and talked about area on earth.

Walt Disney World would later become one of the most popular tourist destinations in the world, but sadly, Disney would not live to see his Florida project welcome its first visitors in 1971. Epcot was Walt Disney's last great act, a venture that moved him so, it captivated his attention until the moment of his passing. Gabler recounts that as Walt was on his deathbed across the street from the studio where he captured America's imagination, he used the framework of the ceiling tiles to draw his Epcot plans in the air for his brother Roy Disney.[57]

ONE POWERFUL MOUSE

Following Walt's death of lung cancer in December 1966, his company presented the Epcot film twice, once at a February 1967 press conference and again for the Florida legislature in March of the same year.[58] The aim in doing so was to gain state approval for the construction of Walt Disney World and for the authority the company sought to carry out the project.

Rick Fogelsong, a professor of political science at Rollins College and author of the 2001 book *Married to the Mouse*, says Walt Disney's company asked for, and received, authorization from the Florida legislature to essentially create a private government. This government would exempt the organization from county planning and zoning regulations. In time, it has come to shield the company from impact fees levied on other developers, as well.[59]

How much of this Florida politicians understood at the time they signed off on the Disney project in the 1960s is a matter of debate. Officials did anticipate massive job creation and economic growth in Central Florida and beyond. Political opposition for the plan was scant. "There were a handful of old-timers who didn't want change, who didn't want anything new, but Governor Haydon Burns and local members of the state legislature pushed it through and so there was no real opposition," Clark explained. "When it came to a vote in the legislature, the only people who really voted against it were people from Miami, who correctly saw it as a threat."[60]

With the legislation signed and passed into law, Disney's company could embark on the creation of the described futuristic city. But that is not what happened.

A DIFFERENT COURSE

There are two main accounts of why Walt Disney's company shifted efforts following his death from building his Epcot to creating the Magic Kingdom, which opened in October 1971. One is that Roy Disney—co-founder and by now head of the company—applied his usual sober business sense and killed the project as an impractical fantasy. Fogelsong points to the fact that Disney's video was presented twice after his death as evidence refuting this idea that Walt's death changed the company's plans.

The other view, held by both Fogelsong and Allman, is that Disney never meant to build the elaborate community he described. Rather, they say that Disney and his company put forward the idea of a community where people lived and worked as a means to convince Florida politicians that Walt Disney World should have the kind of control the company desired from the legislature. A legal memo kept in Disney archives—complete with Disney's notes—opposes the idea of permanent Epcot residents with the notion that those residents could cause the company to one day lose autonomy over its utopian city.[61]

Walt's desire to insulate his Florida attraction from other development did come to fruition, as most of the land that makes up Walt Disney World remains green space. A theme park named Epcot opened in 1982 with some of the ideas Walt had promoted in his original vision, such as areas that re-create the atmosphere of international destinations, as well as the park's "Future World" section, which emphasizes technological and scientific advancements. Two other theme parks in Walt Disney World, Disney's Hollywood Studios and Disney's Animal Kingdom, now accompany the Magic Kingdom and Epcot. In addition, there are two water parks, a Disney dining and shopping area, four golf courses, thirty-six resorts, a sports complex, a wedding center and two spas.[62]

A WORLD-RENOWNED DESTINATION

Today, the Magic Kingdom welcomes more visitors than any other theme park in the world, with 20.5 million in 2015. Combined, Disney's three other Florida theme parks hosted 33.5 million.[63] Walt Disney World employs in excess of 70,000 "cast members."

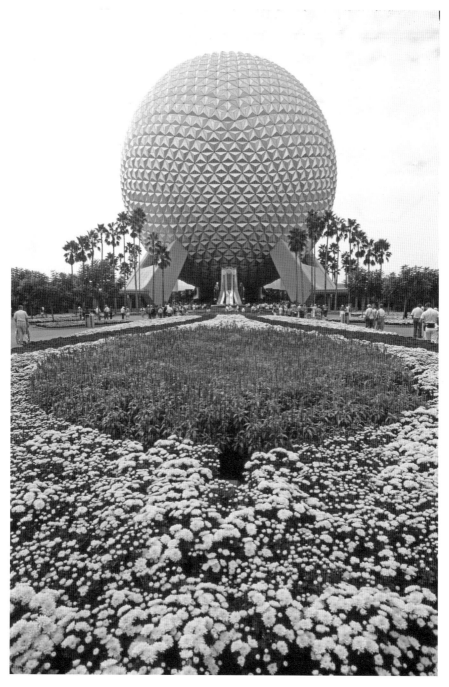

Spaceship Earth is the iconic sphere at the entrance to Walt Disney World's Epcot. *By Dale M. McDonald, courtesy of the State Archives of Florida, Florida Memory.*

In the years since the Magic Kingdom opened in 1971, non-Disney parks have popped up around the Orlando area, including Legoland, three parks built by Universal Studios and three under the SeaWorld name. In 2015, sixty-six million people visited "The City Beautiful," as it has been nicknamed, making it the most popular tourist spot in the nation.[64]

All this tourism is a major boon to the state economy. While there are tourist draws all over Florida, none can rival the popularity of the Orlando area. In 2015 alone, tourism and recreation spurred $89.1 billion in spending in the state, generating $5.3 billion in tax revenue. For 2015, 1.4 million of the state's jobs were traced to tourism.[65]

As Fogelsong put it, "Disney put Orlando on the map, and the benefits of that are incalculable."[66] The company's presentation of the Epcot plans—the ones that would garner so much political support and help them attain the power to build their entertainment empire—rank alongside the Cuban revolution and the invention of air conditioning as the most influential twentieth-century events for the state, he adds.[67]

For his part, Clark believes it is not clear whether the destiny Disney's influence has wrought for the Orlando area is truly better than the one the region might otherwise have realized. "People have speculated that maybe we would have attracted high-paying companies if he hadn't been here," Clark said. But the current state of affairs is better, he advocated, than what might have been if Walt Disney had pursued his version of Epcot. "I think that had he lived, what we ended up with would have been radically different than what we got," Clark noted. "…I think towards the end, people were asking questions like, 'How do you charge people money to come and see where people live?' And so I think that there would have been some issues had he lived. But you know, we can only speculate on what would've actually gotten built had he lived."[68]

But for Disney's decision to expand his empire to Central Florida, Orlando would most likely be a citrus-heavy small town more akin to Lakeland, and one that visitors bypassed in favor of cities such as Tampa and Miami. And without Disney, the Sunshine State would be missing more than half its annual visitors. Regardless of how one views the nuances of Walt Disney's history in Florida, an inescapable point remains: this artist from Missouri continues to draw Florida's future, decades after his death.

NUMBER 3

FIDEL ALEJANDRO CASTRO RUZ

(AUGUST 13, 1926–NOVEMBER 25, 2016)

His policies pushed generations of Cubans to South Florida,
making Miami the "capital" of Latin America.

Stateside, there's no place quite like Little Havana.

Factories sell hand-rolled cigars, Latin music spills from street-side shops and cafés, outdoor domino and chess games unfold in a city park, roosters wander freely, freshly pressed guarapo—sugar cane extract—from a frutería tantalizes taste buds and the bold aroma of Bustelo coffee beckons.

Little Havana is a hotbed of Latin American culture in the United States and the original stateside home of many Cuban immigrants. Today, the Miami neighborhood retains a significant Cuban-American population, with a growing contingent from nations such as Nicaragua, Argentina, Colombia, Peru, Honduras and Uruguay.[69]

With Spanish as the dominant language here and a plethora of Latin American comforts, the neighborhood is a familiar landing place for immigrants from the Caribbean and South and Central America. If you're from Latin America and you want to make a new life for yourself in the United States, Little Havana may just be the best place to do so.

For that, credit goes to the Cuban-American community, which nearly six decades ago began remaking the Miami neighborhoods of Riverside and Shenandoah in the image of the home they left behind: the imperfect, but then thriving and exciting, city of Havana, Cuba—circa 1959.

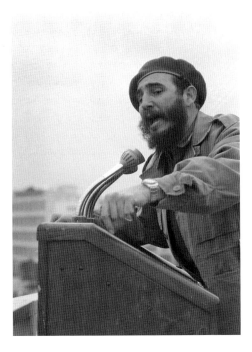

The policies of Fidel Castro led many Cubans to South Florida, where they developed Little Havana, a community similar to the one they left behind. *"Fidel Castro speaking at military parade," by Deena Stryker (Item ID 1092531-R3-E438), Deena Stryker Photographs, David M. Rubenstein, Rare Book & Manuscript Library, Duke University.*

There's someone else who had a great deal to do with the settling of Cuba's one-time elites—and the waves of other Cubans who followed them—in Miami. Without him, these Cubans might still be shaping and molding the character and culture of their original homeland, rather than that of a city 230 miles to the north. That man is Fidel Alejandro Castro Ruz.

Perhaps some will find it wrong or distasteful to recognize a brutal dictator, a longtime enemy of the United States and Cuban-Americans, as an important figure in Florida history. This recognition comes not with adulation but as a nod to historical facts. The purpose of this book is to chronicle the individuals who have had the greatest impact on Florida's development. Florida simply would not be what it is today if not for the power and politics of Fidel Castro.

PRE-CASTRO CUBA

Immediately prior to Castro's revolution, Cuba was a model for Latin America in many arenas. According to an *American Thinker* article by columnist Bruce Walker:

The standard of living of Cubans then was higher than that in any other Latin American nation. Caloric consumption was as high as in any other Latin American nation in the western hemisphere except America and Canada, and it was much higher in protein than in most other Latin American nations. Cuban infant mortality under [Fulgencio] Batista was lower than in France or Italy. Batista set up mobile health units for rural areas. He mandated compulsory industrial insurance for workers and enacted minimum-wage and eight-hour-workday laws.[70]

Cuba in the 1950s outpaced much of Latin America in other ways, too, including literacy (82 percent in 1958)[71] and the prevalence of televisions and radios.[72] These factors enabled the people to take in the entertainment and news content produced by Cuba's independent broadcast stations, newspapers and magazines. The nation enjoyed the third-lowest mortality rate worldwide, as well as the twenty-second spot globally for number of doctors per capita: for every 100,000 people, there were 128.6 physicians.[73]

Things were not bad economically, either. At the start of the decade, value of the Cuban peso was on pace with that of the American dollar. The nation had a flourishing, well-educated and professional upper class. The year before Castro took power, Cubans owned 62 percent of the sugar mills in a nation with an economy centered on sugar.[74]

The government of dictator Fulgencio Batista was no democratic ideal, as political corruption and violence were among citizens' chief complaints. But neither was Cuba languishing in poverty. Castro's rise to power would change all that, pushing Cuba's greatest asset—its people—away from the homeland they loved.

CASTRO'S BACKGROUND AND RISE TO POWER

Fidel Castro was born with one foot in Cuba's upper class and one in its lowest ranks. His parents were Ángel Castro y Argiz—a wealthy and married sugar cane plantation owner—and Lina Ruz González, one of Ángel's domestic servants. Various sources highlight different—and somewhat contradictory—aspects of Fidel's early years, including his upbringing among poor farmworkers (which the dictator himself emphasized),[75] his education in private boarding schools, his parents' affair and his father's refusal to officially recognize Fidel as his son until the boy was seventeen.

Castro's thirst for political power and upheaval became evident during his time studying law at the University of Havana. As a student, he became involved in political groups, co-founded a liberal reformist political party and traveled to the Dominican Republic and Colombia to participate in political rebellions.[76]

In 1951, the year after he graduated from law school, Castro ran for the Cuban House of Representatives. But his candidacy would be cut short, thanks to General Fulgencio Batista. Batista put an end to the election when he seized power as dictator in 1952. Castro became determined to overthrow Batista and, in 1953, led a group of rebels in an attempt to do just that. His attack on one of the nation's largest military bases[77] was unsuccessful. Castro was arrested, tried and received a fifteen-year prison sentence.

Batista ordered Castro and other political prisoners to be released after just two years had passed. But freedom did not erase Castro's loathing for Batista's government, nor his zeal for power. He and his brother Raul fled to Mexico and met up with Argentinian political revolutionary Che Guevara, who was a Marxist. The three organized and trained fellow rebels to take on Batista's forces. They named their group the 26th of July

Most Cuban refugees settled in Miami, remaking neighborhoods in the character of the thriving city they had fled. *Courtesy of the State Archives of Florida, Florida Memory.*

Movement, after the date of Castro's attack on the military barracks in his initial overthrow attempt.

In late 1956, Castro and his force of guerrilla-trained insurgents landed back on the island of Cuba. Though most were killed or captured, Fidel, Raul, Guevara and several others escaped into the mountains, from which they launched a guerrilla warfare campaign. Meanwhile, Batista's support from the U.S. government, and any he had among his own people, was crumbling.

Castro's support from Cubans who opposed Batista—and had been taken in by Castro's propaganda—continued to grow until he had amassed nine thousand guerrilla fighters to descend on Havana and confront Batista.[78] Batista left Cuba on New Year's Day 1959, opening the door for Fidel Castro to step in and take his place. Many Cubans cheered Castro's victory, not yet aware of the kind of leader he would become.

EMBRACING MARXISM

During his rebellion against Batista, Castro had claimed he was fighting to restore democracy in the island nation. But his actions once he took control of the government were just the opposite. In the first few years of Castro's rule, a series of measures began transforming Cuba from a nation with a growing economy to one that would suffer years of scarcity. Castro announced plans to redistribute 7.5 million acres of farmland[79] and nationalized businesses, including the sugar plantations essential to the island's economy, as well as factories. Many assets of U.S. companies were seized in the process. The government began to censor media outlets that reported unfavorably on Castro's actions. In 1961, Castro announced that Cuba was a Communist nation[80] and began a cozy relationship with the Soviet Union that would lead the world to the brink of nuclear war.

The regime also became known as a great violator of human rights, and the Cuban government today continues the reprehensible practices that earned it that status decades ago. In Cuba, participating in orderly demonstrations, having a "dangerous disposition," membership in an unsanctioned organization and many other so-called crimes are punishable by imprisonment.[81] Harassment of people who oppose government policies is also common. Abuse, jail time and torture are often punishments for peaceful demonstrators. Sometimes, demonstrators are murdered. Women known for protesting the unlawful detainment of their relatives, the famed Ladies in White, are sometimes put in jail themselves.

EXILES

With his rise to power in 1959, the Cuban government's seizure of U.S. businesses the next year and his increasingly Marxist leanings, Fidel Castro triggered a diaspora of his countrymen to the United States. The first exodus took place from 1959 to 1962, with additional, highly publicized cohorts of people fleeing the island in 1965–74, 1980 and 1993–95.[82] "Each wave has reached deeper into the layers of Cuban society," explains one resource, "from the wealthy in the 1960s to the dwellers of Havana's squalid inner city neighborhoods in the 1990s."[83] What many people may not realize is that significant movement of Cubans to the United States continues today, with twenty thousand legally arriving each year and another ten thousand entering illegally or overstaying their visas.[84]

When it comes to the U.S. population of Cuban-born people, nowhere compares to South Florida. Of the 1.15 million residing in the United States in the years 2011–15, 938,456 lived in Florida.[85] Miami-Dade County was home to 654,200 Cuban immigrants during that time, more than any other U.S. county. In fact, seven of the nation's top twelve counties for Cuban immigrants are in Florida, including the top four.[86]

Prior to the Cuban Revolution, the Big Apple was the preferred destination for Cubans moving to the United States, said Dario Moreno, an associate professor of politics and international relations at Florida International University, located in Miami. But once the revolution occurred, that changed. "Because people expected to go back to Cuba, they wanted to be closer than New York," Moreno explained, "so that's why Miami was the chosen destination."[87]

This original intent to return to the island, which perhaps some Cuban-Americans today would rather characterize as a hope or a dream, is reflected in wording often used to describe Cubans who have fled since Castro's revolution. The Cuban Adjustment Act, which outlines U.S. policy toward Cubans arriving in the United States, favors the concepts of *political asylum* and *refugee status*. Leaders of the Cuban-American community have been known to refer to the population as *exiles*.[88] Inherent in all three of these terminologies is a sense of a temporary arrangement.

Early Cuban refugees who settled in Miami, the vast majority of whom did not speak English, did not integrate into the existing culture and daily life of the city. Rather, they set about creating an enclave of Cuban society. This was possible in large part because so many of those who fled Cuba from 1959 to 1963 were accomplished and well-educated professionals—the

upper echelon of Cuban society. Moreno described the district they created, aptly named Little Havana, as "sort of this self-contained city within a city, in which you could shop, go to the dentist, see an accountant, see a lawyer, see a doctor, do everything you need to do in your daily life and do it in Spanish and do it with co-ethnics."[89]

Key to the impact of Cubans was the relatively clean slate they found in Miami in the 1960s. A mid-size southern city, Miami was a little smaller in population than a city such as Kansas City, Missouri, but comparable in economic significance.[90] "The Cubans transformed not only their populations but their landscapes, their economies, and their culture," Robert M. Levine and Moisés Asís write in the book *Cuban Miami*. "What the Cubans achieved in Miami, Cuban American banker Luis. J. Botifoll believes, could not have happened if they had concentrated in New York or Atlanta or some other already dynamic city."[91]

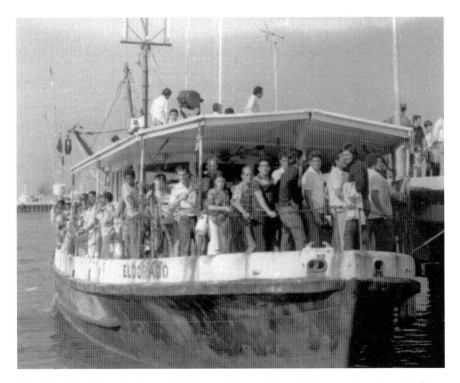

The Mariel boatlift took place in 1980, when Castro allowed Cubans to leave from the Port of Mariel. Around 125,000 people left the island over about six months, including people Castro released from incarceration. *By Dale M. McDonald, courtesy of the State Archives of Florida, Florida Memory.*

Moreno points out that this transformation occurred largely in the span of one generation, a fact that helps to set the Cuban migration apart from most others in modern history. In modern history, influence on par with that of the Cuban diaspora's effect on South Florida is rare. It is comparable to the formation of the state of Israel after World War II, when seventy thousand displaced Jews traveled to Palestine from 1945 to 1948 and formed a new country.[92]

INFLUENCING BUSINESS, TRAVEL, CULTURE AND POLITICS

With Little Havana as the epicenter of Cuban culture in Florida, and Latin Americans settling throughout South Florida, the Miami area has become a center of international banking, business, trade and travel. "Its metro area is home to the largest concentration of international banks in the United States," reports *Global Trade* magazine. "Not surprisingly, Miami is categorized as an 'Alpha' or 'Global City' and considered a critical cog in the world economy. Much of the area's trade is done with Central and South America as well as the Caribbean, which seems only fitting since Miami's diverse population has earned it the nickname 'Capital of Latin America.'"[93]

Nationwide, only New York's John F. Kennedy Airport surpassed Miami International Airport in the number of international passengers for 2015, while Miami International Airport held the top spot for international freight.[94]

Miami's impressive banking and travel statistics are fueled in part by instability—past or present—in Latin America. "It is true that Brazilians, Venezuelans, Colombians—particularly those with money—see Miami in particular as a very nice place to park cash, and often daughters, in case things turn badly in Venezuela, as they have in recent years, or Colombia before that or Brazil now and then," said David Abraham, a professor at the University of Miami School of Law.[95]

Cuban-Americans also have contributed greatly to the U.S. economy by leading, and in some cases founding, a slew of renowned U.S. companies. Companies established or at one time led by Cuban-Americans include the Coca-Cola Co., Bacardi (which was founded in Cuba in 1862 and later moved to the United States),[96] AT&T Mobile and Business Solutions, McDonald's Corp. and Kellogg Co., to name several.[97]

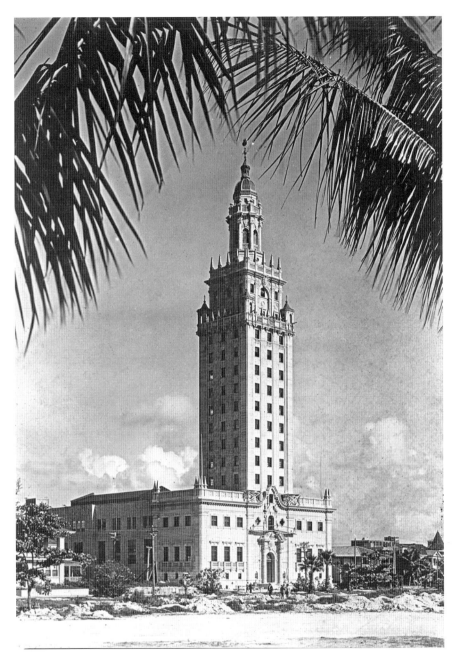

Originally the Miami Daily News Tower, the Freedom Tower got its name after serving as base for the Cuban Assistance Center from 1962 to 1974. *By Richard B. Hoit, courtesy of the State Archives of Florida, Florida Memory.*

Cuban-Americans also have made their mark on American and international culture and entertainment. Emilio Estefan, a music producer whose career has netted nineteen Grammy Awards, and his wife, seven-time Grammy winner Gloria Estefan, were members of the group the Miami Sound Machine, which reached its heyday in the 1980s. Emilio Estefan has served as a producer for such Latin American superstars as Ricky Martin, Jennifer Lopez, Shakira, Jon Secada and Marc Anthony.[98] Contemporary American celebrities with Cuban heritage include Cameron Diaz, Rosario Dawson, Eva Mendes, Pitbull, Soledad O'Brien and Andy Garcia.[99]

The impact Cuban-Americans have made in state and national politics in the few decades since the Cuban Revolution has been extraordinary. Moreno says the Cuban experience of losing freedom in their homeland has imparted to the Cuban-American community a keen understanding of the need for political involvement. "No other ethnic group in the United States has incorporated and assimilated so quickly into American politics as Cuban-Americans," he remarked in a 2015 interview. "It only took 26 years for Cuban-Americans to elect the first Cuban mayor of Miami. Cubans, beginning in the late 1980s, began to serve in Congress; in the early 1980s, in the state legislature. You [had] two Cubans…running for president [in 2016]….All three of the Hispanic senators in the U.S. Senate are Cuban-Americans.* So Cubans have had a tremendous impact on American politics and for a group that's so small—less than 2 million Cubans—it's really extraordinary."

GROWING PAINS

But as with any mass human migration, the effects have not all been rosy. The Mariel boatlift began in April 1980, when Castro announced that anyone who wanted to leave the nation could do so freely through the Port of Mariel. People boarded boats in droves, most traveling to nearby Florida. The exodus carried on for months, with an official end declared in October 1980.[100] All told, around 125,000 people fled the island in the Mariel boatlift. This included people Castro pulled out of jails and mental institutions, shipping them off to the United States.

* Senators Marco Rubio and Ted Cruz both sought the Republican presidential nomination starting in 2015. Rubio, Cruz and Senator Bob Menendez were the three U.S. senators of Hispanic origin as of October 2015. Catherine Marie Cortez Masto, of Mexican and Italian descent, joined them in 2017.

Just how many fell into that category is unclear. A *Washington Post* 1999 special report on the topic claims there were about 2,700.[101] Moreno, the Florida International University associate professor, estimates 15,000,[102] and a 1993 *Ocala-Star Banner* article chronicling an ongoing crime wave in Miami—one that prompted Governor Lawton Chiles to don a bulletproof vest on a visit to the area—puts the number at more than 20,000.[103]

"That kind of adjustment did lead to a flurry of insecurity and then of course it was magnified, much magnified, by the fact that it coincided with the explosion of drug smuggling and use in the country," noted Abraham.[104] Some people believe the increase in drug trade was at least partly a consequence of the boatlift, rather than an unrelated phenomenon that took place around the same time.

In 2008, Raul Castro officially became Cuba's president as his brother suffered a mysterious illness. He has brought some changes to the island, but much has remained the same. A 2017 report by the nonprofit organization Human Rights Watch reports that Cuba's human rights practices are largely unaltered. The group did note that long-term imprisonment is down in recent years, while "arbitrary detentions" reached a six-year high in 2016.[105]

Cubans have continued traveling to Florida for a better life. South Florida's *Sun Sentinel* newspaper published a series of articles in 2015 describing the ways in which some Cubans have taken advantage of the Cuban Adjustment Act and other particulars of the relationship between the two nations. Though the act was adopted to aid Cubans facing oppression and persecution at home, the series claims it is regularly exploited by Cubans who travel back and forth between the two nations.*

* Some Cubans—though it's tough to say how many—set up elaborate criminal enterprises in the United States, operating marijuana grow houses or running sham medical clinics that profit off Medicaid dollars brought in by staged automobile accidents. They send or take money to the island, often escaping U.S. prosecution by fleeing back to Cuba when law enforcement begins to track them down (Sally Kestin, Megan O'Matz and John Maines, "Plundering America: The Cuban Criminal Pipeline Part I: Exploiting U.S. Laws," *Sun Sentinel*, January 8, 2015, accessed October 14, 2015, interactive.sun-sentinel.com/plundering-america/index.html). Others obtain welfare benefits in the United States and then return to live in Cuba (Sally Kestin, Megan O'Matz and John Maines, "Sun Sentinel Investigates: Easy Money—U.S. Welfare Flows to Cuba," *Sun Sentinel*, October 1, 2015, accessed October 14, 2015, www.sun-sentinel.com/us-cuba-welfare-benefits/sfl-us-cuba-welfare-benefits-part-1-htmlstory.html; Sally Kestin, Megan O'Matz and John Maines, "Sun Sentinel Investigates: Easy Money—Cubans Retire to Florida—with Help from U.S. Taxpayers," *Sun Sentinel*, October 1, 2015, accessed October 14, 2015, www.sun-sentinel.com/us-cuba-welfare-benefits/sfl-us-cuba-welfare-benefits-part-2-htmlstory.html).

CUBA'S LOSS, FLORIDA'S GAIN

Dade County, home to the city of Miami, had a population just shy of 500,000 in 1950. The area "was home almost exclusively to white southerners (who pronounced the city's name Myam'uh), retired Jews and Italians from New York, and blacks, including some Bahamians," as reported in the book *Cuban Miami*.[106] Today, the county is a bustling international metropolis unlike anyplace else in Florida. Its estimated 2015 population was 2.7 million people,[107] nearly the same as that of the recorded population of the entire state in 1950.[108] In the second half of the twentieth century, the Miami metropolis underwent greater transformation than any other urban region in the nation. From 1950 to 2000, the area's population exploded, growing 569.5 percent. By comparison, the next largest jump was in the Houston, Texas area, which saw a 344.4 percent increase.[109]

Thanks largely to the influx of Cubans, Miami and South Florida as a whole have risen to become a first-class, global city. With Miami leading the way, Florida has become the first state in the Union with a predominant Hispanic voice in politics and business and has boomed in population to third nationwide.[110] Fidel Castro's oppressive leadership in Cuba pushed the island nation's once-grand promise and potential to the shores of Florida.

With Fidel Castro's death in November 2016, his brother Raul Castro's promise to step down from the presidency in 2018 and President Barack Obama's changes to decades-long U.S. policies toward Cuba, conditions may be ripe for transformation of the Republic of Cuba—and with it, the state of Florida. Or the next generation of political leaders may choose to more or less maintain the status quo. Only time will tell.

But with the richness of Latin American culture and commerce woven into the fabric of the Sunshine State, Florida's road ahead looks to be full of opportunity. Because of the Cuban diaspora, Florida now sits at the gateway to Latin America and may one day become the "Capital of the Americas" as the two hemispheres meet in Miami.

HENRY BRADLEY PLANT

(OCTOBER 27, 1819–JUNE 23, 1899)

He put Tampa on the map as a port city, cigar capital and military hub.

While Henry Flagler was developing Florida's east coast, Connecticut businessman Henry Bradley Plant was building his own empire by purchasing and refurbishing defunct rail lines throughout the South. In so doing, he helped to rebuild the region after the devastation of the Civil War. Where his newly obtained rail lines featured narrow-gauge track, he streamlined operations by swapping it out for standard gauge, allowing trains to run throughout his growing rail network without switching cars. As a result, business and travel throughout the southern states was beginning to boom again in the war-torn former states of the Confederacy. Meanwhile, Plant himself was becoming one of the most recognized and celebrated American businessmen of his day.

One of Plant's most consequential moves, both for his own business interests and for the state of Florida, was connecting his rail line to the tiny town of Tampa. In 1880, a few years prior to Plant's efforts there, the municipality was home to a mere seven hundred people.[111] Plant's work would transform Tampa and the surrounding area from sleepy frontier town into an exciting and pivotal player in Florida's developing economy. His rail system also would open up the interior of the state, with a variety of railroad extensions, for burgeoning postwar commerce, tourism, agriculture and industry. The connection from Tampa to Jacksonville,

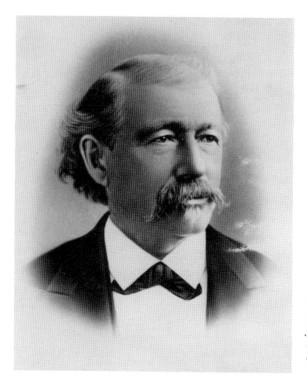

Henry Plant essentially founded Tampa and connected it by rail to Jacksonville. *By H.A. Rost Printing & Pub. Co., courtesy of the Henry B. Plant Museum, Tampa, Florida.*

which was in turn connected to northern states, sparked the creation and growth of business interests along the intervening distance and put Tampa on the path to becoming what it is today: one of the state's most vibrant cities.

CHANGE OF PLANS

But Plant originally had not envisioned Tampa as a Gulf Coast hub in his railroad system. Rather, Tampa came into play after a business deal gone awry left Plant with less than he thought he had bargained for. The diminutive island of Cedar Key, which lies northwest of Tampa in present-day Levy County, was his first target for a Gulf Coast rail station. When Plant came along, there was already a rail terminal in Cedar Key, one that he intended to purchase along with the connected Florida Transit and Peninsular line. The line's owners, however, had other ideas and surreptitiously left the station out of their contract with Plant, a fact he did

not discover until the purchase was complete.[112] Plant didn't know it yet, but the slight ultimately would work out in his favor.

Instead of capitalizing on a rail connection at Cedar Key, Plant purchased a company that had approval to build a rail line from Jacksonville to Tampa and to acquire state land as it did so.[113] His workers completed the track between Sanford and Tampa in 1884, the year after work began. The railroad construction and completed connection to Tampa brought explosive population growth. By 1885, Tampa's populace had blossomed more than fourfold, to three thousand people.[114]

BEYOND THE RAILROADS

The next year, Plant established the Plant Steamship Line, running between Port Tampa, Key West and Havana.[115] The ships carried mail to the two southernmost destinations. He later expanded the steamship operation to include service to Mobile and Boston and to incorporate a Canadian line. This ran between Halifax, Nova Scotia, and Charlottetown, Prince Edward Island. An 1896 advertisement for the Plant Steamship Line ran with the impressive boast that "ships ply between the ports of 3 great nations," including the United States, England and Spain.[116] Some sources on Plant and his transportation system refer to other stops along the Plant Steamship Line, including New Orleans, Bermuda, Jamaica and present-day Belize (then known as British Honduras).[117]

Tampa's inclusion in Plant's transportation system began to return benefits for Tampa and for Florida almost immediately.[118] In 1885, Cuban cigar maker Vicente Martinez Ybor, who was then running his operation in Key West, visited Tampa and saw the potential Plant's transportation network offered. He purchased forty acres near Tampa and founded a "cigar town" to be the new home of his factory. Ybor was one of three cigar manufacturers, all with well-known companies, who had left Cuba to run their businesses in the United States. After he founded Ybor City, the two other manufacturers followed him there. Two years after Ybor began his little town, Tampa annexed it.[119]

Ybor City's cigar scene was transforming Tampa into an economic powerhouse in Florida, a multicultural center and the first heart of the state's Hispanic population. The cigar manufacturers' "factories and their hundreds of employees—all Spanish speaking, all Cuban—made Tampa a bilingual city with an international atmosphere. Within a decade, Tampa

was calling itself The Cigar Capital of the World and had multimillion dollar exports annually," Charles Harner recounts.[120]

Plant's massive expansion of Port Tampa's infrastructure, which followed the founding of his steamship line, only helped the city's growing cigar industry. The work began in 1888, just after a devastating yellow fever epidemic that hit Tampa subsided. Plant put a great deal into connecting his rail line to the waterfront that residents had developed over several decades. Until then, the port had advanced in fits and starts.[121] Kelly Reynolds, a retired University of South Florida adjunct professor, writes:

> First his engineers put a drawbridge over the Hillsborough River and extended the tracks of the South Florida Railroad almost 10 miles into shallow Tampa Bay. Ships could finally begin to load and unload in volume, quickly. Next, every able-bodied survivor for miles around went to work on a tremendous multi-purpose wharf that, when finally completed, jutted better than a mile out into the bay. Here, on the ocean side, ships came to berth next to freight cars, with cargo cranes in between. Likewise passenger trains had immediate access to ships of the Plant Line.[122]

Plant used his steamships to support Ybor City's cigar contingent throughout a Cuban embargo that was set to prohibit export of the island's tobacco. Recognizing the cigar manufacturers' importance to the burgeoning city of Tampa, Plant sent two of his ships on runs to pick up Cuban tobacco. They brought back enough to get Ybor City's cigar entities through the embargo.[123]

In addition to tobacco and cigars, phosphate rock also passed through Tampa's port, starting in the late 1880s with Florida's phosphate boom.[124] Phosphate rock mined from the ground provides the element phosphorous, which is essential to all life. Phosphorous is primarily used to make crop fertilizer but also is added to food and beverage products meant for human consumption and goes into animal feed and detergents.[125] Today, Florida is one of four states that do most of the country's phosphate mining, and the United States ranks third worldwide in phosphate production.[126]

The port and rail connections also benefited Tampa by fueling growth in its fishing industry, jumpstarting tourism in the area and allowing for the import of a variety of goods not previously available in Tampa.[127]

While Tampa continued to grow, Plant was extending his rail line even farther south, creating another Gulf Coast terminal and building a sophisticated two-hundred-room hotel in the little town of Punta Gorda.[128]

Like his east coast counterpart, Flagler, he also invested heavily in Florida hotels. In addition to the Punta Gorda Hotel, Plant would come to own the Seminole Hotel in Winter Park, the Ocala House, the Inn at Port Tampa, the Fort Myers Hotel, the Kissimmee Hotel, the Tampa Bay Hotel and the Belleview Biltmore.[129]

His Tampa establishments—the Inn at Port Tampa and the Tampa Bay Hotel—offered two strikingly different guest experiences. Built on stilts in the bay, the former allowed guests the novel experience of fishing from the windows of their rooms. "The kitchen staff would prepare their catch and serve it to them in the dining room," reports a *Tampa Tribune* article by historian Rodney Kite-Powell.[130]

The Tampa Bay Hotel was built from 1888 to 1891.[131] Once completed, it stood out for its size and opulence. Plant paid nearly $3 million of his own money to build and furnish the 511-room structure, rather than relying on funds from the Plant Investment Company that bankrolled many of his other Florida ventures.[132] With electricity throughout, a treasure-trove of lush furniture and decorations the Plants personally collected from Europe and Asia, and gleaming minarets and domes jutting skyward from the roof, the Tampa Bay Hotel was every bit as grand as Flagler's luxurious St. Augustine establishment, the Hotel Ponce de León.

The latter had opened in 1888, and it seems likely that a bit of friendly cross-state competition helped spur Plant to launch construction of his over-the-top flagship hotel. One thing no one could predict was that the size of the Tampa Bay Hotel would come in quite handy, as it would soon host a small army.[133]

THE SPANISH-AMERICAN WAR

In 1898, seven years after Plant's masterpiece of a hotel opened, the United States found itself embroiled in an increasingly intense conflict with Spain. The source of the conflict was Cuba, which had been vying for independence. The United States supported Cuba's efforts but stopped short of war with Spain until February 1898, when the USS *Maine* exploded in Cuban waters. Though the cause of the blast remains a matter of debate to this day, the tragedy pushed the United States formally into war. All the money and effort Plant had poured into building Tampa earned the city a prime role in U.S. military operations. The tycoon's campaign to bring the army to town didn't hurt, either.

According to the National Park Service, "The U.S. government chose Tampa as the official port of embarkation for American forces heading to Cuba because of its geographical location, deep-water port, and connection to Henry B. Plant—with his railroad line, his ships, his lobbying and connections to the War Department, and his massive Tampa Bay Hotel."[134]

During the war, the area was home to seven U.S. Army camps, and the hotel itself was the officers' headquarters.[135] About thirty thousand troops flowed through the city.[136] The troops who stayed, strategized and trained in Tampa before heading to Cuba included Colonel Teddy Roosevelt and his now-famous Rough Riders. Later that year, the Treaty of Paris of 1898 ended the short-lived conflict and moved Puerto Rico, Guam and—temporarily—Cuba from Spanish control to U.S. authority.

The U.S. victory over Spain in the Spanish-American War established America as an international power, and the effort had largely been launched from Tampa. The end of the nineteenth century saw Tampa's population continue to grow rapidly, as the city approached fifteen thousand people in 1899.[137] In the same year, Henry Plant died unexpectedly. The Atlantic Coast Line purchased his railroad holdings, totaling 2,235 miles of track, in 1902.[138]

A MILITARY FUTURE

Tampa's prominent role in the Spanish-American War, which developed mostly due to Plant's work, was a harbinger of things to come. Since then, the city has become one of the nation's premier military hubs. The same area that had been a staging ground for military action in the Spanish-American War became MacDill Field in 1941.[139] The National Defense Act of 1940 had approved major additions of personnel and equipment for the U.S. Army Air Corps, as well as a significantly increased budget. The $300 million allocated for the air corps in this legislation funded the establishment of MacDill Field and other new airfields.[140]

Tampa's location and robust infrastructure caught the attention of military leaders considering where to build their new airfields, according to a U.S. Air Force base history report: "The airfield for the Southeast had several competitors, primarily in central and southern Florida. However, the choice quickly narrowed down to one due to strategic proximity to the Caribbean and the Panama Canal, weather conditions that supported year-

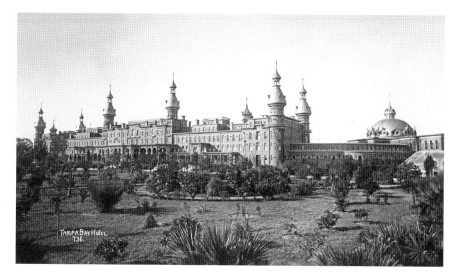

Plant built the Tampa Bay Hotel, which was completed in 1891 and housed American troops during the Spanish-American War. *Courtesy of the State Archives of Florida, Florida Memory.*

round flying, and the closeness of a well-developed transportation center with a source of supplies and housing."[141] MacDill Field later changed its identity to MacDill Air Force Base. Throughout U.S. military conflicts in the twentieth and twenty-first centuries, the base's importance has continued to grow. It is now home to U.S. Central Command, which began operations there in 1983, and U.S. Special Forces Command, which started in 1987. The former manages U.S. military efforts in the Middle East and parts of Africa and Asia, while the latter oversees America's military action in crisis situations worldwide.[142]

In the 2014 fiscal year, MacDill Air Force Base had a $4.7 billion economic impact, including responsibility for twenty-four thousand jobs and also the presence of approximately seventy-three thousand resident military retirees and spouses in the Tampa Bay area. Thanks to Florida's plentiful sunshine and warm weather, military retirees account for a significant portion of MacDill's economic impact.[143] Overall, MacDill's economic impact accounted for nearly 6 percent of Florida's total defense industry economic impact ($79.8 billion) in 2014.[144]

U.S. Coast Guard Air Station Clearwater is also in the Tampa Bay area. The station's website identifies it as "the largest and busiest air station in the Coast Guard."[145]

OTHER INDUSTRIES

Along with defense, the Tampa Bay area's other two main industries are financial services and technology, according to *Forbes*.[146] Plant's investment in Tampa has benefited all three by literally transporting people to the Tampa Bay area and making it easier for businesses of all kinds to grow there and easily ship goods to customers across the globe. In December 2016, Port Tampa Bay, as it is now called, saw $201.4 million in export activity.[147] The port's president announced in November 2016 that with the scheduled 2018 addition of another cruise ship—the port's second—to reside in Tampa year round, the port anticipates handling one million cruise passengers each year.[148] In 2015, nearly twenty-two million visitors traveled to Hillsborough County,[149] which is home to Tampa but is just one of several counties considered part of the Tampa Bay region.

Agriculture remains strong in Hillsborough County, with an emphasis on ornamental plants, vegetables, strawberries, beef cattle, aquaculture and several other sectors.[150] The University of Florida's Institute of Food and Agricultural Sciences ranks the county third in the state for agricultural-related employment (176,296 jobs in 2013) and value-added economic impact ($11.92 billion in 2013).[151]

Local healthcare industry statistics are impressive, too. A list of the Tampa Bay area's largest employers includes seven hospital or healthcare systems that employ more than one thousand people each.[152]

TAMPA WITHOUT PLANT?

Where would Tampa Bay be without Plant? By remaking a town of seven hundred people with the key building blocks it needed to become a major American city, Plant founded the most populous urban center on Florida's Gulf Coast. Without his investment, the entire region would have grown more slowly and likely would have missed several decisive events that shaped the region into what it is today and continue as defining aspects of its identity. Minus his rail and steamship lines and spectacular hotel, few would have found reason to visit the small town of Tampa in the 1880s and 1890s. Even fewer businesses would have set up shop, and rail and port infrastructure would have remained nonexistent. All of this would have made the area far less attractive to the U.S. Army as a launching point for the invasion of Cuba in the Spanish-American War.

Without the momentum Plant gave the region, what would Tampa's port be like today? Would farther south Charlotte Harbor—with its nearby cities of Punta Gorda and Fort Myers—instead host the most important port city and urban center on Florida's west coast? Would Tampa Bay be the military community it is today without that initial deployment to Cuba, made possible by Plant's foundational work? Would there been reason to construct Interstate 4 to connect Tampa to Central Florida, enticing Walt Disney to strategically situate his new theme park domain at its intersection with Florida's turnpike? Would Flagler have created his empire of Sunshine State resorts and railroads, absent Plant's start in Tampa Bay to inspire him?

Because of Plant, Tampa Bay is one of the state's most vibrant regions and anchors the I-4 corridor, a super-region extending from Tampa to Orlando, then on to Daytona. The Tampa–St. Petersburg–Clearwater metropolitan area ranks second in the state with an estimated 2016 population of three million people.[153] Though he didn't live to see Tampa reach a population of even fifteen thousand, Plant outfitted the city with everything it needed to become a thriving area with diverse interests. Henry Flagler's work transformed Florida's east coast; Plant's influence was no less formative for Tampa Bay.

HAMILTON DISSTON

(AUGUST 23, 1844–APRIL 30, 1896)

NAPOLEON BONAPARTE BROWARD

(APRIL 19, 1857–OCTOBER 1, 1910)

Through financial investment and Everglades drainage, these men cleared two of the greatest obstacles to Florida development at the turn of the twentieth century and forever altered the state's landscape.

enry Flagler is often called the father of Florida. And with good reason: his railroads, hotels and municipal infrastructure brought millions of people to enjoy the beauty and climate of the state's coastline, and his development efforts gave birth to the international gateway that is now Miami, Florida's most prominent city. But even the wealthy, ambitious Flagler, with a vision great enough to erect a railroad across a chain of islands stretching into the Gulf of Mexico, declined to pursue an aspiration many others of his day thought worthy: the draining of the Florida Everglades.

Flagler had good reason to leave this task alone: it was a gargantuan undertaking that started decades before his own work in Florida and continued for decades more after his death. The undrained Everglades occupied an astonishing 2,560,000 acres—four thousand square miles. Its northern headwaters originated near Kissimmee, and the wetlands extended to the peninsula's southern tip.[154] The nineteenth and early twentieth centuries saw much debate about the feasibility and benefit of draining the Everglades, and many people, Flagler included, viewed the job as too massive, too intense and too likely to fail.

Left: Hamilton Disston freed the state from a financial quandary by purchasing more than four million acres of Florida land and was the first to seriously tackle Everglades drainage. *By Sandy Gandy, courtesy of the State Archives of Florida, Florida Memory.*

Right: Governor Napoleon Broward made draining the Everglades a central component of his campaign for office and his administration. *Courtesy of the State Archives of Florida, Florida Memory.*

The two greatest pioneers of this colossal endeavor were Hamilton Disston and Napoleon Bonaparte Broward. The former was born in Philadelphia in 1844, while the latter was a native Floridian born in 1857.[155]

The two men did not work together on the project. Rather, Broward picked it up nine years after Disston's 1896 death. Through their efforts, much of the Everglades ecosystem ultimately would be drained, opening the door for an explosion in population growth and agricultural production in South Florida that otherwise would not have been possible.

Everglades drainage also has brought unforeseen and detrimental consequences to the Sunshine State—chiefly, ecological damage and accompanying water supply issues that cannot be fully reversed. Yet Florida's leaders and its people are working to improve the natural environment, with the aim of preserving its beauty and resources for future generations.

As the residents of Broward County—named for the man whose drainage efforts were instrumental in transforming that part of the state—would surely attest, Florida just would not be the same without the work of Disston and

Broward. With their work, the foundations of society laid in South Florida by Flagler's building of railroads and hotels along the coast would continue inland, as future generations made their homes and livelihoods on land that once was a flooded wilderness.

OPEN FOR BUSINESS

Before Flagler and Disney, both of whom were wealthy businessmen from other states, decided to invest in Florida, there was Hamilton Disston. The head of his father's renowned Philadelphia-based saw and tool manufacturing company, Disston first visited Florida on a fishing trip.[156] The ambitious young man saw in the largely undeveloped state an exciting new business opportunity and entered into a deal with the state government. He would drain much of the Everglades ecosystem.

Governor William Bloxham welcomed Disston, with his industrious nature and tremendous financial resources, as the indispensable man for the Everglades drainage program. As monumental as the mission was to transform millions of underwater acres into usable ground, the financial outcome—delivering the state government from a quagmire of debt—was even more important. The latter Disston achieved by purchasing four million acres from the state, at a price of $1 million. With this money, the state freed its insolvent Internal Improvement Fund from creditors who had embroiled the state in a lawsuit and held a lien on the land. The land purchase was reportedly the largest "by a private individual in the history of the United States."[157]

Charles E. Harner describes the deal's benefits for Florida in his book *Florida's Promoters: The Men Who Made It Big*: "With the signing of the Disston Purchase in 1881, the state came to life. With credit restored, outside capital began to flow into the state and the moneyed titans, Henry Flagler and Henry Plant, constructed their own empires to the east and the west of the Disston domain."[158]

Ben DiBiase, director of educational resources at the Florida Historical Society, agrees that Disston's bailout of the fund was ultimately more important than his drainage work.

> *He ended up—probably not directly—but he ended up funding a lot of railroad projects through South Florida, road projects and other things—*

other transportation-related projects and infrastructure projects that were outside of…his original idea, at least, of draining the Everglades and then cultivating that land.[159]

Plant and Flagler began building their Florida rail lines in the 1880s and, in so doing, spurred the first substantial development and population growth on Florida's east and west coasts. Both were enticed into constructing rail lines in the Sunshine State partly by the state's promise that, in return for their investment, they would receive right of way on land their railroads crossed. Disston's bailout provided the money and freed up the land the state needed to incentivize the pair of Henrys to build their railroad empires. Absent these benefits, it is doubtful that Flagler and Plant would have begun expanding into Florida when they did. But for Disston's massive purchase of Florida land, a whole series of development milestones in the state would have likely been delayed and may have been more modest when they did come to pass.

"The Disston sale sparked Florida's first land boom, bursting the dam of debt that had held back immigration and capital," writes Michael Grunwald, author of *The Swamp*. "In the four years following the sale, Florida added 800 miles of railroad tracks; in the previous two decades, it had built fewer than 200 miles. Florida's taxable property doubled in value during Bloxham's term, and land sales to settlers increased sixfold."[160]

Disston did drain some of his Florida land, but certainly not all of it. One of the most notable canals his workers dug allowed Lake Okeechobee to drain into the Gulf of Mexico, by way of the Caloosahatchee River.[161] Disston's men also dredged a connection between the Kissimmee River and Lake Okeechobee. According to Harner: "Disston dredges opened up most of the farmlands around Lake Okeechobee, dug the first eight miles of the canal to Miami, made possible the cities and villages which ring the lake today and opened the western part of the Intracoastal Waterway across Florida."[162]

All this work allowed for steamship travel up into the heart of Florida, from Fort Myers to Kissimmee, and also exposed vast tracts of what had previously been swampland. Disston planted twenty thousand acres of sugar cane in Florida. His St. Cloud plantation was perhaps the largest in the nation[163] and later became the Florida Sugar Manufacturing Company.[164] He also built another factory and planted five thousand acres of rice.[165]

But the results of Disston's drainage work were not all heartwarming forward progress. Disston and the people of Florida had to contend with an

overflowing Caloosahatchee River, thanks to the canal that connected Lake Okeechobee to the river. He might have gone on to dig the rest of the canals needed to fully drain the Everglades, were it not for a series of unfortunate events that began with the nation's financial crisis in 1893 and ended with his death in 1896, at his home. Sandwiched in between were blows to Florida's agriculture and economy: in 1894 the U.S. government ended the sugar tariff, and in the following year, two freezes damaged crops throughout the state.[166] After Disston's death, his brothers sold some of his Florida land. Disston also had sold other large parcels before his ill-timed passing.

Though he did not finish the work of draining the Everglades, Disston's mark on the state was central to Florida's transformation from a place where not many Americans wanted to live to one that attracted some of the wealthiest men of the day. It also set the stage for mass migration. Disston also is the father of Florida agribusiness, due to his work advancing sugar cane farming on a large scale in Florida. Thanks to Disston, Florida became open for commerce in a new and exciting way. He invested time, money and effort into the state's coffers and land when the challenges the peninsula presented seemed insurmountable to many. The Sunshine State transformed into a center of economic power and vitality, with Disston essential to the metamorphosis. He also laid the groundwork for development of Florida's east and west coasts by Flagler and Plant.

Restarting the Work

For about nine years after Disston's death, no one carried on the Philadelphia businessman's work of draining the Everglades. Then came Napoleon Bonaparte Broward, a vivacious character who held a wide variety of occupations—including gun smuggler to Cuba—before starting his life of public service. He completed several terms as Duval County sheriff, was a member of the Jacksonville City Council, served in Florida's House of Representatives, sat on the state Board of Health and, in 1904, vied to become Florida's nineteenth governor.[167]

Everglades drainage was a key issue in Broward's gubernatorial campaign. The prevailing mindset of the day saw draining the Everglades as a duty, so that people might put the land to good use rather than letting it just sit there under feet of water.[168] Reports of soil unmatched in its fertility and richness segued nicely into the view that drained Everglades land would be the ideal

This nineteenth-century image depicts a dredge, owned by Disston, on the St. Cloud Canal. *Courtesy of the State Archives of Florida, Florida Memory.*

place for a man who was down on his luck to start over by effortlessly growing bumper crops of produce.

Broward was seen as a champion of the people and promised to push Florida growth forward by creating an "Empire of the Everglades."[169] His humble background and tough lot in life, including being orphaned at age twelve, formed his populist views and appeal.

"He was someone who came from very meager beginnings," said DiBiase, "rose up through the political ranks through kind of non-traditional routes and was the champion of the people. He got a lot of the rural vote. He got a lot of people in Florida excited about drainage, excited about development and opening up…the wild lands of Florida."[170]

America's early conservation movement was beginning to gain steam in the late 1800s and early 1900s, with people, organizations and governments taking steps to preserve wildlife, including Everglades wildlife. There was special interest in the wading birds that lived there, hundreds of thousands strong. But curiously enough, this concern for Everglades wildlife did not extend to an interest in preserving their habitat, as Grunwald notes.[171]

In 1905, the same year that Broward became governor, Florida's Board of Drainage Commissioners was formed. Two years later, the

Everglades Drainage District replaced it,[172] at Broward's urging. By imposing a property tax on South Florida landowners at the rate of five cents per acre,[173] this body brought in some of the money required for the expensive drainage project that would become the defining issue of Broward's governorship.

With his matter-of-fact catchphrase, "Water will run downhill!" Broward doggedly pushed along the drainage project throughout his term. The Fort Lauderdale Historical Society puts it this way:

> *He was a man of action and a man of his word. Broward fought off railroad interests to gain control of the land. He then sold off a significant portion of the land to developer Richard Bolles by promising the state would drain the land, and he proceeded to use those funds to launch an ambitious dredging campaign. Broward died prematurely, but that did not diminish momentum for the reclamation program, and succeeding years are considered part of the Broward Era as the promised canals were completed.*[174]

Broward ultimately would be responsible for draining more of the Everglades ecosystem than Disston. Though he served only one term as governor and died before he could take the U.S. Senate seat to which he had been elected, Broward set the state firmly on the path of Everglades drainage. State leaders after him would continue on this path for decades to come.

"If Broward as governor is best remembered for any single act," historian Michael Gannon writes in his book *Florida: A Short History*, "it is for his leadership in initiating state-funded drainage of the Everglades to permit settlement of the southern part of the state. By 1921, sixteen settlements with two hundred people could be found in the Lake Okeechobee region."[175] Prior to Everglades drainage efforts, this area was mostly wild, with some settlement by Native Americans.[176]

Though he was as dedicated as anyone could be to the cause of Everglades drainage, Broward's tenure as governor included other important accomplishments as well. He "reorganized Florida's universities, banned child labor in its factories, expanded its roads, and erected more state buildings than all his predecessors combined," Grunwald writes.[177] Napoleon Bonaparte Broward was indeed a man of action.

LAND BOOM

Around the time of the drainage work, the state and private owners of land in the Everglades ecosystem—including Disston—launched overly rosy sales campaigns, marketing the region as a soon-to-be-dry paradise of unparalleled potential.[178] News writers trumpeted the same message, touting Everglades land as so fertile it required no real cultivation to grow bountiful crops. Advertisements targeted prospective land buyers in Europe and across the United States.[179]

The campaigns worked, enticing people from out of state to purchase plots of land they had never seen. DiBiase said it is likely that hundreds of thousands of people bought land in these transactions, over a period of twenty to thirty years.[180] Not everyone stayed. Many were bitterly disappointed when they showed up to see their land, only to find it and everything surrounding it under feet of water. Lawsuits and criminal convictions followed. This saga put a damper on sales of Everglades land for a while, but drainage efforts continued.[181]

THE WORK CONTINUES

In the decades following Broward's death, the people of Florida came to learn that creating his Empire of the Everglades required more than an elaborate network of canals. Hurricanes that struck southeast Florida in 1926 and 1928 pushed the waters of Lake Okeechobee above the simple mounds that had been built to contain it, flooding the surrounding area and killing more than 2,500 people. To prevent overwhelming damage to nearby communities and agricultural land, the U.S. Army Corps of Engineers stepped in, completing more significant barriers in the 1930s and finally building the Herbert Hoover Dike that today encircles the lake. This 143-mile dam was built in the 1960s.[182]

The corps' original levees, according to a U.S. Geological Survey publication, "permanently severed the natural connection between the Everglades proper and its headwaters. For millennia, the Everglades had been fed by intermittent, diffuse overflow of the imperfect natural levee south of the Lake."[183] The dam allowed for more extensive and permanent development of the area, the kind Broward had envisioned.

Further drainage of the Everglades ecosystem continued. But state and federal officials also came to recognize the importance of preserving and protecting at least a portion of the Everglades and set aside 1.3 million acres for the formation of Everglades National Park. The park was dedicated in 1947.[184]

THE RIVER OF GRASS TODAY

Today, about half of the original Everglades has been drained. Cities and towns hug South Florida's Gulf and Atlantic coastlines but also extend into the center of what Marjory Stoneman Douglas called the "River of Grass."

Agriculture is the heart of these communities in Florida's interior, though making a living through farming is hardly as effortless as the shady land salesmen at the dawn of the twentieth century portrayed. Pahokee, Belle Glade, Immokalee, Clewiston and other communities are built around crops grown on Everglades soil. Inland southeast Florida is home to expansive sugar cane fields, and the Collier County farm town of Immokalee has been called the tomato capital of America. Other popular crops include citrus, sweet corn, beans, potatoes and plants grown for nurseries, to name a few.[185] Livestock is another important component of South Florida agriculture.

According to a 2015 report from the University of Florida's Institute of Food and Agricultural Sciences, "agriculture, natural resources and food industries" statewide accounted for $148.5 billion in revenue in 2013.[186] South Florida's regional economy depends heavily on agriculture. The same report ranked the area identified as the Miami–Fort Lauderdale region as the state's top for agricultural "value-added and employment impacts." In the ten counties that comprise this region—counties that once were significantly under water—agriculture added $43.31 billion to the economy in 2013 and accounted for 704,885 jobs.[187]

With the growth of agriculture in the area—and Flagler's work to develop southeast Florida into a tourist destination—came explosive population growth. At the 1880 census, taken a year before the Disston Purchase and two years before he began his drainage work, Broward and Palm Beach Counties were not yet formed. Dade County, which included present-day Broward and Palm Beach Counties, was home to just 257 people.[188] But the area saw extensive change in the first half of the twentieth century. Agriculture grew and gave way in some areas to residential and commercial

development. By 1930, for example, the population of Dade, Broward and Palm Beach combined had grown more than eight hundred fold, to nearly 215,000.[189]

Broward County, now one of the most urbanized in Florida, has been a prime example of this explosive growth. In their book *Insiders' Guide to Greater Fort Lauderdale: Fort Lauderdale, Hollywood, Pompano, Dania & Deerfield Beaches*, Caroline Sieg and Steve Winston describe the county's early twentieth-century transformation, spurred in part by the end of World War I: "Between 1920 and 1925, the county's population nearly tripled, climbing from 5,135 to 14,242. This boom helped spark the new development model: planned cities, not just neighborhoods. In addition, it changed the demographics of the county. Until now, most settlers had been farmers. The newcomers, however, for the most part wanted nothing to do with the land and had little affinity for sweating over it. They were urban people, many of them retirees."[190]

Today, the eastern parts of Palm Beach, Broward and Miami-Dade Counties are home to booming populations that, in addition to agriculture, are supported by industries such as tourism, trade, media, banking and technology.[191] Combined, the estimated 2015 population of these counties was just over six million people, according to U.S. Census Bureau figures.[192] That's approaching one-third of the state's people living in an area mostly uninhabitable at the start of the last century. Southwest Florida, Collier and Monroe Counties also sit in the Everglades ecosystem. Though not nearly as populous as its neighbors to the east, Collier County is a hub for tourism, healthcare and technology—as well as agriculture. Meanwhile, Monroe County, home to the exciting Florida Keys, is a tourist destination like none other in the nation. This—the population, agricultural and economic growth of Florida's southern half—is Broward's Empire of the Everglades.

UNINTENDED CONSEQUENCES

Upending the natural order of things also has brought difficult repercussions. In addition to flooding from the Caloosahatchee River and Lake Okeechobee, Florida's natural environment and its people have seen a chain of detrimental effects that have meant significant challenges for Florida.

Coral reefs bordering the peninsula's shoreline once benefited greatly from the nutrient-rich outflow of the intact Everglades. Cutting off much of that flow and adding in nutrients from agriculture and pollutants from a booming South Florida society has been harmful to the reefs. Ridding Florida of so much of the fresh water that once flowed over the land, coupled with southeast Florida's growing population, also has exposed natural freshwater sources to saltwater intrusion.[193] South Florida communities are now tapping freshwater sources in north central Florida.[194] Native Florida plant and animal species have also taken a hit, and South Florida agriculture is threatened by diminishing soil depth. Some people today view the work of Disston and Broward as ultimately more damaging than beneficial for the state.

Fortunately, Everglades restoration efforts have been underway since the 1980s. The goal is not to undo the development that has occurred in South Florida but to reinstate the natural flow of the River of Grass as much as possible, especially in undeveloped areas. Doing so will help to improve the health of Florida's coastal environment, an environment that supports activities and industries such as fishing, outdoor recreation and tourism while also providing the water we use each day and that agriculture requires. A federal plan for this restoration will take an estimated fifty years and nearly $10 billion to complete.[195]

FOR BETTER AND WORSE

Disston and Broward could not have foreseen all of the consequences—positive or negative—of Everglades drainage. Even so, their work to drain the Everglades—and, in the case of Disston, to bail the state out of a financial mess—made possible much of the development, population growth, agriculture and tourism that have shaped Florida from the late nineteenth century through the present day.

For better and worse, Disston and Broward changed Florida forever, in a way that others around them may not have done. Though they did not work together, their unique combination of financial resources, entrepreneurial spirit, populist vision, determination and political prowess was just what was required to steer the mighty Everglades—and, with it, Florida's future—in a new direction.

DR. JOSEPH YATES PORTER

(OCTOBER 21, 1847–MARCH 16, 1927)

His passion for mosquito control freed Florida from the grip of yellow fever—a necessary precondition for the development of Florida—and laid the foundation for malaria eradication and future mosquito control efforts.

F loridians sometimes joke that the mosquito is their state bird. While anyone who's ever battled the pesky blood suckers during an otherwise-perfect outdoor gathering or returned from a weekend camping trip covered in angry bites can appreciate the sentiment, Florida's modern mosquito situation pales in comparison to that of centuries past. For that, Americans can thank Dr. Joseph Yates Porter, Florida's pioneer of mosquito control.

Menacing black clouds of the pests swarmed the land through the first decades of the twentieth century, announcing their presence with an ominous whirring sound. It was not unheard of for mosquito hordes to suffocate cattle and drive people to bury themselves in sand to escape the insects. Fires burned across the landscape, set in hopes that the smoke would keep the mosquitoes at bay. In *The Mosquito Wars: A History of Mosquito Control in Florida*, environmental historian Gordon Patterson gives a picture of the devastation mosquitoes wrought on Florida before effective mosquito control.

Cracker cattlemen and Seminole Indians in the late nineteenth and early twentieth centuries regularly reported that mosquitoes killed their livestock.

As late as 1932, researchers at a U.S. Department of Agriculture test station near Cape Sable chronicled the arrival of a brood of Glades mosquitoes.

"By evening of that day, the buzzing was so loud as that of a swarm of bees. During the night livestock could be heard running and thrashing in the underbrush, and on the morning of September 6, dead animals were found throughout the section. The recorded mortality was 80 head of cattle, 3 horses, 1 mule, 67 hogs, 20 chickens, and 2 dogs. Postmortem examinations showed no mosquitoes in the respiratory apparatus, indicating that the animals died either from loss of blood, nervous exhaustion, or the effects of some toxin."[196]

Mosquitoes were so ubiquitous in Florida that areas and geographic features of the state were named after the insects. According to a Florida Department of Agriculture and Consumer Services document, "In the 18th Century, the part of Florida lying between the St. John's River and the coastal lagoons north of Cape Canaveral was called 'The Mosquito Country,' or 'The Mosquitoes.'"[197] This area was later named Mosquito County before eventually becoming Orange County, the location of "many of our major attractions in and around Orlando."[198]

Dr. Joseph Porter was the state's first health officer. He implemented effective mosquito control measures in Florida, essentially wiping out yellow fever in the state and setting the foundation for elimination of malaria. *Courtesy of Florida Department of Health.*

Until mosquitoes came under scrutiny by epidemiologists starting in the late nineteenth century, little was widely known about their development and breeding habits. The peninsula's residents likely did not realize its abundant wetlands were ideal mosquito habitat. Neither did they know the mosquito posed dangers beyond itchy welts, suffocation, hysteria and livestock deaths. More obtrusive and far reaching than the black clouds that spread over the land were the diseases the mosquitoes carried. The two most deadly and notable in nineteenth and twentieth-century Florida were yellow fever and malaria.

Malaria devastated whole towns, even prompting a lumber company in one small town to financially support local mosquito-control efforts in 1919. Statewide statistical data on malaria was not available until 1915, when the first report came out from Florida's Bureau of Vital Statistics.[199] "The state statistician identified 128 communities that had experienced outbreaks of malaria and, across the state, there had been 40,830 cases of malaria with sixty deaths."[200] Florida had a reputation—justifiably—as a disease-ridden land.

As late as 1905, life-threatening epidemics of yellow fever were commonplace in Florida. A 2009 white paper by the Florida Coordinating Council on Mosquito Control describes the toll in the tail end of the nineteenth century:

> *In the 1870 and 1880 outbreaks of yellow fever (YF) in such widespread locations as Pensacola, Fernandina, Jacksonville, Key West, Tampa, Plant City and Manatee County, there was a tremendous toll in human suffering and death. In Jacksonville, with a population of 26,800, the 1888 epidemic killed 400 people, sickened 5,000 people, and caused 10,000 people to flee the city. Of the 16,400 people remaining in the city, 14,000 citizens were left unemployed as a result of the breakdown of commerce.*[201]

An 1877 outbreak in Fernandina left an astonishing 1,500 of the town's 1,600 inhabitants dead.[202] The menace of yellow fever was key in prompting state officials to approve the creation of Florida's State Board of Health, which was established in 1889 and led by Dr. Porter, a Key West native and a former military physician, as Florida's first state health officer. For the first few years of his tenure, his views on the disease and his methods for fighting it followed common wisdom of the day, some of which also applied to malaria.

Unclean air—referred to as miasmas—and mysterious particles called fomites got most of the blame as the causes of these diseases. Though natural medicinal substances were used by the ancient Chinese (Qinghao, from which some modern antimalarial drugs are derived) and by Native American tribes for an undetermined period of time (quinine, also an effective modern antimalarial medication) to fight malaria, other efforts to combat the diseases were more misled.[203]

People sprayed mercury solution on homes in an effort to eradicate the disease or burned buildings and towns completely.[204] Others, like the residents of the young city of Tampa, fled their homes to seek refuge in

the woods in September 1887 when yellow fever swept through the town, recounts Harner in *Florida's Promoters*. "By the time cold weather came to kill off the mosquitoes, 79 persons were dead and some 750 more were invalids," he reports.[205] Quarantines were common in Florida, and people fled cities attempting to escape disease. In a more absurd example, repeated cannon blasts in the middle of town were thought to break up fomites that might be floating through the air.[206]

Unfortunately, Florida overall lacked an advantage other parts of the country had in fighting mosquito-borne disease: the consistent seasonal change to cold weather. In 1793, for example, an outbreak of yellow fever that struck Philadelphia lasted for several months and killed five thousand people, but it subsided thanks to a late October cold front that killed the mosquitoes.[207]

Fortunately, the end of the nineteenth century would see the first real strides in scientific understanding of these two diseases that so often plagued Florida and many other parts of the world.

SCIENCE TO THE RESCUE

It took the work of scientists and physicians from several nations to solve the mysteries of malaria and yellow fever. The malaria parasite was discovered in 1880 by French military surgeon Charles Louis Alphonse Laveran. Italian scientist Camillo Golgi identified two different species of the parasite in 1886, while the work of British physician Ronald Ross in 1897 and 1898 proved that mosquitoes spread the disease between humans. Each man received a Nobel Prize for his findings.[208]

In Florida, Dr. Porter followed the science on malaria and yellow fever, including the work of Carlos Finlay, a Cuban doctor living in Havana who posited that mosquitoes were responsible for the spread of yellow fever; Walter Reed, a U.S. Army physician who led a group commissioned to study yellow fever in Cuba in the early 1900s; and William Crawford Gorgas, another army doctor who also worked in yellow fever–infested Havana and followed the untested strategy of eliminating mosquito breeding areas to control populations of the insect and the diseases they carry. Put together, the work of these three men was transformative.

Building on Finlay's work, Reed's team confirmed mosquitoes as the vector for yellow fever, a key point the former had been unable to prove via

experimentation.[209] Reed's method of having healthy men sleep in bedding tainted by yellow fever patients, only to have the volunteers retain their health, showed that dirty linens and clothing were not an infection source. Many people had believed they were. Other experiments daringly exposed subjects to mosquitoes that had shared space with yellow fever patients, and these trials did cause illness in volunteers.[210]

With concrete evidence to prove mosquitoes spread malaria and yellow fever, the silly business of blasting cannons in town squares could be laid to rest, if only the public would consent. Scientists were working to develop effective methods for controlling the spread of disease by controlling mosquitoes. Havana, Cuba, would be the first proving ground.

SAVING HAVANA

U.S. Army physician Gorgas ordered standing water throughout the fever-plagued city to be drained. Where it could not be, as in the case of latrines, kerosene poured on the water killed mosquito larvae. Regular inspections were conducted to keep residents from letting water accumulate in open containers on their properties, with fines for noncompliance.[211]

Screens were installed on windows and doors and netting used over beds to help protect the population from mosquitoes. People who came down with the disease were protected from exposure to mosquitoes, to prevent infection of more mosquitoes and transmission to more people.[212] The results spoke for themselves: "Though the task had many difficulties, Havana was not only freed of its mosquitoes but was permanently rid of yellow fever," reads an account by the U.S. Army Medical Department's Office of Medical History.[213*]

* The mosquito and disease problem surrounding the Panama Canal Zone was another big challenge for the U.S. government, which moved Gorgas from Havana to Washington, D.C., to study the matter. The French had abandoned the project largely due to mosquito-borne disease and deaths among workers. Despite much political wrangling, including the belief by some U.S. legislators that he merely wanted to improve living conditions in cities near the zone, Gorgas implemented the same methods that succeeded in Cuba. His work extended into the jungles of Panama and nearby cities, improving their sanitation vastly and effectively freeing the canal zone of yellow fever (James M. Phalen, "Chiefs of the Medical Department, U.S. Army 1775–1940, Biographical Sketches," *Army Medical Bulletin* 52 (1940): 88–93, excerpt republished by U.S. Army Medical Department Office of Medical History, http://history.amedd.army.mil/surgeongenerals/W_Gorgas.html). His accomplishments in Panama earned him recognition as a hero by the media and medical professionals.

RELIEF IN FLORIDA

For a while, Porter remained skeptical of the growing case for mosquitoes as yellow fever transmitters, and he continued to adhere to publicly accepted methods to fight the disease. But those methods were not working, and the evidence supporting the mosquito theory became too compelling.

Finally, in 1903, Porter decided he was fully on board.[214] This was the start of his zealous, decades-long campaign to control mosquitoes in the Sunshine State. Though mosquito control continued to evolve for much of the twentieth century—long after Porter retired—it would be a relatively short period of time before yellow fever stopped killing Floridians.

Porter and Gorgas communicated about quarantines, sanitary engineering and other matters.[215] But with scant funding for Florida's State Board of Health, Porter could not yet go as far as to undertake drainage programs around the state to limit mosquito breeding areas. Rather, he sought to educate other health officials and sanitary workers, as well as the public, on mosquito-borne disease and methods for mosquito control. His first publication from the State Board of Health addressed malaria, highlighting the genus of mosquito (*Anopheles*) that transmitted it and also "recommending removal of standing water near homes and the use of screening and mosquito netting to prevent the transfer of mosquito-borne diseases," Patterson writes.[216]

Patterson also describes Porter's campaign against malaria and yellow fever as a three-pronged approach focused on quarantines to prevent further disease spread, vessel inspections at ports throughout Florida and public education on mosquito elimination. He also commissioned the state's first proper study of mosquitoes, performed by his assistant. The research identified nearly two dozen species of mosquitoes living in Florida—including those that are vectors for malaria and yellow fever—and chronicled their development.[217]

Using methods promoted and modeled in Panama and Cuba, Porter was instrumental in stopping an epidemic of yellow fever in Tampa before it began and worked to contain one in Pensacola, both in 1905. This was the last year yellow fever tormented the people of Florida.[218]

But there was still much to be done. Malaria continued to be a problem in the state for decades. Porter understood that hard scientific data was key to gaining public and political support for his work to control mosquitoes and mosquito-borne disease in Florida. To this end, he sought and obtained legislative approval for the creation of Florida's Bureau of Vital Statistics and, sixteen years later, for the entity's funding.[219]

A nineteenth-century newspaper illustration depicts yellow fever as a ghoul pulling down the state of Florida. *By Matthew Somerville Morgan, courtesy of the State Archives of Florida, Florida Memory.*

He was especially creative and far-reaching with his public education promotions. Porter was instrumental in the creation of the Health Train, a moving exhibit that rolled through Florida with materials on disease prevention, hygiene and sanitation. According to a Florida Department of Health podcast: "By 1916, this three-car train, fitted with moving pictures, models, electric devices, panel texts, and several other devices and informational materials, began to travel from settlement to settlement" and reached twenty-five to thirty communities per month.[220] Porter's State Board of Health also mailed monthly health bulletins to citizens upon request, at no cost to them.[221]

At Porter's invitation, the U.S. Public Health Service visited Florida to evaluate the State Board of Health. In 1916, the service recommended a reorganization of the board, including the creation of an engineering department. Porter complied and created the Bureau of Engineering. Finally, Florida had a body that could carry out more extensive sanitary work aimed at greater control of mosquitoes. But Porter's days with the State Board of Health were numbered. Governor Sidney Catts was not a fan of his work and forced Porter from his post in 1917.[222]

MOVING FORWARD

Porter's mosquito control work in the state continued, however, as he became the president of the newly formed Florida Anti-Mosquito Association in 1922.[223] Today, the organization is called the Florida Mosquito Control Association. Members of the group continue to promote safe and effective mosquito control methods and related scientific research.

Porter's passion for mosquito control lived on at the State Board of Health, most notably in the work of George Simon, the young engineer he had hired to head the board's first Bureau of Engineering. World War I intensified interest in the cause of mosquito control in and around military bases. Simon helped lead the efforts at the U.S. Government Military Reservation in Jacksonville, carrying the passionate campaign against mosquitoes started by Porter to new heights. The work here was more akin to the highly organized mosquito control campaign Gorgas had executed in Panama and Cuba, with ditch digging and control of mosquito habitats near the base.[224]

Municipal leaders across the state began to see mosquito control as essential to the growth of their communities and called in Simon and his

Florida State Board of Health

MOSQUITO FACTS

The female MOSQUITO lays eggs on any accumulation of water, however small, inside or outside the house.

The EGGS look like pieces of soot on the water.

EGGS hatch into larvae (wigglers) in about forty-eight hours.

LARVAE (wigglers) become pupae (tumblers) in about one week.

PUPAE (tumblers) become MOSQUI-TOES on the wing in about forty-eight hours.

Prevent Mosquito Breeding
Prevent Access of Mosquitoes to Water

Inspect your Rain Barrels, Cisterns, Tubs and Urns

DO YOUR PART

Left: Educating Floridians on mosquito dangers and control was a major focus of Porter's career. *By Florida State Board of Health, courtesy of the State Archives of Florida, Florida Memory.*

Below: The Health Train was a traveling display that educated people around Florida on topics such as sanitation and disease prevention. *Courtesy of Florida Department of Health and State Archives of Florida, Florida Memory.*

crew to provide similar services for their people.[225] Cases of malaria and dengue fever, another serious mosquito-borne illness, declined significantly in these areas. Porter's vision of mosquito control districts throughout the state, with local staff to keep abreast of the situation in their areas, began to take shape and would eventually come to fruition. Despite all this, it would be several more decades before malaria no longer plagued Florida. It was considered eradicated in 1948.[226]

A LASTING IMPACT

In the years that followed, scientists developed more advanced and chemical-dependent measures to reduce mosquito populations. While these methods have been successful, Porter deserves the credit for setting Florida squarely on the path of mosquito control. His early victory against yellow fever and his drive to bring the people of the state into the mosquito control battle through public education laid the foundation for generations of mosquito-control professionals.

As Florida's municipal leaders began to understand in the early twentieth century, mosquito control was essential to the state's growth and development. Many people credit air conditioning as the invention that drove migration to Florida. This technology certainly has been instrumental to the state's development, but the truth is that millions of northerners moved to the Sunshine State before air conditioning was prevalent.

U.S. Census reports testify to this. The 1950 census counted 2.77 million people living in the state.[227] From that same census, a detailed survey about housing characteristics addresses heating apparatus in homes but not air conditioning.[228] This indicates that the technology was not prevalent enough to be included. The 1960 census reported 4.95 million[229] and did address air conditioning: of the 1.55 million housing units in the state, 1.27 million had no air conditioner.[230] In the decade between the two surveys, Florida's population grew by 79 percent, without the luxury of air conditioning available to most people. Even before most Florida homes had air conditioners, the state was successfully drawing newcomers at impressive rates. But if yellow fever and malaria remained rampant, would nearly as many people have relocated to Florida? Surely not.

Today's Floridians and the tourists who fuel their economy generally live, work and play without much thought to these diseases. Although

a new mosquito-borne illness, Zika virus, has surfaced, through efforts including those introduced in Florida by Porter, this disease is largely under control in the Sunshine State. This, too, is proof that mosquito control in Florida continues to be a resounding success. It all started with Dr. Joseph Yates Porter.

NUMBER 8

DR. JOHN GORRIE

(OCTOBER 3, 1802–JUNE 1855)

*His patented ice-making and refrigeration machine
was the first major advance in artificial cooling.*

The twin technologies of artificial cooling upended American life beginning in the late 1800s, altering everyday habits and realities people had previously taken for granted as unchangeable: the need for iceboxes, the chore of daily food shopping or harvesting and the inescapable heat of a Florida summer.

A flurry of would-be inventors in the late nineteenth and early twentieth centuries chased the goal of developing a means of artificial cooling, some more successfully than others. Medical benefit, not mere comfort or access to chilled food, was the primary motivation for Dr. John Gorrie, the man whom some now call the father of mechanical refrigeration and air conditioning. Gorrie, whom famed Florida author Gene Burnett wrote was Hispanic despite reports of Scottish heritage,[231] was practicing in the small Florida panhandle town of Apalachicola when he began his pursuit of artificial cooling as a way to help hospital patients.

In her book *Air-Conditioning America: Engineers and the Controlled Environment, 1900–1960*, Gail Cooper characterizes Gorrie as "one of the earliest visionaries to articulate the benefits of atmospheric cooling…who focused on the importance of temperature rather than humidity."[232]

Gorrie began his experiments with mechanical refrigeration in the 1840s, seeking a cure for patients suffering from fever. Some sources report that

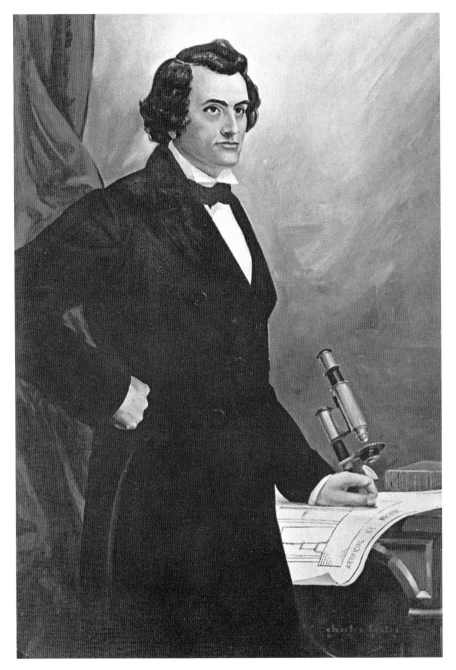

Dr. John Gorrie invented an ice-making machine to cool patients suffering from yellow fever. It could both cool air and make ice. He is considered the father of refrigeration and air conditioning. *By Charles Foster, courtesy of the State Archives of Florida, Florida Memory.*

he was specifically targeting yellow fever. This harrowing disease continued to plague Florida until Dr. Joseph Porter worked to eradicate it in the early twentieth century. Gorrie had noticed that yellow fever, malaria and other diseases did not rear their ugly heads in cold weather and reasoned that cold must be a powerful remedy. Plus, many of the patients he served at the local hospital were burning up with fever, a misery exacerbated by Florida's hot, sticky climate.

To assuage his patients' illness and discomfort, Gorrie first cooled their quarters by suspending a pot containing a sizable ice block from the ceiling of each room and then passing air over the block. Though it did not ultimately cure yellow fever, malaria or any of the other diseases Gorrie hoped to defeat, this setup did chill the rooms and provide some relief to patients. It also depended on shipments of ice from New England. But nature was not always cooperative.

When turbulent tropical weather caused multiple shipwrecks that held up travel from the Northeast, Gorrie found himself without ice, the key ingredient in his simple room-cooling scheme.[233] He began brainstorming ways to bring down the temperature indoors without natural ice.

As author Steven Johnson describes in his book *How We Got to Now: Six Innovations that Made the Modern World*, the scientific climate of Gorrie's time was ripe for the development of mechanical refrigeration and air conditioning. In the centuries that preceded Gorrie's work, humans had made a series of scientific discoveries and advances that set the stage for artificial cooling. The first was the discovery of the vacuum:

> *That meant there must be some invisible substance that normal air was made of. And it suggested that changing the volume or pressure of gases could change their temperature. Our knowledge expanded in the eighteenth century, as the steam engine forced engineers to figure out exactly how heat and energy are converted, inventing a whole science of thermodynamics. Tools for measuring heat and weight with increased precision were developed, along with standardized scales such as Celsius and Fahrenheit, and as is so often the case in the history of science and innovation, when you have a leap forward in the accuracy of measuring something, new possibilities emerge.[234]*

By considering and experimenting with properties such as temperature and pressure, Gorrie came up with an ingenious way to cool air. The first step was to compress the air inside his machine. The process of compression

naturally heated the air, so then Gorrie reduced its temperature by moving it through water-chilled pipes inside the machine. The air was now both compressed and cooled. Combined, these properties enabled the air to pull heat from its surroundings as it expanded. In this way, Gorrie's machine could cool air and also make ice.[235]

The doctor knew he was onto something big and applied for patents. In August 1850, he received London Patent number 13,124. The following spring, he received U.S. Patent number 8080.[236] According to the National Museum of American History, the latter was "the first patent for a mechanical refrigerating or ice-making machine issued by the United States Patent Office."[237]

In the years after he developed his refrigeration and ice-making machine, Gorrie's understanding of the benefits that his invention could offer to society grew. He came to see the device not only as a source of much-needed relief for hospital patients but also one that could cool homes and even serve an entire city through a central system. Applications for food and for manufacturing also became apparent.[238]

But the set of recently uncovered facts and newly defined measures that helped Gorrie and others make the logical leap to artificial cooling did not mean the public was ready for such a concept. He obtained the support of one forward-thinking investor but was left in the lurch when this person died. Gorrie courted other backers throughout the South, to no avail.

His lack of support stemmed, in part, from vocal criticism of his invention. Newspaper editorials mocked the idea that he could make ice, and New England ice baron Frederic Tudor spread the word that Gorrie's ice was riddled with bacteria.[239] Despite Gorrie's vision, his ingenuity and the great potential of artificial cooling, he died without ever profiting from his invention. Nonetheless, "his machine was commercially practicable and his process of refrigeration underlies the entire fabric of the great cold storage industry of to-day," read a 1908 magazine article.[240]

ARTIFICIAL COOLING CATCHES ON

It is astounding that the man who patented the technology that was a precursor to mechanical refrigerators and air conditioners—both staples of modern life—did not reap financial gain from his invention. If Americans had known how drastically air conditioning could improve their daily lives,

they would have lined the streets of Apalachicola for a chance to put Gorrie's technology to use in their homes and businesses and to invest in it financially.

Instead, it took a Frenchman and a brutal war to bring artificial cooling to the forefront of American life. Ice machines developed by Ferdinand Carré—whom at least one source says learned from Gorrie's design[241]—became popular in the southern United States during the Civil War. At that time, ice from the North was not available to Confederates.[242]

Other forms of artificial cooling—mechanical refrigeration, freezers and air conditioning—came into vogue over the next century. The first air conditioner of the modern era came about when Willis Carrier paired artificial cooling technology with electric motors in 1902.[243] Air conditioning took off first in manufacturing and commercial buildings. By 1942, its popularity was growing so rapidly that the country got a power plant designed specifically to accommodate the increased demand for electricity in summer months. In 1947, affordable window-unit air conditioners became available. Americans could not resist the allure of cooling their homes so easily, and in 1953, more than one million of the units sold.[244]

How Cooling Changed Florida—and The World

This convenient new way to cope with Florida's hot, humid climate helped to drive a change of enormous proportions for the state. The 1960s saw an increase in population of nearly 40 percent, to 6.79 million.[245] Though these were baby boom years, migration into the state was the most significant source of growth during this time. Net migration accounted for 75 percent of Florida's growth in these years. In the 1950s through 1990s, only California outpaced the Sunshine State in terms of growth credited to net migration.[246]

During this era, all of the Sun Belt states, which stretch across the lower half of the nation, benefited from the advent of residential air conditioning, along with other factors. By 2000, the Sun Belt as a whole accounted for 40 percent of the American population, up from 28 percent in 1950.[247]

The southward population shift has held substantial political ramifications for the nation. Florida's spectacular growth has catapulted the state from a mostly empty one with little sway in the national arena to a political heavy hitter. For the 2012, 2016 and 2020 presidential elections, Florida has been allotted twenty-nine electoral college votes, tying it with New York and

A model of Gorrie's ice-making machine. *By Karl E. Holland, courtesy of the State Archives of Florida, Florida Memory.*

leaving it behind only California (fifty-five) and Texas (thirty-eight).[248] Thanks in part to air conditioning, the three most influential states in presidential election years are currently in the Sun Belt.

In addition to moving south, people also have come to depend less and less on local food products, because mechanical refrigeration allows for superior preservation of foods and beverages brought in from faraway

locations. As transportation also improved and food from across the nation—and even the world—became increasingly available to Americans, the nation's distinct regional cuisines began to fade in favor of a more homogenized culinary scene. These capabilities expanded greatly, thanks to the work of Clarence Birdseye in the early 1920s to improve techniques for freezing foods and beverages.[249]

With the technology of mechanical refrigeration steadily improving and the invention of freezing processes such as Birdseye's, Florida citrus growers had a reliable answer for spoilage, one of the most troublesome aspects of exporting their whole fruit and juice products to other states. In a place like Florida, ice was hard to come by, but mechanical refrigeration using coolants made that a concern of the past. Another crucial development was the post–World War II emergence of mechanical refrigerators and freezers as mainstays in grocery stores and homes. This enabled retailers and consumers across the country to safely store Florida citrus products. It wasn't long before Florida orange juice became a nationally popular product.[250] Today, Americans consume an average of forty-five pounds of oranges per person each year, the majority of them from Florida.[251]

Growers of other Florida crops also have reaped the benefits of mechanical refrigeration, and the Sunshine State is now a primary source of winter vegetables—particularly tomatoes—for the nation. Thanks in part to mechanical refrigeration, Florida also ranks near the top nationally in production of watermelons, snap beans, cucumber, sweet corn, bell peppers, strawberries, avocadoes and agricultural products.[252]

Air conditioning also affected the makeup of American cities and their surrounding areas. By the 1970s, suburbs offered freshly built homes equipped with central air conditioning to provide the magic of cool air through a simple thermostat adjustment.[253] Architectural features meant to promote interior cooling began to fade from popularity, as described in an article published in *The Atlantic* in 2011:

> *Before air conditioning, in a bygone and surely less comfortable era, people employed all sorts of strategies for keeping cool in the heat. Houses were designed with airflow in mind—more windows, higher ceilings. A style once prevalent in the American south, the dogtrot house, was really two smaller cabins—one for cooking and the other for living—connected under one roof with an open-air corridor between them. In addition, many homes had porches where families could spend a hot day, and also*

sleeping porches with beds where they could ride out a hot night. Many home designs took passive solar design principles into account, even if they didn't name them as such.[254]

With such designs falling out of style, homes increasingly favored an indoor lifestyle. In addition, building materials in Florida and elsewhere once were selected in large part to reduce temperatures indoors. In South Florida, for example, that meant tin roofs.[255] But a drive through South Florida neighborhoods today will reveal significant numbers of homes with shingle or tile roofs.

Thanks in part to air conditioning, a new device called the television began to take center stage. "Families gather inside," wrote Rebecca Rosen, author of *The Atlantic* piece, "in the comfort of 72-degree living rooms, to watch TV. Would television have even gained its central place in American family life, were the rooms from which we watch it not so enjoyably cool?"[256] Rosen's article poses another provoking question: Where would the information technology industry be without the advent of artificial cooling to keep large systems from overheating? Applying this line of questioning to Florida, one might ask whether America's space program—and, with it, Kennedy Space Center—would be anything like the computer-driven marvel we know today. Air conditioning provides comfort and protection for the people of the space program, too. During mankind's first walk on the moon, Neil Armstrong and Buzz Aldrin wore suits outfitted with cooling mechanisms.[257]

Two of Florida's top four industries—healthcare and defense—are high-tech industries. Like the information technology and aerospace fields, these computer-heavy areas depend on artificial cooling to maintain critical machines in working order. The state's other top two industries—tourism and agriculture[258]—also benefit greatly from air conditioning and mechanical refrigeration. Can you imagine waiting for and then riding the Magic Kingdom's famous Space Mountain in a hot, uncooled space? Or a luxurious beachside resort unable to offer ice-cold beverages to guests because it had run out of ice? What if visitors to the Sunshine State could sip a glass of Florida orange juice only at certain times of the year? Such realities, though unimaginable to us today, would make a Florida vacation much less enjoyable.

Though Florida's population was already growing before air conditioning became commonplace, the inventions of mechanical refrigeration and air conditioning boosted that growth greatly and have made Florida a much more desirable and prosperous place to live. Their contributions

have been invaluable in helping Florida emerge as a political dynamo, one of the globe's top travel destinations and a strong economic player on the national and world scene. Without a doubt, Florida would not be the nation's third most populous state without air conditioning and mechanical refrigeration. Nor would it be a haven for retirees seeking to live their golden years in comfort and leisure, or a playground for the wealthy. Though the machines we use today have been developed and perfected by others, Dr. John Gorrie—practicing medicine before the Civil War in the town of Apalachicola—pioneered the way.

CAPTAIN WASHINGTON IRVING CHAMBERS

(APRIL 4, 1856–SEPTEMBER 23, 1934)

The Father of Naval Aviation brought America's first Naval Air Station to Pensacola, laying groundwork for Florida's prominent role in military training during two world wars, ushering in the establishment of dozens of military installations around the state and fueling Florida's postwar growth.

Washington Irving Chambers entered the U.S. Naval Academy in the 1871–72 school year at the tender age of fifteen. The navy he joined was a tepid force suffering from budget cuts, lack of serious consideration of engineering and a tame vision of the future.[259] As historian Stephen K. Stein describes in his book *From Torpedoes to Aviation: Washington Irving Chambers & Technological Innovation in the New Navy 1876 to 1913*, wooden ships were rotting and traditionalist leaders were reluctant to embrace change.

Some forty years after Chambers's entry into the Naval Academy and almost two years after his demotion that forced him toward retirement, an airplane soared off the deck of an armored cruiser in Pensacola Bay, hurtled skyward by a catapult that was based on his own design.[260] Pensacola had become the site of the nation's first Naval Air Station and would soon be the bustling hub of U.S. Naval aviation training. Since those early days, these developments have earned it the nickname "Cradle of Naval Aviation." Though many officers of that day deserve credit for the U.S. Navy's astonishing evolution in the late 1800s and early 1900s—which included notable advances in numerous arenas, not just aviation—Chambers led the

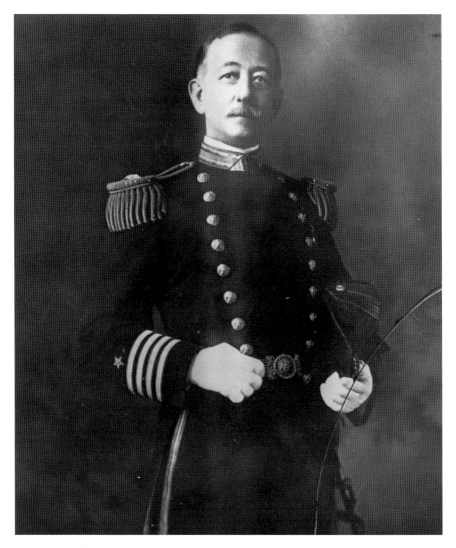

Captain Washington Irving Chambers was the U.S. Navy's biggest advocate for the adoption of naval aviation and was instrumental in founding the nation's first naval air station, at Pensacola. *Photo Archives, Naval History and Heritage Command, Catalog #80-G-424786.*

charge toward the establishment and strategic growth of naval aviation. He was not the first to promote the merits of aviation to the U.S. Navy, but Chambers was the one who successfully lobbied for its adoption. His success changed the face of America's worldwide military presence—and the makeup of Florida—forever.

PUSHING FOR CHANGE

Though he served in numerous roles throughout his naval career, Chambers is best known for his devotion to naval aviation and technological advancement. His intense interest in aviation began late in his career, as part of his assignment to serve as the navy's "assistant to the aide for material." A short while after he began this job in 1909, he was tasked with handling all aviation-related mail sent to the secretary of the navy. Six years earlier, the Wright brothers had achieved what many others had tried, but failed, to accomplish: manned flight. The world was abuzz with talk of what aviation might become and the changes it might bring. Militaries around the world were just beginning to assess aviation's potential. Flight also was fascinating civilians, capturing the imagination and support of the public and the press. Increasingly, pilots and others interested in aviation were writing to the navy about the subject. Chambers's mail duty soon branched into a dogged pursuit of aviation-related information,[261] and he became perhaps the navy's most vocal champion for the development of a naval aviation program.

As the navy's interest in aviation slowly grew, Chambers attended an aviation "meet" to make his own up-close observations of airplanes and to speak with people who developed and operated them.[262] Such events emphasized for him the need for intensive scientific study of airplanes and flight, Stein notes. Chambers was a stickler for adherence to sound scientific standards, a fact evidenced partly by his involvement "in the introduction of scientific principles to ship design three decades before."[263]

He longed to see the same discipline applied to aviation and pushed for the development of a national lab devoted to aeronautics, a naval aeronautics office, naval aviation training, a naval airfield, a naval aviation research program and more. He also persisted in seeking permission from superiors until he was allowed to arrange demonstrations of planes landing on and taking off from the decks of naval ships.[264]

Lacking funding from the navy, Chambers secured the financial backing of a wealthy politician for the first display, which took place in November 1910 at Hampton Roads, Virginia. There, civilian pilot Eugene Ely executed the first airplane takeoff from a ship, the USS *Birmingham*. Two months later, Ely took off from the shore of San Francisco Bay and landed aboard the USS *Pennsylvania*. The event was complete with arresting equipment to bring the plane to a full stop, and Ely followed up his successful landing with a return flight to shore.[265] Following these

exhibitions, and the successful efforts of Glenn Curtiss to display the water-landing and takeoff capabilities of a seaplane, Congress funded naval aviation with an introductory sum of $25,000. Finally, the United States Navy was in the aviation business.[266]

THE CRADLE OF NAVAL AVIATION ESTABLISHED

Despite opposition from within the navy and outside it, Captain Chambers continued to promote and grow the navy's aviation program over the next several years. All his work in service to establishing a U.S. Naval aviation program led the secretary of the navy to select him in October 1913 to lead a committee called the Board on Aeronautics to study aviation development possibilities. The board's report contained numerous recommendations, including, as described by a later statement prepared for a U.S. House of Representatives Committee on Naval Affairs, "the establishment of a naval aeronautic base and training station at Pensacola, Fla., a new system of organization and training, the development of lighter-than-air craft and the progressive installation of aeroplanes on all suitable ships with provision for auxiliary and movable bases."[267] This proposal from the Board on Aeronautics was the beginning of the first Naval Air Station, and it was created under Chambers's leadership.[268]

In January 1914, the Naval Air Station got its start at the site of the decommissioned Pensacola Navy Yard.* Sadly, Chambers had been "plucked," or pushed toward retirement, before this took place. A combination of naval politics and his prolonged shore duty in service to aviation was his undoing. He continued to serve the navy but was slowly pushed out of his duties, until he was hospitalized with pneumonia in early 1914. Chambers never returned, and an officer junior to him got the task of building NAS Pensacola.[269] The nascent naval aviation program at NAS Pensacola was, by today's standards, meager when the United States entered World War I in 1917:

* The naval yard was constructed under the orders of President John Quincy Adams and opened in 1826. European presence in the area of Pensacola, however, began in 1559 with an attempted settlement by Spanish explorer Don Tristan de Luna (Drew Buchanan, "190 Years Ago, President Adams Establishes Navy Yard at Pensacola," *The Pulse*, December 4, 2015, accessed February 27, 2017, pulsegulfcoast.com/2015/12/4993; Ben Brotemarkle, "Hurricane Kept Fleet from Settling," *Florida Today*, August 12, 2014, accessed via the Florida Historical Society, February 27, 2017, myfloridahistory.org/frontiers/article/29).

Upon entry into World War I, Pensacola, still the only naval air station, had 38 naval aviators, 163 enlisted men trained in aviation and 54 airplanes. Two years later, by the signing of the armistice in November 1918, the air station, with 438 officers and 5,538 enlisted men, had trained 1,000 naval aviators. At the war's end, seaplanes, dirigibles and free kite balloons were housed in steel and wooden hangars stretching a mile down the air station beach.[270]

Nor did NAS Pensacola remain the only air station for long. Others opened stateside and abroad during the war, including another Florida base in 1917, NAS Key West. This station also trained naval aviators and played a key role in the navy's anti-submarine aviation efforts.[271]

NAS Pensacola's rapid expansion and prolific production of naval aviators during World War I, and NAS Key West's usefulness as a base of anti-submarine aviation, put on full display the advantages Florida offered for military training: generous expanses of flat, vacant land; generally favorable weather; its position on both the Atlantic Ocean and the Gulf of Mexico; and thousands of miles of undeveloped coastline. The Sunshine State supported the war effort in myriad other ways, as well. The war saw some forty-two thousand Floridians serving in the armed forces and great civilian involvement throughout the rest of the state: Florida forests and farmlands gave up their bounty for the cause, while Jacksonville and Tampa shipyards produced naval vessels.[272] As important and noble as they were, these contributions paled in comparison to what was to come twenty-three years later. The next time the nation became embroiled in a global conflict, Florida would be even more thoroughly involved and more thoroughly transformed.

World War II Grows Florida

The seeds Chambers planted for aviation in Florida budded anew when the Japanese attack on Pearl Harbor plunged America back into war. Florida once again became a go-to location for military aviation training. World War II saw 40 airfields in the Sunshine State used for military training purposes.[273] Some of the war's most well-known American pilots trained in Florida, including the Tuskegee Airmen in Tallahassee and Lieutenant Colonel

Jimmy Doolittle and his men at Eglin Air Force Base, who led an attack on Japan in 1942 in retaliation for the devastation at Pearl Harbor.[274] The U.S. military presence in Florida expanded far beyond aviation. Altogether, about 172 military establishments operated in the Sunshine State by 1943. This was a dramatic increase over the 8 that existed in 1940.[275]

In addition to NAS Pensacola, another military training site of great significance was Camp Gordon Johnston, near Carrabelle Island, where amphibious training took place in preparation for the D-day invasion.[276] For housing troops, the military used many of the lavish resorts that magnates such as Plant and Flagler had built around the state. There also were both prisoner of war camps and internment camps in Florida, as in many other states. Many of the military bases have since been decommissioned. Florida Atlantic University's Boca Raton campus now operates on a former military airfield.

Without the proliferation of military bases that took place in Florida during the early decades of the twentieth century, the state would be a much different place. Through U.S. involvement in World War II, and the development it brought, Florida ascended from its 1940 rank of twenty-seventh most populous state in the nation, and least populated in the South.[277] As occurred across the nation during World War II, military bases, and the increased economic activity they brought, provided quite a boost for Florida. Though the war helped to revive the entire nation from the Great Depression's lingering effects, Kurt Piehler, director of the Institute on World War II and the Human Experience at Florida State University, says the effect was especially poignant in the South. "World War II definitely helped the South, which was an incredibly impoverished region, get a higher share of wealth from military bases, and while most defense contracts went to the traditional, strong…regions like the Northeast and the Midwest and California, Florida and other parts of the South did receive more money for industrial development," he stated.[278]

Piehler went on to point out that with this growth of industrial opportunities, many Floridians who were "eking out a living as sharecroppers" or in other agricultural roles acquired more profitable defense-related work within the state or elsewhere. In a somewhat similar effect, many African American women were able to leave behind their work as domestic servants, thanks in large part to allotment checks sent on behalf of family members serving in the war.[279]

Agriculture in Florida also saw a boost from the war, notably in citrus and cotton. It was during the war that the Sunshine State's citrus production outpaced that of California for the first time.[280]

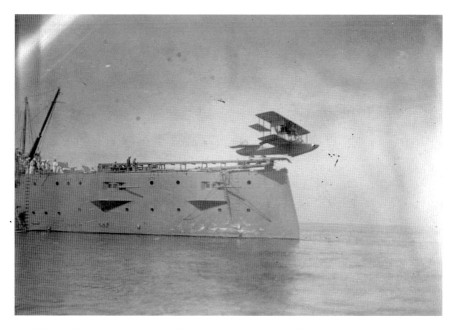

In 1915, the first catapult launch of a plane from a moving ship took place at Pensacola. *Photo Archives, Naval History and Heritage Command, Catalog #NH 44886.*

AFTEREFFECTS

Florida's strong role in the two world wars paid off handsomely as its population grew explosively in the years that followed: 46 percent as compared to the national population growth rate of 15 percent.[281] Enchanted by the state's natural beauty, and increasingly protected from the suffocating heat by air conditioning and from swarming mosquitoes by the advancing science of mosquito control, many GIs returned to call the Sunshine State home in the years following World War II. If Chambers had not brought aviation to Florida, these GIs may never have experienced Florida life in the first place.

The economy and culture of the South as a whole, and especially Florida, continue to be heavily entwined with the U.S. military. Though many of the military establishments that operated in the Sunshine State during World War II have since been decommissioned, 20 major bases remain, as of the writing of this book,[282] and there was a total of 209 military sites (sites include entities such as rented properties and vacant land, in addition to bases) in Florida in 2015. Only California, Texas and

Montana have more. [283] Florida's military establishments also provide national and international clout for the state. Of the U.S. military's nine unified combatant commands, three are in Florida. These commands oversee activities in Central and South America, Central Asia, the Middle East and the Caribbean and supervise special operations of all branches of the military except the coast guard. Save Virginia, which houses the Pentagon and neighbors Washington, D.C., Florida plays a larger role than any other state in military leadership, strategy and guidance. The wars in Afghanistan and Iraq both were supervised by Central Command at MacDill Air Force Base in Tampa. Additionally, civilian-run defense companies make up a significant portion of Florida's economy, and the defense industry is one of the state's most productive. As a recent Florida Chamber of Commerce report describes, the military and defense industry are responsible for nearly 775,000 Florida jobs and contribute almost $80 billion a year to the state's economy.[284]

Pensacola remains a center of naval aviation training, and NAS Pensacola is considered one of the most important military bases in the nation and arguably the most important in the state. All U.S. Naval aviators begin their training at NAS Pensacola, and members of the coast guard, marines and air force also undergo training there, either to fly or to maintain aircraft.[285] NAS Whiting Field, located just outside Pensacola in Milton, Florida, is the site for all naval aviators' primary training and for the advanced training of helicopter pilots.[286]

The navy also operates air stations in Jacksonville and Key West and has additional facilities in Pensacola, Mayport, Orlando, Panama City and the Ocala National Forest. MacDill Air Force Base hosts U.S. Special Operations Command and U.S. Central Command. U.S. Southern Command Headquarters, which manages military activities in Central and South America and the Caribbean, is in Doral, located in Miami-Dade County.

A few of the other major military installations in Florida include Cape Canaveral Air Force Station and Patrick Air Force Base, with their ties to America's space program; Eglin Air Force Base, the world's largest Air Force base, a hub of air-delivered weapons development and home to Camp James E. Rudder, where a portion of Army Ranger training takes place; Camp Blanding, a National Guard training site; U.S. Coast Guard Seventh District Headquarters in Miami; and Tyndall Air Force Base, a crucial base for training personnel on the F-22 Raptor.[287]

In comparison to most other states, a significant proportion of both Florida's land and its people are devoted to the military. For 2014 (the

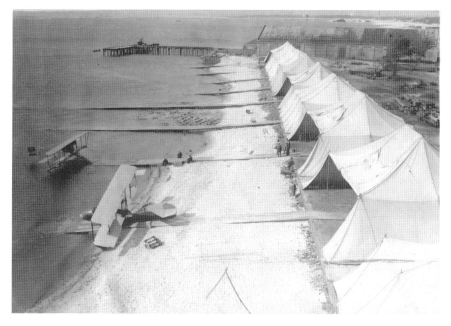

Tent hangars line the beach in Pensacola in 1914. *Photo Archives, Naval History and Heritage Command, Catalog #UA 41.01.43.*

latest year for which analysis was available, as of this writing), 2 percent of all land in the state—nearly 700,000 acres—was occupied by military installments, putting Florida in tenth place nationally, percentage-wise.[288] And for 2013, Florida, Georgia and Maine were the most prolific states for military enlistment, relative to their populations. These three states each had seven people enlist for every one thousand people ages eighteen to twenty-four.[289]

The military legacy of the early twentieth century remains crucially influential in Florida today, shaping the population, commerce and other key facets of society. Florida's dynamic military heritage and culture are directly tied to its robust involvement in the world wars of the early twentieth century. This, in turn, is strongly linked to the establishment of the nation's first Naval Air Station in Pensacola. NAS Pensacola would prove pivotal to American engagement in both world wars and was a predecessor to the modern-era training facilities that sprouted up all over Florida during these two conflicts.

The Pensacola Naval Air Station owes its existence largely to Captain Washington Irving Chambers, who managed to spur lasting change in

the U.S. Navy, despite a lifelong struggle with internal naval politics and disagreements about the way to move America's sea force forward into the modern era. His success promoting naval aviation, before there even really was such a thing, would come to transform the U.S. Navy and the state of Florida right along with it.

JULIA DEFOREST TUTTLE

(JANUARY 22, 1848–SEPTEMBER 14, 1898)

She became the mother of Miami through perseverance, vision and business savvy in a male-dominated world. She remains the only woman to found a major American city.

J ulia DeForest Tuttle, who is known as the mother of Miami, moved to untamed South Florida on a barge in 1891. There was no railroad to take her family and their belongings to their new home. She brought the essentials she needed, including two dairy cows, to make a pioneering start for herself and her grown children.[290] She also brought determination in abundance and an optimistic outlook toward her plans.

Having lost both her father and her husband in the previous few years, Tuttle was seeking a place to begin a fresh chapter. She had spent time in Florida with her father before, which had given her a glimpse into the wild life that awaited her. And yet, this foray into South Florida on a barge was much different than some of the ideas she had entertained about her future in the Sunshine State.

Seeking additional income after her husband's death, Tuttle at first pursued a position as a housekeeper at one of Flagler's St. Augustine hotels. She wrote to John D. Rockefeller, who was Flagler's partner at Standard Oil as well as a business contact of her father-in-law's and a fellow member of her church in Cleveland. She requested Rockefeller recommend her for the job.[291] He did contact Flagler on her behalf, but thankfully for Floridians, the housekeeping position did not materialize. This left Tuttle to invent another, more purposeful role for herself.

Julia Tuttle is the "Mother of Miami" and the only woman to found a major American city.
Courtesy of the State Archives of Florida, Florida Memory.

She found it in the area that is now Miami. Tuttle had inherited about 40 acres there from her late father and, by drawing on the estates of her deceased parents and husband, purchased about 640 more, including the old army installment called Fort Dallas. Fort Dallas lay on the north side of the Miami River, near the river's mouth, and had served as a base during the Seminole Wars. Tuttle renovated the officers' quarters, turning them into a family home.[292]

She became captivated by the idea that Miami was destined to blossom into a city with a pivotal role to play in international trade. Some experts emphasize the romantic notions Tuttle had of beautiful houses and lush landscaping along the river, while others point to the financial gain she would earn from selling much of her acreage.[293] Most likely, the truth is a mix of both. Whatever the case, Tuttle knew the grand city of her imaginings required a rail connection to get started.

Courting a Railroad

Not shy to request favors, Tuttle began reaching out to a man she believed could provide just such a link: Henry Plant, the rail tycoon on Florida's west coast. But Plant would not be party to her ambitions. The great wilderness of the Florida Everglades blocked this initial attempt to woo a rail baron to Miami. The Everglades proved too insurmountable to Plant's exploration party,[294] as mentioned in chapter 1.

Unswayed, she turned next to another Henry—Henry Flagler—who, at the time, had no plans to extend his railroad south of West Palm Beach. Though he could reach the Miami River much more easily than Plant, Flagler was uninterested in the venture. Tuttle's repeated pleas seemed to be in vain as Flagler declined time and again to become involved.[295] But a surprising turn of nature would prove a powerful persuader.

The cruel winter of 1894–95 moved Flagler to reconsider Tuttle's invitation. In West Palm Beach, temperatures plummeted into the twenties, with several freezes devastating citrus crops throughout most of Florida. However, the state's southernmost region, including Miami, was unharmed. A touching tale relates that in the midst of this turmoil, Tuttle sent a bouquet of verdant orange blossoms to Flagler in St. Augustine as proof that the freeze had spared Miami. The details of this story are fuzzy, as some people claim that James Ingraham, a surveyor

who had first worked for Plant before Flagler, bore citrus branches and other evidence of still-viable crops north to Flagler after a meeting with Tuttle in Miami.[296] Another claim says the orange-blossom exchange was simply a cute way to attract press attention after Flagler already had determined to extend his railway.[297]

Whatever the case, his decision to extend the railroad to Miami came on the heels of this bitter winter. With an empire built on transporting Florida-grown citrus north and on appealing to high society's desire for an all-seasons, warm-weather paradise in the South, Flagler could now clearly see the draw of Tuttle's neighborhood. The clever businesswoman sweetened the deal for Flagler with the promise of pristine acreage on both banks of the Miami River: some of her own and that of her cross-river neighbors, fellow former Clevelanders William and Mary Brickell.

MIAMI'S BEGINNINGS

The first train chugged into present-day Miami on the Florida East Coast Railway in 1896, and the town was incorporated later that year. As discussed in chapter 1, Flagler also built much of the necessary infrastructure, including water and power systems, roads and more. He constructed the grand Royal Palm Hotel.

Tuttle embraced other projects, such as a school, a church and a hospital. But the bustling metropolis she had envisioned did not appear during her lifetime. In 1898, at age fifty, she died, possibly of meningitis. Her land grants to Flagler and failed attempts to sell her own land (vacant, compared to Flagler's, which he kept developing) in Miami left her in substantial debt.[298]

The city continued to develop, and a few decades later, Miami's growth took off like wildfire: "The destruction of mangroves and draining swampland created new land for settlers," reads a history resource from Miami-Dade County government. "In the 1920s a real estate boom changed the area as new subdivisions and tourist resorts were built. From one winter season to the next the City of Miami changed so rapidly that visitors remarked that it had 'grown like magic' and Miami came to be known as the 'Magic City.'"[299] If only Tuttle had lived to see it.

A DIFFERENT MIAMI?

Though the area surely would have grown eventually without Flagler's involvement, its development would have been significantly delayed without his extensive work, at Tuttle's prompting, to lay the foundational blocks for a modern society. With its founding just before the close of the nineteenth century, Miami sat ready to benefit from a series of national and world events that helped to speed its growth. The small town's pivotal location at the southern end of Florida's Atlantic coast, in proximity to Cuba and the rest of the Caribbean, made it a strategic station for military operations and troop placement starting with the rather primitive, short-lived U.S. Army camp in nascent Miami during the Spanish-American War.[300]

By the onset of World War I, the city of Miami was growing nicely and proved again to be a convenient location for military installments. These, in turn, as discussed in other chapters, helped to propel the economic and population growth of the area. The speculators who sparked Florida's 1920s

Tuttle's Miami home, circa 1898, once was the officers' quarters for Fort Dallas, a former U.S. military installment. *Tuttle Family Collection, HistoryMiami Museum, 1975-025-99.*

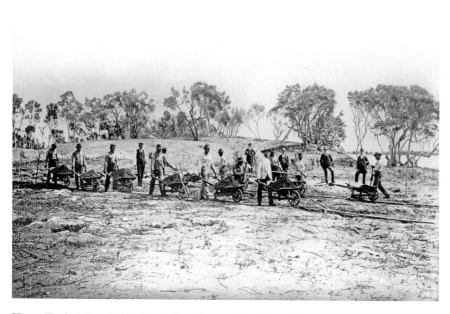

Henry Flagler's Royal Palm Hotel drew the wealthy elite to Miami. Here, workers dig the hotel's foundation. *Courtesy of the State Archives of Florida, Florida Memory.*

land boom likely would not have noticed undeveloped Florida without Tuttle's efforts. Miami, in turn, might now more closely resemble present-day Homestead, Florida, a lightly populated agricultural area just south of Miami, instead of the unofficial capital of Latin America it has become.

Had Miami been founded much later, it is also likely that community pillars Carl Fisher and George Merrick would never have become involved in the county's development. Each of these two men created a culturally important community that has become an integral part of what is now called Miami-Dade County. In addition, Merrick donated land for the creation of the University of Miami. Both men first came to the area in Miami's early years. Absent the foundations laid by Tuttle and Flagler, it is doubtful they would have come at all. And a metropolitan Miami shaped by different hands would look very different than what Floridians enjoy today.

Fisher bullishly went to great lengths and poured a fortune and a decade into transforming a sandbar into the livable community of Miami Beach.

Few others had the means or resolve to build up such a watery mess. Even if someone had, what would Miami Beach built outside the Art Deco years look like? Certainly not like the quintessentially Miami locale we know. In the same vein, George Merrick's vision for Coral Gables as a combination of Mediterranean architecture and meticulous community planning imbued the town with a European aesthetic that has made the city one of America's most beautiful.

TUTTLE'S LEGACY

The fresh beginning for Mrs. Tuttle after the deaths of her husband and father gave way to something new—and ultimately something very big—for the Sunshine State. Tuttle had the vision to foresee a thriving metropolis in a location that Henry Flagler, known for his extraordinary ambitions for Florida and his perseverance to bring his plans to fruition, viewed with little imagination. Even after he brought his railroad south to the Miami River, Flagler thought Miami would amount to nothing more than a fishing village.[301] It was Tuttle's vision that became the reality we know as the modern Miami. The countless benefits Miami has afforded to the state of Florida, to the nation and even to its corner of the globe have been well accounted for in previous chapters.

Just seven years after making her permanent home in Miami, Tuttle passed away, with a sizable pile of debt. Her children sold off much of her remaining land to pay her creditors.[302] Today, an interstate causeway in Miami and a statue in a waterfront park honor the mother of Miami. But her legacy remains so much greater. This sprawling city of global influence would surely exceed even her lofty expectations.

CARL GRAHAM FISHER

(JANUARY 12, 1874–JULY 15, 1939)

The mastermind behind Miami Beach and Dixie Highway, he played a significant role in sparking the Florida land boom of the 1920s and also inspired the modern interstate system.

Carl Fisher had his hands in the creation, improvement, promotion and sale of a great many new and developing technologies of the late nineteenth and early twentieth centuries. From headlights to diesel engines, from bicycles to the manufacture of automobiles[303]—not to mention his role in founding the Indianapolis Motor Speedway and the Indy 500—Fisher's interests and investments were quite varied.

But more significant to his legacy than any of his product developments—even than his best-selling Prest-O-Lite automobile headlights—was his impact on American travel habits, the American economy and the popularity of automobiles. Wrapped up in that legacy is Florida, specifically Miami, which was the terminus of one of two interstate highways Fisher dreamed up and saw to fruition. In the dawning era of the automobile as a mass-market product, Fisher helped make it so that Americans could hop on either of these roads and travel from one end of the country to another.

The Lincoln Highway came first, spanning from New York City to San Francisco. Creating it involved connecting and paving existing roadways across the country, many of which had been in a mucky, rather primitive state. In some places, expansive stretches of new road were required to link local roads. The Lincoln Highway Association was formed in 1913 and

Carl Fisher loved automobiles and driving. This 1915 image shows him with his Packard. *Courtesy of the State Archives of Florida, Florida Memory.*

disbanded in 1928, with the result of its efforts being a road longer than any other then existing on earth—even if some portions remained unpaved.[304] In the words of author Charles E. Harner, "It carried more traffic than ever had moved anywhere before. It sold more cars than the industry originally had dreamed of making. And it helped make America a traveling nation…. Chambers of Commerce vied to get the route through the business districts of their towns. It signaled the first big impact of the automobile on the nation's economy."[305]

Meanwhile, in the years it had taken Fisher and the Lincoln Highway Association, of which he originally was vice president,[306] to put together the transcontinental route, the imaginative, high-spirited entrepreneur had become captivated by yet another dream: to transform a sodden, mangrove-laden Florida sandbar into a resort town for America's most elite, well-heeled families. He acquired two hundred acres of the sandbar in a deal with farmer John Collins, who cultivated what would become the world's largest avocado and mango groves in the area now known as Miami Beach. The problem was Collins had run out of money, and Fisher had plenty of that.

The latter seemingly spared no expense to achieve his vision of Miami Beach as a luxurious American playground. He got additional acreage from other sources, and construction crews transformed the water-logged real estate into stable land that held golf courses, polo grounds, stables, grand

hotels, tennis courts, residential neighborhoods and the like.[307] There was a harbor for yachts. A herd of cows relocated to the island provided dairy for hotel guests.[308] Alcohol illegally shipped in from Cuba and other exotic locales slaked the thirst of Prohibition-era tourists and, increasingly, that of Fisher himself.

Though the city of Miami Beach incorporated in 1915, population and visitor growth was slow at first. Fisher did all he could to promote his paradise by hosting various sporting contests and providing access to all the amenities and recreational activities his guests could desire. By the early 1920s, conditions were ripe, especially in South Florida, for a sizzling surge in real estate values and transactions. Then president-elect Warren G. Harding visited the state in 1921, and the press coverage of his trip highlighted all the best aspects of Florida life. He went to Flagler's Hotel Ponce de León, played golf, enjoyed a boat cruise and deep-sea fishing along the Atlantic coast and stayed at one of Fisher's new Miami Beach hotels.[309] Ever the creative publicity-seeker, Fisher supplied an elephant to serve as the president-elect's golf caddy.

All of this hit just the right note with the American public, who began flooding to Florida for vacations and real estate investments. Hordes of them came down the other interstate roadway that Fisher had launched, a north–south route called Dixie Highway.

Fisher's promotion of Dixie Highway had begun in earnest in 1915 with a conference to promote the road's creation.[310] As did the Lincoln Highway project before it, the effort stirred up the excitement of state and municipal governments that wanted in on the action. Unlike the Lincoln project, Fisher expected that public funding would pay for much of the highway and that governments along the way would take responsibility for building and upkeep of the road. The Dixie Highway Association would be an organizing body that would take on such tasks as surveying and promoting the thoroughfare.[311] The work lasted from 1915 to 1927.[312]

The road that resulted was not a single motorway stretching from north to south but a network resembling a winding ladder. Two roughly parallel routes traversed the Midwest and the Southeast, joined by a series of smaller connectors. The highway extended from the U.S.-Canada border on the northern edge of Michigan's upper peninsula, all the way down to Miami Beach on the Atlantic Coast and the village of Marco on the Gulf Coast.[313] Dixie Highway's quality varied depending on what segment of the highway one was driving,[314] but it was nonetheless a connected, largely improved route that funneled eager fortune-seekers and winter-weary sun-lovers

A 1919 map of Dixie Highway. *By C.J. Holleran, for the* Atlanta
Constitution, *courtesy of the State Archives of Florida, Florida Memory.*

right on into Florida. It quickly began to transform the American South, including the Sunshine State. Americans no longer had to depend on a railroad to reach paradise.

The Florida land boom had begun, and some say it truly started right there in Fisher's well-staged utopia.[315] Property values soared. Fisher was just one of many investors who saw mind-boggling profits. His reached into the multimillions on a monthly basis by summer 1925.[316] Journalist Michael Grunwald provided an apt example of the insanity that plagued the South Florida real estate market in his book *The Swamp: The Everglades, Florida and the Politics of Paradise*: "A screaming mob snapped up 400 acres of mangrove shoreline in three hours for $33 million."[317]

The craze spawned the proliferation of "binder boys," explains Willie Drye in the book *For Sale—American Paradise: How Our Nation Was Sold an Impossible Dream in Florida*. These real estate investors often dressed in golf knickers and secured properties in their names by buying binders on lots for sale. They paid only the required binder, a small percentage of the cost of the land, then sold the binder to another buyer at an elevated cost before more money was due.[318]

"The binder boys turned downtown Miami into an open-air real estate market," Drye writes. "And the sales never stopped. At night, some of the more successful binder boys would hire a few musicians to play jazz softly as they peddled acreage on Flagler Street. As long as real estate prices kept skyrocketing, the binder boys raked in huge profits selling what essentially were fantasies."[319]

But the momentum of Florida growth brought on by idyllic images in newspapers and the opening of Dixie Highway would not continue unabated forever. Miami Beach's original heyday, and the Florida land boom, slipped away with the arrival of a devastating 1926 hurricane that decimated much of South Florida. Miami Beach did not escape the catastrophic damage.

The storm also spelled the beginning of the end for Carl Fisher's literal and figurative fortune. Stretched thin by his futile efforts to develop a northeastern version of Miami Beach in New York, at Montauk, Long Island, Fisher spent the last years of his life in an increasingly dire financial situation. Alcoholism complicated matters, and the once-irrepressible man died in 1939 with a failed marriage, a faltering liver and a faded fortune.

The Great Depression followed closely on the heels of the 1926 hurricane and dealt the blow that finally killed the land boom. While Miami Beach development and redevelopment continued during the downturn, it was not with the same intensity Fisher had once brought. But the era did bring

something else of lasting appeal: the city's distinctive Art Deco architecture, which remains a hallmark of Miami Beach even today.

The Lincoln Highway and Dixie Highway were some of the most celebrated roadways that came out of an era in which America as a nation was fixated on road building. In addition to these two well-known avenues, smaller roads (of quality superior to the often muddy and degrading rural roads that preceded them) branched out across the country, connecting America in a more intricate and reliable way than ever before.[320]

The Lincoln Highway also served as inspiration for the interstate system the federal government created decades later under the leadership of President Dwight D. Eisenhower. In 1919, Eisenhower's duty as a U.S. Army lieutenant colonel took him cross country on the Lincoln from Washington, D.C., to San Francisco. He would later cite this experience, combined with the advantages of the German autobahn that he observed during his World War II military service, as motivation for his interstate program.[321]

Though Fisher died seventeen years before Eisenhower signed the National Interstate and Defense Highways Act, the interstate system it brought about is just the kind of network the ingenious Hoosier had envisioned. While soliciting support for the Lincoln Highway effort, Fisher described what he believed the Lincoln would mean for the nation's future,

Early Dixie Highway, somewhere near Miami. *By W.A. Fishbaugh, courtesy of the State Archives of Florida, Florida Memory.*

saying he believed the highway would "stimulate as nothing else could the building of enduring highways everywhere that will not only be a credit to the American people but that will also mean much to American agriculture and American commerce."[322]

Indeed, Dixie Highway and the Interstate System *have* meant much to Florida agriculture and commerce. Interstates 75 and 95 carry tourists and snowbirds—lynchpins in the state's economy—from Canada, Michigan, Ohio, Pennsylvania, New York and other origins into a hotbed of amusement parks, beach resorts, golf courses, outlet malls, cruise ports and retirement communities. Semi-trucks speeding over freeways join trains and container ships in transporting the bounty of Florida fields and fisheries to outside markets. Interstate 4 serves the Orlando area's maze of tourist attractions, while Interstate 10 links the panhandle, the state capital and Jacksonville, the nation's largest city by land mass.[323]

It is likely that a federally funded system of more-or-less uniform interstate highways would have come about even without Fisher's influence. Americans were road crazy in the first half of the twentieth century, and others talked of creating highways similar to the Lincoln and the Dixie. But Fisher got the job done and, with his other contributions to the world of the automobile, fueled in other ways Americans' obsession with the road. Absent the Lincoln Highway for Eisenhower to journey across, the president who spearheaded the modern-day interstate system might not have been the man to push for its construction. America's interstates as we know them might not have emerged until later, delaying the economic development that resulted from their sprawling reach into nearly every corner of the continental United States, especially far-flung Florida.

And then there is the man-made wonderland that motivated Fisher to promote the construction of Dixie Highway and that helped spark the Florida land boom. One of Florida's most iconic and well-known destinations, Miami Beach might very well remain an underdeveloped sandbar were it not for Carl Fisher. Opening southeast Florida to automobile traffic from northern states before the Great Depression accelerated the area's growth enough to create the boom, and with it an exciting atmosphere in 1920s Florida that people wanted to revive after the dark days of the 1930s passed. Lacking such growth, southeast Florida might well have remained a placid, under-the-radar area much like southwest Florida's Marco Island and Naples did until the latter half of the twentieth century. Instead, the charismatic go-getter Carl Fisher left a mark on Florida that was as unique and unforgettable as he was.

DOUGLAS DUMMETT

(JANUARY 1806–MARCH 27, 1873)

By rescuing the state's orange industry after the catastrophic 1835 freeze, he became the hero of Sunshine State citrus. He also is considered the father of world-renowned Indian River citrus, and his grafting techniques made Florida groves much more profitable.

O ver and over, winter has attempted to steal one of Florida's most delectable and beloved treasures: its citrus. Repeated freezes over the centuries have posed immense challenges for Sunshine State citrus growers and, in some cases, threatened the industry with its death knell. And over and over, scientists and growers have found ways to rise from these challenges to revive and strengthen the industry. Their ingenuity and tenacity have been impressive, turning the orange from another commodity brought to the New World by Spanish explorers into an enduring symbol of Florida and a multibillion-dollar business.

In 1835, when Florida's citrus groves were concentrated much farther north than they are today, Jack Frost struck especially hard with a February freeze that killed groves clear across the young U.S. territory. Pulitzer Prize–winning journalist John McPhee described it this way in his book *Oranges*: "The temperature dropped as low as eleven degrees, the salt water froze in the bays, and fifty-six hours of unremitting freeze killed nearly every orange tree in the state."[324]

The man of the hour was Douglas Dummett, a native of Barbados who had moved to the United States with his family as a boy. Popular accounts

Douglas Dummett is known as the father of Indian River citrus and was instrumental in saving Florida's orange industry after the devastating freeze of 1835. *Courtesy of Vera Zimmerman.*

hold that he owned the only sweet orange grove in all of Florida that remained viable after the freeze.* It lay on his Merritt Island estate, which was enveloped by the warmer waters of a lagoon known as the Indian River. Merritt Island lies off Florida's east coast, not far from the Gulf Stream, and benefits from the current's warm temperature. Dummett's resilient trees not only thrived because of their location but were also products of his own inventive grafting techniques.[325] Cuttings and seeds from these trees would be transplanted into dead Florida orange groves, breathing new life into a frostbitten industry. Jack Frost would have to try again.

* Today, expert accounts vary as to how far the freeze extended, how devastating it was and how far afield in Florida Dummett's stock was used to revive groves after the freeze. Based on a National Weather Service report ("Great Florida Freeze of 1835," National Oceanic and Atmospheric Administration, accessed December 22, 2017, www.weather.gov/media/tbw/paig/PresAmFreeze1835.pdf), McPhee's book and a letter written by noted citrus scientist T. Ralph Robinson, we hold to the view that Dummett's was one of the only, if not the only, remaining domesticated sweet orange groves (still today the main category of orange for consumption purposes) in Florida and that "seed and budwood" (T. Ralph Robinson, letter to the editor, *Proceedings of the Florida State Horticultural Society* 39 (1926): 234) from his grove had the most significant contribution in restoring Florida citrus after this, the first major freeze in Florida statehood ("Timeline of Major Florida Freezes," Florida Citrus Mutual, accessed December 22, 2017, flcitrusmutual.com/render.aspx?p=/industry-issues/weather/freeze_timeline.aspx).

This was not Dummett's only contribution to Sunshine State citrus—far from it. Beyond rescuing the fledgling industry, he also made it easier for upstart farmers to bring a grove to profitability and make a nice living growing oranges. The University of Florida Institute of Food and Agricultural Sciences' website describes how Dummett (whose family name is also written Dummitt) invented "a new propagation technique by cutting wild sour orange trees down to a few feet from the ground and grafting the buds of sweet orange trees onto the stumps. Known as 'top working,' this technique shaved years off the growing process and produced a hardy tree that yielded sweet oranges in high demand by the northern markets. By the 1860s, Dummitt had over 2,000 trees in his groves, each yielding about 10-20 boxes of oranges."[326]

As this strategy spread across the state, Florida farmers could see substantial financial return from their groves more quickly than ever before. Meanwhile, railroads began snaking their way down the peninsula, and the science of growing oranges became more refined. The University of Florida and the U.S. Department of Agriculture both established agricultural research facilities in the state in the late 1800s, offering growers new tactics for improving their enterprises. All these factors soon elevated oranges to become Florida's signature crop.[327]

Though groves all across Florida benefited from Dummett's hardy trees and his methods, there remains something special about citrus—specifically grapefruit—grown in what is now known as the Indian River Citrus District. Growers in the region credit Dummett, who cultivated "the first-known citrus grove" in the district, as the founder of Indian River citrus.[328]

After episodes in which growers from many different parts of Florida falsely labeled their citrus with the words "Indian River," the region's growers pursued protections for their label. Following a lengthy boundary-setting process, the term "Indian River Citrus" now is an appellation used only for citrus grown in a slender, two-hundred-mile stretch of land that reaches southward from the Daytona Beach area to West Palm Beach. It includes about 150,000 acres of groves.[329]

Much like winemakers in Bordeaux, France, fiercely protect the term "Bordeaux" and Italian Parmigiano-Reggiano is not the same as American Parmesan cheese, so Indian River growers contend that their grapefruit is unlike any grown elsewhere in the world. Grapefruit came to be the district's dominant crop in the 1960s and today composes 70 percent of the fruit grown here.[330]

One of Douglas Dummett's original trees on his grove in what is now the Indian River Citrus District. *Courtesy of the Brevard County Historical Commission.*

Indian River grapefruit has more sugar and 10 percent more juice than other grapefruit. It also has an exceptionally thin skin, a desirable quality for citrus fruit. The Indian River Citrus League attributes the fruit's outstanding characteristics to the coquina rock underlying Florida's east coast—which they say provides just the right mineral content—the district's nearness to the Gulf Stream, its ideal average yearly rainfall and the use of sour orange rootstock in the district.[331]

Dating back to Dummett's day, the superior qualities of Indian River citrus have made it a globally sought commodity. McPhee recounts that Russian czars were so enamored with Indian River oranges that they sent ships to Florida to retrieve them.

Indian River fruit is still recognized and sold by name worldwide. Citrus buyers from Asia and Europe traverse all the way to Florida to peruse Indian River Citrus District groves.

Thanks in large part to Dummett's contributions, the Sunshine State's orange scene was not entirely lost in the 1835 freeze. Floridians were able to quickly restart their orange groves and did not have to turn to Texas or California to do so, as Doug Bournique, executive vice president of the Indian River Citrus League, believes they likely would have done absent Dummett.[332] Generations of agricultural innovators have worked contemporaneously with or followed Dummett in improving Florida citriculture in myriad ways. To name a few, Edmund Hall Hart developed the fruit now known as the Valencia Orange, which is known largely for its delectable juice.[333] Claude Everett Street built the nation's first citrus processing plant and employed many Floridians at such plants through the Great Depression.[334] World War II research efforts brought frozen orange juice concentrate.[335] Lee Bronson Skinner and his family invented the citrus grader and other machinery and later opened the first plant for citrus concentrate.[336]

Florida's citrus scene has produced citrus barons, such as Ben Hill Griffin Jr., who was once one of the state's five largest growers and became chief executive officer of Alico, a company that has owned mega amounts of Florida land, with interests in agriculture, oil and mining.[337] Jack Berry, who used drainage ditches and daring to make a fortune growing citrus in soggy South Florida, surprised everyone with his success and blazed the way for a new era of citrus growing.[338]

Florida citrus continues to face serious challenges, including diseases such as citrus greening and citrus canker; escalating competition from growers in other nations (Brazil and China now lead the world in orange production);[339]

Near the Indian River in 1949, a conveyor moves oranges onto a truck. *Courtesy of the State Archives of Florida, Florida Memory.*

and changing consumer tastes. Increasingly, acres once devoted to citrus groves are being sold for development.

Despite all this, Florida remains the top producer of oranges in the nation, with its crop valued at $1.17 billion, according to the USDA's 2015 State Agriculture Overview for Florida. The report shows 405,500 acres of oranges harvested with a yield of 239 boxes per acre. Valuations of other major Florida citrus crops included tangelos at $9.2 million, tangerines at $47.9 million and grapefruit at $127.3 million.[340] For 2014–15, Florida produced 56 percent of all U.S.-grown citrus.[341]

As a result, the business of Florida citrus accounts for seventy-six thousand jobs and adds $9 billion annually to the state economy.[342] Florida is a hotbed of citrus research that benefits home growers and commercial farmers across the world, while elevating the state's academic profile. And nearly two centuries after Dummett, discerning buyers still flock to the Indian River Citrus District, now seeking the world's finest grapefruit.

This 1950 photo by the Florida Department of Commerce showcases a variety of citrus fruit and products. *Courtesy of the State Archives of Florida, Florida Memory.*

Douglas Dummett could not have foreseen these outcomes as he was developing his signature top-working technique, carefully tending his Merritt Island grove surrounded by warm Indian River waters or imparting his budwood to fellow growers. But the juicy deliciousness of the nation's most prolific citrus industry—a taste that with its vibrant color and zesty flavor reflects the exciting, sun-soaked Florida lifestyle—owes a great deal to Dummett. By extension, so does the state as a whole.

DR. KURT HEINRICH DEBUS

(NOVEMBER 29, 1908–OCTOBER 10, 1983)

The German rocket scientist made Florida America's launching point to the moon.

Though named for the late president John F. Kennedy, Kennedy Space Center in Cape Canaveral, Florida, owes its establishment and prominence in America's space program largely to a band of unlikely and, in hindsight, rather controversial American heroes. In fact, these men were not American by birth, but German, and had come to the United States while the guns of World War II were still cooling in Europe and the Pacific.

Before they became American heroes, they were integral players in Hitler's war machine. They had served the Third Reich, creating the V-2 rocket and other weapons for the Nazis. The rockets they crafted were some of Germany's most advanced technologies of the day and were unparalleled by any rockets the Allied forces produced.

With the war drawing to a close, American special forces sought out these scientists to bring them across the Atlantic, not to stand trial or languish in jail cells, but to do for the United States what they had done so well for Germany: build rockets.

German engineer Dr. Wernher von Braun had led the Third Reich's V-2 program. Dr. Kurt Debus played a significant role in the program and was one of the scientists who came with von Braun to the United States via a secret mission codenamed Operation Paperclip. In America, he was tasked with developing and managing a missile testing laboratory for the Army

Dr. Kurt Debus was Kennedy Space Center's founding director and played a central role in the decision to build the center in Florida. *Courtesy of NASA, Kennedy Space Center.*

Missile Ballistics Agency. At the laboratory, V-2 rockets the Americans had picked up in Europe and modified, along with other rockets created stateside by von Braun's production team, flew on test runs.

He served at a missile facility in Fort Bliss, Texas. Then, he and other scientists were moved to Huntsville, Alabama, to continue their work. The facility there was known as Redstone Arsenal.

But the military still needed a testing area that offered hundreds of miles of uninhabited land, should rockets fail in testing and plummet back to Earth. In 1949, President Truman approved the establishment of a Long Range Proving Ground for missile testing. A joint committee ultimately selected Cape Canaveral as the location, but only after the preferred location—El Centro, California—was ruled out due to an errant missile that raised the ire of the president of Mexico.

Rockets launched at El Centro would have flown over Baja California, an arrangement that required permission from the Mexican government. But President Miguel Alemán refused to grant the United States such permission after a rocket malfunctioned during a test launch at White Sands, New Mexico, in 1947 and crashed into a Mexican cemetery.[343] Without this fluke accident, California—not Florida—may have become the center of American aerospace activity.

Instead, the air force assumed control of the Banana River Naval Air Station that had been established at Cape Canaveral during the war. This site began hosting rocket and missile launch facilities for the military. Debus subsequently relocated his laboratory there, and it was his team that launched the Explorer 1 satellite—America's first in space—in 1958.[344] Debus also took charge of the Launch Operations Directorate at Cape Canaveral, which fell under the authority of the National Aeronautics and Space Administration (NASA)'s George C. Marshall Space Flight Center at Huntsville, Alabama, and was the precursor to Kennedy Space Center.

Over the next several years, rockets moved from being solely a military application in the United States to a largely civilian one. In 1958, NASA was formed as the entity to move the nation forward in the space race against the Soviet Union. The Army Missile Ballistics Agency, for which von Braun, Debus and their rocket teams worked, was transferred to the new agency.[345] NASA launches and military ones all continued to take place at Cape Canaveral Air Force Station until America's space program got a new sense of urgency from President Kennedy. The president's famous 1961 speech sped up NASA's timetable for sending a man to the moon.[346] To comply with the president's wishes, the agency had fewer than nine years to put humanity on the moon and safely bring back the astronauts who took the first pioneering steps in another world.

With the president's newly imposed timetable, NASA, which originally had planned to send its first astronaut to the moon sometime after 1970,[347] had to heighten its intensity. Officials recognized that NASA needed new launch facilities to accommodate the size of Saturn V, which would be the

agency's largest rocket to date and the one to take Americans to the moon.[348] Discussion began as to where these facilities would be located. Here again, Debus played an instrumental role. He and Major General Leighton I. Davis, of the U.S. Air Force, co-chaired the group of NASA and air force personnel assigned to identify the best options.

"It was a logical decision by NASA to turn to Kurt Debus to recommend where its Manned Lunar Landing Program (MLLP) should be based, and it was Cape Canaveral, Florida that was Debus' only logical choice," Al Feinberg, a Kennedy Space Center Communications Office representative who specializes in NASA history, wrote of the Debus-Davis study.[349]

Cape Canaveral was one site considered under the Debus-Davis study, but certainly not the only one. In total, the study examined eight sites.[350] "Debus was well aware of the superior combination of factors," Feinberg continued, "that put the Cape ahead of other of the seven locations under consideration: expandable, already-existing launch and tracking facilities; warm weather; no populous areas to be endangered by a launch or overflight mishap; proximity to the Equator; water over which large space vehicles could be transported by barge from missile assembly plant to launch facility; and the technical competence of experienced personnel."[351]

The Debus-Davis report ultimately recommended Merritt Island, Florida, adjacent to Cape Canaveral. Cumberland Island, Georgia, had been its biggest competitor. Following the study's release, a higher-level NASA administrator endorsed the recommendation,[352] and NASA requested and received congressional approval to purchase Merritt Island property for a new launch site. NASA ultimately announced Merritt Island as the site of the manned launches to the moon.[353] The move solidified Florida's predominant role in America's space program.

DEVELOPING AN AMERICAN ICON

The U.S. Army Corps of Engineers took responsibility for acquiring the land for the new space center, buying up hundreds of thousands of acres. NASA formally established its new space center in 1962 by moving Debus's Launch Operations Directorate out from under the authority of the Marshall center in Alabama and renaming it the Launch Operations Center.[354] This was the beginning of what would become Kennedy Space Center, and Debus, the center's first director, was largely running the show. The center grew as

NASA brought other entities, including some controlled by NASA's Houston and Maryland centers, under the umbrella of its Merritt Island site.

With NASA gearing up for lunar missions, which would prove to be the agency's most historically significant endeavors, Debus's decisions in the first several years of the new center's existence were some of the most formational for its identity. Under his leadership, Kennedy Space Center personnel created elements of the space center that remain some of its most iconic to this day. He prescribed, for example, that the Saturn V rocket and Apollo capsule that would take the first humans to the moon would be assembled inside a building and then transported as one unit to the launch pad.

This brought about the construction of NASA's behemoth Vehicle Assembly Building, which stands 525 feet tall and occupies 129.4 million cubic feet.[355] Debus's decision also required the design and assembly of the two enormous and unparalleled crawler transporters. Each crawler transporter weighs 6 million pounds on its own, measures 131 feet long by 114 feet wide and, as of 2015, was slated to be upgraded to carry 18 million pounds, over the former capacity of 12 million.[356] The crawler transporters and Vehicle Assembly Building served NASA through the lunar and space shuttle programs and persist as critical, well-known components of Kennedy Space Center operations.

Debus's guidance saw the space program and Kennedy Space Center through a series of inspiring milestones, including the flight of Alan Shepard, first American in space; the flight of John Glenn, first American to orbit Earth; thirteen Saturn V launches; six manned lunar landings that took twelve astronauts to the moon;[357] the launch of the Skylab research laboratory into orbit; and other achievements. Early in Debus's tenure, visitor tours were set up at Kennedy Space Center, at the urging of Olin Teague, a Texas congressman who led the House Subcommittee on Manned Spaceflight. They were immensely popular, drawing more than 100,000 people in the first year. In 1967, the official visitor complex was opened to the public. With America's space program in its heyday, Kennedy Space Center became one of the most visited destinations in Florida, second only to Busch Gardens.[358] The complex has since been updated and continues to attract throngs of tourists. In the 2014 fiscal year, 1.4 million people visited the Kennedy Space Center Visitor Complex.[359]

While running the center, Debus also lobbied successfully for the establishment of Merritt Island National Wildlife Refuge, which abuts Cape Canaveral. It comprises 140,000 acres of marine, wetland and dry ground territory and today is home to 15 protected or endangered species.[360] In

Debus (*third from left*) attends a 1962 briefing with President Kennedy, Vice President Johnson and other high-ranking officials. *Courtesy of NASA, Kennedy Space Center.*

total, more than 1,500 flora and fauna species reside here.[361] Today, Brevard County also is home to Canaveral National Seashore, which is close to NASA and air force facilities.

ROCKET-PROPELLED POPULATION GROWTH

While the world was captivated with American space flight, Florida's space coast was undergoing a dramatic transformation from a rural coastal community with only a handful of residents to a worldwide leader in scientific and technological advances and the center of some of our nation's most impressive accomplishments. Military aerospace activities brought the first space workers—engineers and others with high levels of scientific and technical knowledge and skills—to Florida. At first, it was a slow, transient trickle of workers brought by smaller individual projects, rather than sweeping, long-term space missions.

"A lot of the individuals that came did not stay there for prolonged periods of time," explained Lori Walters, a University of Central Florida assistant professor specializing in Cape Canaveral history. "They came down from Martin Company or from Boeing or from Convair, or whatever contractor had a contract with the government to develop a missile. They would develop the missile, test it and then most of the workers actually went back to wherever they came from."[362]

As the space race intensified, rocket workers began to stay longer in the community.[363] Eventually, the race to meet Kennedy's lunar landing deadline brought a flood of new NASA employees to call Brevard County and its surrounding areas home. Of course, many brought families with them, and a whole modern community took shape where just a few years prior, there seemed to be no reason to believe such growth was possible. Some people chose to live in nearby Volusia and Orange Counties, but Brevard saw the largest increase.

For three straight decades—the 1950s through the 1970s—population growth in Brevard County was among the most rapid in the country.[364] The 1950 U.S. Census recorded 23,653 residents in Brevard County. By 1960, the county saw a nearly five-fold increase, to 111,453 people, and the 1970 number was more than double that, at 230,006.[365] Though these were the baby boom years, a previously sleepy Florida county built around a single industry was one of the national leaders in population increase.

TOWARD A MORE DIVERSE WORKFORCE

Brevard County also was leading Florida on the path to a more diverse and vibrant economic landscape, workforce and educational system. Before the growth of aerospace programs, Florida lacked any significant cadre of workers skilled in technological fields such as mechanical or electrical engineering. The Sunshine State's go-to industries—tourism and agriculture—largely did not require such expertise.

State leaders responded to the demand for a more diversified workforce by creating Florida Technological University, which focused on fields of study that would aid the space race. A physicist from RCA, Jerome Keuper, founded Brevard Engineering College in Melbourne with a similar mission.[366] These schools would later be renamed the University of

Central Florida and the Florida Institute of Technology, respectively. Von Braun himself served as a visiting professor at the latter.

Throughout the years, NASA has collaborated with and supported research at both institutions. NASA also partners with numerous other universities and colleges in the state through programs such as the Florida Space Grant Consortium.

Since its founding, the University of Central Florida has expanded considerably in size and focus. It is now home to thirteen colleges, an increase over its original five. In the science and technology realm, there are the colleges of engineering and computer science, optics and photonics, sciences, medicine, nursing and health and public affairs. An especially notable non-science addition is the Rosen College of Hospitality Management, which is aptly situated in one of the world's top tourist destinations. UCF has ten regional campuses and had 54,513 undergraduate students in the fall of 2015, making it the largest university in the nation.[367]

Florida Institute of Technology has stuck more closely to a science- and technology-centric approach and a smaller student body. Its 2014 undergraduate enrollment was approximately 3,600 students.[368] The school has six colleges.

The very intentional investment in public and private educational institutions that emphasize engineering and other aerospace-related fields of study has paid off handsomely for Florida. Such investment, coupled with the presence of NASA and military aerospace facilities in the Sunshine State, has made Florida a forerunner in the aerospace industry.

FLORIDA AEROSPACE TODAY

More than five hundred aerospace-related companies operate in Florida, including such well-known names as Boeing, Northrop Grumman, SpaceX, Blue Origin, Embraer, Lockheed Martin and Pratt & Whitney.[369] In addition to Kennedy Space Center, the state also is home to Cecil Spaceport, located in Jacksonville. Cecil Spaceport is "an FAA-licensed spaceport that can host suborbital, horizontal launches from its site," according to the state of Florida's aerospace development group, Space Florida. Space Florida is studying the feasibility of constructing another facility called Shiloh Commercial Spaceport, on two hundred acres of

unused Kennedy Space Center land.[370] In addition, following the 2011 discontinuation of NASA's space shuttle program, components of Kennedy Space Center are being used for commercial launches.

America's Launch Pad to Space

Debus's leadership in establishing Kennedy Space Center in Brevard County and seeing it through the success of the Apollo program definitively changed the region, and the state of Florida, forever. Thanks to the men and women who have built and launched rockets and space shuttles on Florida's east coast over the past half a century, Florida will always have a unique and fascinating place in our nation's history.

One could argue that humanity's most historic and memorable event—the successful journey to the moon's surface and subsequent safe return home—would not have occurred absent the leadership, ambition and intelligence Debus provided. Even if it ultimately did unfold, this voyage may not have launched from Florida. The Sunshine State's role in space exploration will continue into the foreseeable future, as Kennedy Space Center plays a prominent part in NASA's series of planned missions to Mars.

But with the closing of the space shuttle program, the center is less of an economic boon to the county than it once was. In this regard, the county's rapid growth and focus on aerospace are proving to have downsides, too. As is common in communities built primarily around one industry, Brevard County has struggled economically when NASA and Kennedy Space Center have gone through slowdowns or changes. The northern part of the county, in and around Titusville, has been especially affected, thanks in part to the fact that NASA and the air force block access to beach property in this area, notes Walters, the UCF assistant professor of history. Central and southern Brevard County, meanwhile, draw tourists, retirees and others with their beachfront.

"While there's incredible development in the central and southern part, the north part of the county, and the Titusville area, is really, really tied more to the [aerospace] activity there than…the other two regions," she said. "The other two regions have developed other industries—be it tourism, be it the creation of the Florida Institute of Technology down in Melbourne, be it retirees coming down."[371]

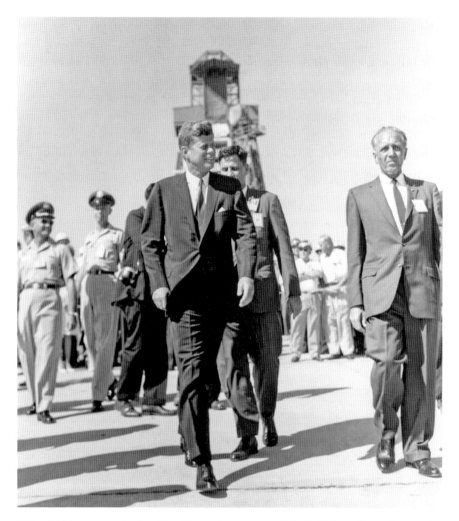

Debus (*right*) accompanies President Kennedy on a tour of the facilities at Cape Canaveral. *Courtesy of NASA, Kennedy Space Center.*

Meanwhile, North Brevard leaders are seeking ways to diversify their economy. The county may experience future waves of space-centric prosperity and growth if NASA activities at Kennedy Space Center revive to previous levels or if commercial space launch becomes prominent in the county.

But even if this does not come to pass, there's no denying that Debus's leadership in establishing Kennedy Space Center in Brevard County and seeing it through the successes and failures of the Apollo program has

irrefutably changed the region, and the state of Florida, forever. The positive aspects of this change are obvious, as the county and the state have gained a major industry, a place of prominence on the world stage, a unique and highly popular tourist destination and a new identity as a place suitable for the most ambitious, forward-thinking tech companies to take root and grow. Without aerospace activities at Cape Canaveral Air Force Station and Kennedy Space Center, Brevard County either would still be the sleepy, rural community with few residents that it was through the first half of the twentieth century, or it would be a nondescript Florida beach destination with an identity built predominantly on tourism. And, more importantly, Florida would not be known as America's gateway to the stars, the moon and the galaxies beyond.

BARRON GIFT COLLIER SR.

(MARCH 23, 1873–MARCH 13, 1939)

He invested his money and time to complete the Tamiami Trail, routing it through newly formed Collier County and opening the door for Fort Myers and Naples to develop. The trail also exposed Everglades wildlife and Seminole Indians to modern American life.

The Tamiami Trail—the first single road to cross southern Florida— did more when it opened in 1928 than simply provide a direct, reliable route across the Everglades.* It opened the door for the substantial growth of southwest Florida, determining that the small town of Fort Myers—rather than Arcadia or LaBelle—would one day become a blossoming city and part of the nation's third-fastest-growing metro area.[372] The transformations of Fort Myers and Naples were not as swift as those seen in some other areas of the state, most notably southeast Florida, but nonetheless have been highly dependent on the presence of the trail.

* The previous cross-state connector, Road 7, shown on a 1917 Florida Department of Transportation road map, crossed from Sarasota to Fort Pierce as a laddered connector of the two coasts that more closely resembled a network of roads rather than a single road (State Road Department of Florida, "Road Map State of Florida 1917," Florida Department of Transportation, accessed June 26, 1917, www.fdot.gov/geospatial/Past_StateMap/Maps/FLStatemap1917.pdf). The Bellamy Road connected Pensacola/west Florida and St. Augustine in the early 1800s ("Bellamy Road," Alachua County Library District Heritage Collection, 2002, accessed August 12, 2017, heritage.aclib.us/1101-1150/1109.html; Brian Hunt, "The Stump Knocker: Bellamy Road," H*ome magazine Gainesville*, accessed August 12, 2017, homemagazinegainesville.com/the-stump-knocker-bellamys-road/). Tamiami Trail provided a direct route between the southern sections of the two coasts.

One person, more than anyone else, brought all this about. Barron Collier, an advertising magnate who made his fortune in New York City, got his first glimpse of southwest Florida via a visit to Useppa Island, owned by one of his business associates.[373]

He fell in love with the serenity, natural beauty and potential of the area and soon was buying up immense tracts of land in the region. His holdings in the Sunshine State grew to exceed the size of the state of Delaware. From 1921 to 1923, Collier purchased more than 1.0 million acres of undeveloped land in Lee County. At one point, he also held land in Hendry County and his property ranged all the way up to Tampa and as far east as Palm Beach.[374] He would eventually own 1.3 to 1.4 million acres in Florida.[375]

Barron Collier funded completion of Tamiami Trail, overseeing and paying for construction across the Everglades. *Courtesy of the State Archives of Florida, Florida Memory.*

Around this time, Florida, like the rest of the nation, was swept up in the excitement of road building. As automobiles became increasingly popular and mosquito control made the Sunshine State a more hospitable place to live, one way people sought to conquer and develop Florida's vast untamed wilderness was through roads.

There were several proposed routes for a single road to span the width of the peninsula in central or southern Florida. Two emerged as leaders. A map of the pair of proposed routes, as of 1915–17, shows that the Tamiami Trail would go down the Gulf Coast south from Tampa, to Fort Myers and farther south through Monroe County before turning eastward to Miami. Its name combines the names Tampa and Miami, which are the two end points of the route. The trail's main challenger, the Cross State Highway, would stretch southward from the Dixie Highway to Arcadia southeast of Tampa, then east to LaBelle, southeast to Immokalee and on to Miami.[376] Those plans would shift with time, and by 1922, the Cross State Highway route was nearly a straight shot east from LaBelle, with significantly less distance through the Everglades than the Tamiami Trail. Changes to the Tamiami Trail plans meant it

would cut through the very bottom of the newly formed Collier County, just missing Monroe County.[377]

Thanks largely to Collier's growing influence in the state and his immense interest in the development of his own growing southwest Florida empire, the Tamiami Trail would win. In 1923, state legislation designated the Tamiami Trail as a state undertaking. The federal Bureau of Public Roads would recognize and help fund the road, and it would be printed on national maps.[378]

Portions of the route had been completed by county governments prior to Collier's involvement. Yet it still remained to build a stable, passable road southeast through the hostile Everglades. That is just what Collier did. When the state could not put up any more money for the trail's construction, he assumed the financial burden of completing what remained of the sixty-five-mile stretch between the two coasts.[379] In exchange for the Tamiami Trail undertaking, state legislators agreed in 1923 to carve the bottom half off Lee County to form the eponymous Collier County.

Collier was the primary proponent of the east–west portion of the road being built as far south as it was. A stipulation of his offer to bankroll the road's completion was that it would cut through Collier County. This was a modification from the route as it had been previously planned. For Collier, cutting through his namesake county and including Fort Myers along the route were key to his strategy of growing southwest Florida. His resorts and fishing/hunting club stood to do very well with the increase in traffic brought by the trail.

Collier also took on oversight of the project, with detailed reports sent to him frequently. He gave thorough project management orders based on these. In terms of difficulty, building the trail was akin to constructing Flagler's Overseas Railroad to Key West or the deadly, mosquito-plagued work on the Panama Canal. Menacing wildlife such as snakes, alligators and swarming mosquitoes were one set of perils, while swampy water reaching chest high in some places was another.[380] "The job began with surveyors and rod men clearing the right-of-way, working breast-deep in the swamp," reads a photo essay about the project. "After them came the drillers, blasting their way through more than ninety miles of hard rock under the muck. Ox carts were used to haul dynamite. When bogged down, men would shoulder the explosives and flounder through the water. Giant dredges followed, throwing up the loose rock to provide a base for the segment of road."[381]

By 1923, two men had already died working on the road. The job required nearly 2.6 million sticks of dynamite in total, weekly delivery—

from an ocean tanker—of ten thousand gallons of gasoline, a skimmer (precursor to modern bulldozers) working twenty-four hours a day to create a level roadbed and an army of other machinery for dredging, grading and other tasks. Operations ran out of a military-style base developed at the tiny outpost of Everglade, which was later renamed Everglades and is now better known as Everglades City.[382] Completion of a steady, passable road through the Everglades was a true engineering miracle.

Though an exact figure on how much he spent on the trail is difficult to come by (even a representative of Barron Collier Companies could not provide one), Collier spent several million dollars on the project.[383]

He also developed Everglade into a bona fide county seat. In 1925, he opened the Rod and Gun Club in Everglade, where he would entertain dignitaries including presidents, all the while drawing attention to his growing empire in southwest Florida and to the region itself.

The completed trail opened in 1928, providing access to hundreds of thousands of previously untapped acres. Its construction and Collier's work draining swamp acreage were two of many factors that fueled the massive increase in land values that came with the great Florida land boom even before the trail was done.[384]

In addition to financing construction of the most challenging part of the Tamiami Trail and developing Everglade as Collier County's original seat, Collier's contributions included agricultural properties, such as citrus groves, cattle ranches and timber lands; a legacy of land conservation that led to 847,769 acres being held in conservation; the search for and discovery of the first oil found in Florida, albeit after his death; and a series of hotels along the trail and other Florida roadways.[385]

EFFECTS

Absent the lobbying, oversight and financial support of Barron Collier, the Tamiami Trail may not have been completed. It is quite possible that advocates for the popular Cross State Highway option would have succeeded in obtaining state and federal endorsements. Then, the main thoroughfare across the state would have avoided Fort Myers altogether. It would instead have connected Arcadia and LaBelle to the two coasts, concentrating growth much more in the center of the state than has occurred to date in Florida.

Completing the span across the Everglades required a variety of approaches and equipment, ranging from the large excavator pictured above to the more primitive use of wooden rails to move materials forward (*picture below*). *Courtesy of the State Archives of Florida, Florida Memory.*

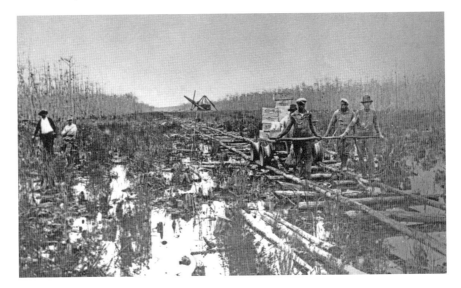

Architect Theresa Hamilton Proverbs put it best, in her *Journal of Planning History* article about the two proposed highways: "Had the Cross State Highway succeeded, Labelle [*sic*] would certainly have developed into a significant node of agriculture and industry in Florida. Roles may well have been reversed and Fort Myers may have remained a small town but almost certainly the mega wealthy resort that is Naples in Collier County would not exist."

"People only noticed Naples and Fort Myers, really, because it was on the way to Miami," said Blake Gable, chief executive officer of Barron Collier Companies and a fourth-generation member of the Collier family. "They were small little towns, very limited population....That one decision of his to go ahead and build that road and complete it for the state really kind of opened up this part of the world for other people to see."[386]

Without the trail, it is hard to imagine Fort Myers attaining the number three spot on the U.S. Census Bureau's list of fastest-growing metropolitan areas, with a 3.3 percent population increase from 2014 to 2015.[387] The Census Bureau has estimated the July 2015 Cape Coral–Fort Myers metro area population at 701,982.[388]

Equally unimaginable, then, would be Moody's Analytics 2016 prediction for the metro area to lead the nation in job growth through 2018, with a projected annual rate of 3.9 percent (2.5 percentage points higher than the average nationally). Most of that increase is expected in real estate and hospitality.[389] Like other coastal Florida communities, Fort Myers and its surrounding areas also are tourism magnets. Lee County welcomed an estimated 4.9 million visitors in 2015, according to the Lee County Visitor & Convention Bureau.[390] The bureau reports that 20 percent of its jobs are in tourism and that tourism garners $3 billion in sales annually.[391]

In Collier County, the "mega wealthy resort" of Naples, Florida, has its own distinctions. In 2016, Naples-Immokalee–Marco Island took the top spot on the Gallup-Healthways Well-Being Index of the healthiest places to live in the United States.[392]

DOWNSIDES

Despite the positive growth in southwest Florida, other effects of the Tamiami Trail have been mixed or negative. Combined with the ecological effects of Everglades drainage, the construction of the trail played a significant role

in irreversibly altering the way of life for Florida's Seminole people. The trail blocked the Everglades' natural water flow southward, contributing to problems inflicted by drainage, such as poor soil quality, decreased water flow and shrinking wildlife populations.

The New History of Florida describes the "social costs" of the trail's construction:

> *The Seminole Indians, who prior to the 1920s had lived in semi-isolation, now confronted modernity. Soon dugout canoes and subsistence living surrendered to airboats, bingo, and alligator wrestling. A tourist economy offered the Seminoles a new and different life-style. Hunters enjoyed easy access to the bounties of Big Cypress country and quickly depopulated the wildlife of the region. When Winchesters and Remingtons failed to kill, Fords and Chevrolets often added to the toll. The Tamiami Trail proved ruinous to the Florida panther.* [393]

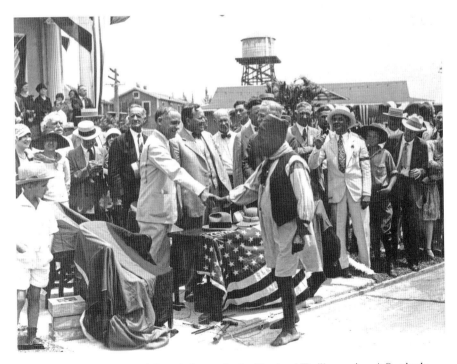

A celebration in the town of Everglades marks the Tamiami Trail's opening. A Seminole Indian stands at the center of the image. Collier is right next to him, partially blocked from view. *By Matlack Studio, courtesy of the State Archives of Florida, Florida Memory.*

The Seminole Tribe's website describes the changes this way: "The collapse of the frontier Seminole economy in the 1920s threatened the Florida Indians with assimilation and extinction. The wilderness no longer offered salvation; many lived as tenants on lands or farms where they worked or as spectacles in the many tiny tourist attractions sprouting up across tourist South Florida."[394]

In 1926, Congress established an Indian reservation in the state near Dania, Florida. Ten years later, two more opened in the center of the state.[395]

Of course, to pin the changes described above entirely on Collier or the trail would be unfair. Collier was also a champion of Florida land preservation,[396] and natural factors, such as hurricanes and droughts, sped changes for the tribe. But there is no denying the trail's impact in bringing modern life to the Seminoles' doorsteps.

One cannot help but wonder how the Seminoles would have fared if they had remained relatively isolated in the Everglades for at least several more decades and if their natural resources had not faced the pressures brought by the trail. Would the Seminoles have been able to better sustain their traditional lifestyle? Would they ever have ventured into gambling, which has become a surprisingly prosperous venture for them? One also could pose hypotheticals about the fate of the majestic and endangered Florida panther, of which automobiles are a primary killer. And where would Florida be without one of its signature destinations, Naples?

Overall, the legacy of Barron Collier in Florida is positive. His accomplishment of a seemingly impossible engineering task—the construction of a durable, long-standing highway across the intimidating Everglades to connect the southern reaches of Florida's twin coasts—is admirable and awe-inspiring. But to view the legacy of the trail, arguably his greatest single accomplishment in the Sunshine State, as either solely positive or negative would be a mistake. Like all great figures, his achievements have had mixed results, but they have undoubtedly shaped Florida's development in profound and irreversible ways.

MARJORY STONEMAN DOUGLAS

(APRIL 7, 1890–MAY 14, 1998)

Nicknamed the "grande dame" of the Everglades, this petite Minnesota native's journalism and activism moved Floridians, along with state and federal politicians, to save the Sunshine State's vast, incomparable wetlands from annihilation.

Beginning in an era when the Everglades were viewed mostly as nuisance swampland, women had only recently earned the right to vote and female journalists garnered little respect,[397] a petite woman named Marjory Stoneman Douglas changed the public's view of Florida's most unique natural asset. One of her first writings on the subject was a 1930 *Saturday Evening Post* story titled "Plumes," which addressed the widespread practice of hunting birds for their feathers.[398] Such pillaging was ravaging the Everglades' avian population. Seventeen years later, she released a book that has become one of the environmental movement's most influential volumes. *The Everglades: River of Grass* was the first of eleven books for this *Miami Herald* writer turned freelance journalist, and it remains undoubtedly her most well-known.

The book's release in late 1947 coincided with the dedication of Everglades National Park—the creation of which she had advocated for—and brought a deeper comprehension of and appreciation for the fragile beauty and benefits of the nation's "largest subtropical wilderness."[399] Her description of the Everglades as a "river of grass" was especially impactful. Far from its reputation as a dead, rank swamp that served only to frustrate

Marjory Stoneman Douglas's book *The Everglades: River of Grass* provided new perspective on the nature of the Everglades and the benefits it provides. *Courtesy of the State Archives of Florida, Florida Memory.*

human expansion and to breed disease-carrying organisms and so-called bad air, Douglas showed the Everglades to be a slow-moving body of fresh water. That body supported a cornucopia of intriguing plant and animal life while also refilling South Florida's primary freshwater source, the Biscayne Aquifer. As she recounts in her autobiography, *Marjory Stoneman Douglas: Voice*

of the River, a fellow conservationist once told her that through the phrase "river of grass," "I changed everybody's knowledge and educated the world as to what the Everglades meant."[400]

Today we know the Everglades to be a complex ecosystem—a patchwork of varied habitats—but Douglas's famous phrase still sticks in helping us to understand it as a vibrant, living region.

Though the Everglades drainage work of men such as Hamilton Disston and Governor Napoleon Bonaparte Broward had allowed for much development and positive growth in South Florida, it also had caused great ecological havoc that affected not only plant and animal life but also human life. As Michael Grunwald, author of *The Swamp*, puts it, "The biblical onslaught of fires and floods suggested that something clearly wasn't working, and inspired the first intense scientific research on the Everglades."[401] Douglas's work covering and advocating for the Everglades was based in this investigation. Her research for the book included delving into the Everglades' history, hydrology, flora and fauna and much more.

Ben DiBiase, the director of educational resources for the Florida Historical Society, describes her role as that of a "liaison" conveying newly uncovered scientific knowledge on the Everglades to legislators through her writings.[402] The public also benefited from her work. She explained that carving up and draining the Everglades actually had undermined the welfare of South Florida's burgeoning population by seriously damaging the natural environment that supported it.

"The Everglades were dying," Douglas wrote in her chapter aptly titled "The Eleventh Hour."

> *The endless acres of saw grass, brown as an enormous shadow where rain and lake water had once flowed, rustled dry. The birds flew high above them, the ibis, the egret, the heron beating steadily southward along drying watercourses to the last brackish pools. Fires that one night glittered along a narrow horizon the next day, before a racing wind, flashed crackling and roaring across the grassy world and flamed up in rolling columns of yellow smoke like pillars of dirty clouds.*[403]

But informing these audiences and protecting the Everglades were not one and the same job. Douglas had served on a committee that had successfully lobbied for the creation of Everglades National Park, yet the original size of the park was much smaller than the committee's ideal.[404] Much of the actual Everglades still lay outside the boundaries of the park, and developers,

Douglas takes a canoe ride in the Everglades with a Miccosukee Indian. *Courtesy of the State Archives of Florida, Florida Memory.*

along with agricultural and industrial interests, continued to operate and plan projects for construction and drainage immediately adjacent to and inside the Everglades.

Douglas, who had also taken up causes such as women's suffrage and racial justice, fought against such impacts not only through writing but also through organizations such as Friends of the Everglades, which she founded in 1969. She served as its president for twenty-one years.[405] A massive planned jetport in Big Cypress Swamp, which bordered the park, spurred her to create the group. Under the banner of Friends of the Everglades, she delivered a series of speeches around the Sunshine State, decrying the devastation the jetport would bring to the Everglades.[406] Douglas was just one player in an impassioned campaign launched against the jetport by many pro-Everglades activists, but her voice—that of a now elderly and somewhat crotchety woman who was not easily denied—was irreplaceable.

"There are certain people that seem to emerge at certain periods in history that…become a symbol for that cause or that movement, and I think Douglas absolutely fits within that," DiBiase said. He sees her as one of the "wonderfully eccentric characters" Florida attracts from other places, those who "somehow make their way down here, for whatever reason, and effect change, be that positive or negative."[407]

In 1970, the jetport's construction came to a halt over environmental concerns.[408]

Through Friends of the Everglades and in other ways, Douglas "called for the restoration of the original Everglades ecology, taking on the well-financed and politically influential cattle and sugar industries and their supporters among state and federal policymakers," writes Jack E. Davis in a chapter

on Douglas in the book *Making Waves: Female Activists in Twentieth-Century Florida*. "The group's efforts began paying off when, in 1983, Governor Bob Graham unveiled the 'Save Our Everglades' program,"[409] with much the same focus.

Other significant victories for the Everglades included the establishment of Big Cypress National Preserve in 1974, President George H.W. Bush's 1989 approval of a bill that added 109,000 acres to Everglades National Park and the start of restoration work in the 1980s.[410] Everglades National Park today consists of 1.5 million acres, almost 90 percent of which has been protected even further from development as the Marjory Stoneman Douglas Wilderness Area.[411]

These and other successes in protecting South Florida's magnificent wetlands owe much to the goodwill toward, and interest in, the Everglades that Douglas's game-changing book and her work through Friends of the Everglades fostered among the public. There is simply no telling how many other residential, agricultural, industrial or drainage projects would have overtaken substantial portions of the remaining Everglades, or sullied territory within the park due to their proximity to it, without Douglas's contributions. Put simply, Douglas became the face and voice of Everglades restoration.

ADVOCATING 'TIL THE END

As mentioned in a previous chapter, Everglades restoration efforts have a projected timeline of half a century and an estimated budget of almost $10 billion. Douglas, who worked on behalf of the Everglades until her death at the age of 108 in 1998, had plenty to say about Everglades restoration and just how it should be done.

Analysis of the restoration efforts' success varies. DiBiase, for example, describes the Everglades as being "on life support."[412] Others point to the substantial reduction of phosphorous that flows from area farms into the Everglades.[413] There's also been work done to restore some of the area's more natural waterflow by transforming portions of Tamiami Trail, which has blocked the passage of water southward, into bridges. The first mile of bridge opened in 2013, and the U.S. Army Corps of Engineers began construction of a 2.6-mile segment in 2016. Current plans call for 6.5 miles of bridge in total.[414]

The Greater Everglades Ecosystem is composed of nine different habitats. *By Paul Marcellini.*

A 2012 study commissioned by the Everglades Foundation estimated a return of $4.04 for each dollar to be spent on the Comprehensive Everglades Restoration Plan, in terms of the value of improved water supply, real estate appreciation, increased park visits, greater commercial and recreational opportunities and other benefits.[415]

Thanks to pioneers such as Douglas, present-day Floridians have the Everglades to save, restore, study and enjoy. In 2015, 1,077,427 people visited Everglades National Park to take in its wondrous beauty for themselves.[416] This number is dwarfed by the universe of animal and plant life that calls the park home. Twenty endangered species, such as the Florida panther, the Florida bonneted bat, the green turtle and the Everglades snail kite, live or spend time in the park.[417] The American alligator and American crocodile both were once endangered but now fall into less-dire classifications (within the United States, at least).[418] The Everglades is prime territory for these rugged reptiles, territory that has no doubt been important to their recovery. But where would these species be without the Everglades and, by connection, the work of conservationists such as Douglas? Considering such hypotheticals begs another question: Could Florida truly still be Florida without its alligators?

Most importantly, the Everglades, with its flow of water from the north and its abundant flora, helps to sustain the water supply supporting South Florida's more than six million residents. It replenishes and filters the region's freshwater source, the Biscayne Aquifer. South Florida and its current population could not survive—let alone thrive—without this restorative influence.

Douglas fought against overwhelming odds to preserve what is now described as one of the seven natural wonders of North America.[419] In protecting the Everglades and the plant and animal life it hosts, she also undoubtedly protected a bit of the soul and spirit of the Sunshine State. Douglas helped to ally the environment and economy of South Florida by sparking a focus on conservation that ultimately benefits both. The region's economy cannot thrive without its unique environment, and Douglas's work to protect that environment has allowed South Florida to more sustainably develop into the massive, growing region it is today.

MARY MCLEOD BETHUNE

(JULY 10, 1875–MAY 18, 1955)

Lauded as the First Lady of the Struggle, this determined visionary set for the world an example of peaceful integration and bettered the plight of black Floridians through the school, hospital and other institutions she founded. The nation came to value her wisdom as she advised politicians and inspired everyday Americans to strive for an equitable society.

Mary McLeod Bethune was a leader before her time. A black female educator whose parents had been slaves, Bethune defied limitations of her era and her upbringing. She rose to become a college president in a time when only a handful of women held the position, as well as a highly regarded and effective champion of civil rights and a trusted advisor and public servant under four U.S. presidents. Her work lifted the spirits and the sights of African Americans not only in Florida, where she founded a girls' school that would later become a co-ed university and a center of integration, but across the nation as she promoted the rights and welfare of black Americans. She did so in strategic ways, building bridges across racial divides and enlisting the help of community leaders, business leaders and lay folk regardless of their color.

In 1904, Bethune started her own school for black girls, strategically positioned in Daytona Beach to attract the children of African American workers who were relocating to the area to construct Henry Flagler's Florida East Coast Railway. At the time, conditions in black schools in the Sunshine State and elsewhere were far inferior to those in white schools.[420]

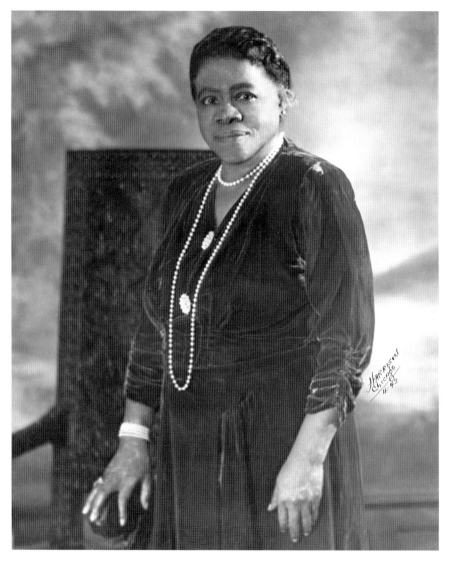

Mary McLeod Bethune founded the Daytona Literary and Industrial School for Training Negro Girls, which later merged with a boys' school and then became a junior college before becoming a four-year institution. Today, it is called Bethune-Cookman University. *By Harrison's Studio, courtesy of the State Archives of Florida, Florida Memory.*

"Even though the education provided to blacks in Florida at the turn of the century was inadequate and remained so for decades, blacks took every opportunity afforded them," Maxine Jones, a professor of history at Florida State University, writes in *The New History of Florida*. "The disparities between

black and white schools were myriad, in facilities, supplies, student load per teacher, expenditures per student, length of school year, and teacher salaries."[421]

Determined to help the black population rise above these public school challenges, Bethune made ink for her students from berries, pencils from charcoal and desks and chairs from old crates. The beginning of the Daytona Literary and Industrial School for Training Negro Girls was far from glamorous, but that was unimportant. Students in the one-room rented school learned home economics alongside reading and writing.[422] Together, Bethune and her students were making history. The girls' education was fuel for knowledgeable, distinguished and successful social activism, as well as an improved quality of life.

With her foresight, tenacity and pleasant spirit, Bethune won the hearts and support of many in her community. She wooed affluent white citizens to donate time and finances and also to lend their wisdom. She stated in a 1940 interview that she chose Daytona Beach as the place to found her school because it was "a town where very conservative people lived and where James M. Gamble (of the Procter and Gamble Company of Cincinnati); Thomas White (of the White Sewing Machine Company of Cleveland); and other fine people [owned homes]. A fine club of white women in that section formed a philanthropic group, [the] Palmetto Club, through whom I thought approaches could be made."[423]

She did indeed gain the support of both White and Gamble, as well as numerous other well-heeled white Americans. Gamble chaired the school's trustee board for twenty years.[424] The Rockefeller and Astor families also contributed to the cause.[425] But African Americans in Daytona Beach were the "backbone of the school," donating food, goods and labor to construct new buildings, writes Ashley N. Robertson, curator for Bethune's namesake foundation and National Historic Landmark, in her book *Mary McLeod Bethune in Florida: Bringing Social Justice to the Sunshine State*.[426] Bethune and her students raised money by selling food in the community.

Bethune's own efforts, the pressing needs of the black community and the contributions of backers of both races meant rapid growth for the school. Just fifteen years after its founding, the Daytona Educational and Industrial Institute, as it was then called, had twenty acres of land, a new auditorium that cost $40,000, two multistory buildings and an expanded curriculum. In addition to the home economics, gardening and agriculture courses that Bethune believed were vital to students' self-sufficiency, plus the basics of reading and writing, the institute also offered training in the professions of teaching and nursing.[427] By soliciting support from the benefactors of her

school, she founded the city's only hospital for African Americans in 1911 and grew it from two beds to twenty-six. Both white and black doctors worked there, and the hospital was the center of the school's nurse training programs.[428]

The school later merged with a boys' school and in 1931 became a junior college. Ten years later, Bethune-Cookman College offered a full four-year baccalaureate program. Bethune, who would earn honorary degrees from several institutions and become known as Dr. Bethune, was president until 1942, then served a short second stint as president beginning in 1946.[429] Despite admirable levels of interracial cooperation in support of the school, Bethune and the institute also faced criticism, fervent opposition and threats of violence. Bethune was undeterred. She used the school to embody to the community the ideals of unity and racial equality.

The college hosted integrated community events, at which blacks and whites sat in the same sections. At Mother's Day get-togethers, Sunday choir concerts and friendly discussion forums hosting students from white Florida schools, tourists and Daytona residents experienced integration in peaceful, enjoyable settings.[430] Such occasions, and the larger positive influence of Bethune-Cookman College in Daytona Beach during the civil rights era, fostered a more racially friendly atmosphere in the community than existed in many other cities during this time.

Bethune welcomed legendary baseball player Jackie Robinson and his wife to campus when the couple spent time in Daytona Beach. Robinson biographer Bill Schulman even credits Dr. Bethune for helping to lay the groundwork for Jackie Robinson's pioneering breakthrough into white-dominated Major League Baseball. Robinson played in integrated spring training games in Daytona Beach without opposition from city officials.[431] "When Robinson played baseball here in 1946, no citizen complaints concerning segregation law violations were recognized by Daytona Beach city officials, and the integration of baseball continued," Schulman wrote in a 2016 newspaper article. "Compare this to cities like Sanford and Jacksonville in 1946, where city officials took a formal stand to uphold Jim Crow laws against Robinson playing baseball."[432]

Bethune's efforts to improve Volusia County and Florida extended beyond her work at the school. She successfully lobbied for the addition of an African American arm to the local hospital, and her school continued training nurses "who would bridge the gap in medical access."[433] Dr. Bethune also pushed for better housing for local black families and came to serve on the Daytona Beach Housing Board, as the sole African American representative.[434] She also opened a beach for blacks. In addition, Bethune

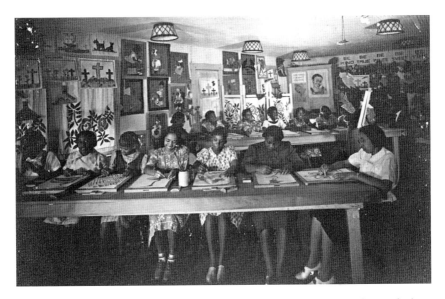

School curriculum included classes in art (pictured), cooking, home economics, gardening and academic basics such as reading and writing, as well as training in teaching and nursing. *Courtesy of the State Archives of Florida, Florida Memory.*

made quite an impression on attendees of an interracial conference she spoke at in Lakeland, Florida, plainly appealing for equal treatment of and accommodations for African Americans.[435]

Her influence seemed to know no bounds. She developed a close friendship with President Franklin D. Roosevelt and First Lady Eleanor Roosevelt, advising and collaborating with them on matters of concern to the African American community. She served on the president's Black Cabinet, and he chose her to be director of Negro Affairs for the National Youth Administration, "the first U.S. post created for an African-American woman."[436] Bethune also served the nation under three other presidents.[437]

She held prominent roles with organizations such as the American Red Cross, the National Association for the Advancement of Colored People, the National Association for Colored Women, the National Association of Teachers in Colored Schools, the National Urban League and, in World War II, with the Women's Army Auxiliary Corps, to name a few; and also founded the National Council of Negro Women and a company established to serve blacks, the Central Life Insurance Company of Tampa.[438] She also led anti-lynching and voter registration campaigns.[439]

Space does not permit a full list of the myriad ways in which Bethune improved her community or contributed to racial equality and convergence.

While the school that bears her name has had thousands of graduates since the early 1940s,[440] her legacy is beyond quantifying.

Bethune allowed generations of black Floridians to receive an education who otherwise likely would not have—from the girls she taught to read in her one-room schoolhouse to the proud graduates of Bethune-Cookman College and Bethune-Cookman University. Until 1958, the college was one of just a few higher education options for black people in Florida[441] and, for a while, in America.

She did much to sustain a local "tradition of racial moderation,"[442] as Daytona State College professor of history Leonard R. Lempel described it in the book *Old South, New South, or Down South?* Thanks in no small part to Bethune, African Americans in Daytona Beach seemed to have more social capital than those in other Florida cities. Though segregation shamefully persisted as the norm in Daytona Beach schools through the 1960s, local politicians engaged with the black community on civic matters, courted the black vote and employed black residents in city jobs.[443]

Lempel traces the city's staggered progress toward and through integration, noting the hard-fought but nonviolent desegregation of community staples such as the Woolworth lunch counter (achieved by students of Bethune-Cookman College and the school's third president) and the municipal golf club in the early 1960s. Though it did occur, racial violence was less prominent in Daytona Beach than in other Florida cities through the 1960s,[444] and cooperation between the races was commonplace.

Bethune's wise, persistent and peacemaking activism helped to make Daytona Beach a beacon of imperfect but continued progress on matters of race within the Sunshine State. Beyond Daytona Beach, her institution's education of generations of African Americans profited Florida immeasurably. Along with her advocacy for and involvement in organizations working toward better standards of living for the black community (some at the federal level), she shepherded Florida's African American population to better opportunity. Bethune's example—through school-hosted events in which black and white attendees sat in mixed audiences without conflict—embodied in public view what a society of greater racial harmony could look like. In doing so, she helped usher Florida into a process of desegregation that was more positive and less violent than seen in other southern states. She also cultivated an environment that made the state more hospitable for immigrants from northern states. Her work and voice became vital to the civil rights movement in Florida and then beyond, inspiring hope and vision for a better America.

THOMAS LEROY COLLINS

(MARCH 10, 1909–MARCH 12, 1991)

Florida's thirty-third governor, he stood out among southern politicians of the civil rights era as one willing to challenge white constituents on the moral and spiritual validity of segregation. His constant calls for order and moderation afforded Florida a more peaceful journey through tumultuous times, while his focus on modernizing the state ushered in a more diverse, open-minded Florida.

The man named Floridian of the Century in 1991 by the Florida House of Representatives served sixteen years in the state legislature, served in the U.S. Navy during World War II and was the first governor of Florida to be elected to consecutive terms. A visionary and a man of integrity who led Florida steadily from 1955 to 1961—through six years of the nation's tumultuous civil rights era—LeRoy Collins is credited with ushering the Sunshine State into the "New South."

Despite winning the governorship on a platform that included maintaining segregation as a southern tradition, Collins allowed his heart to be moved by the injustice of segregation and racial discrimination and by his disdain for mob rule. He became a bellwether for change in Florida and the American South as a whole, calling for racial harmony and unity, brotherly love, civil order and forward-thinking community engagement. Today, he is hailed as "the first Southern governor to actively work toward desegregation in the South and toward reapportionment."[445] The latter reference is to his efforts to break up the impenetrable voting bloc of vehemently segregationist North Florida politicians known as the Pork Chop Gang.

Governor LeRoy Collins helped Florida navigate the civil rights era with much less violence than was seen in other southern states. *By Florida News Bureau, courtesy of the State Archives of Florida, Florida Memory.*

Collins created a biracial committee to study and advise him on race relations in Florida. He made no secret of the fact that one of its aims was to improve quality of life for African Americans. In 1960, he asked Floridians to form such committees in their communities to study local issues and formulate solutions.

By modernizing Florida in many aspects and helping to create an attractive business environment, Collins aided greatly in drawing people from other parts of the country to the state. Milestones realized during his

governorship included the opening of the Florida Turnpike's initial leg from Miami to Fort Pierce, beginning of construction on a turnpike extension to Orlando, establishment of merit pay for teachers, establishment of the State Development Commission[446] to foster business investment in Florida, adding to the state university system and creating the state's community college system. He also fought for the modernization of Florida's constitution, which was achieved seven years after he left office. As a state legislator, he had sponsored bills to establish a statewide teacher retirement program and to pay for educational programs for disabled students.[447]

All this positive change, and the influx of people it encouraged, transformed Florida from a sleepy southern state to one more inviting to an increasingly diverse population. As historian David R. Colburn points out in *The New History of Florida*, following Collins's governorship, the state became "a seedbed of change as a result of massive population growth, a burgeoning tourist economy, and an expanding civil rights movement," making it ever more difficult for the segregationist governors who served next to preserve segregation.[448]

Guiding Florida through a transition from segregation to integration was no small endeavor. The most noteworthy and daring profile in courage of Collins's career may have been his scathing written reply to a resolution from the Florida legislature. The resolution called for interposition—that is, for the state to willfully defy the U.S. Supreme Court's *Brown v. Board of Education*, which ruled segregation unconstitutional. The governor responded that he would not be party to a call to defy the court's order. Collin's commentary on the resolution, handwritten in the spot reserved for the governor's signature, stands out today as an example of his masterful way of finding the path of moderation in almost any situation:

This concurrent resolution of "Interposition" crosses the Governor's desk as a matter of routine. I have no authority to veto it. I take this means however to advise the student of government, who may examine this document in the archives of the state in the years to come, that the Governor of Florida expressed open and vigorous opposition thereto. I feel that the U.S. Supreme Court has improperly usurped powers reserved to the states under the constitution. I have joined in protesting such and in seeking legal means of avoidance. But if this resolution declaring the decisions of the court to be "null and void" is to be taken seriously, it is anarchy and rebellion against the nation which must remain "indivisible under God" if it is to survive. Not only will I not condone "interposition" as so many have sought me to

do, I decry it as an evil thing, whipped up by the demagogues and carried on the hot and erratic winds of passion, prejudice, and hysteria. If history judges me right this day, I want it known that I did my best to avert this blot. If I am judged wrong, then here in my own handwriting and over my signature is the proof of guilt to support my conviction.

 LeRoy Collins
 Governor[449]

As governor, he often followed a path of moderation, avoiding passionate extremes such as the one lawmakers called for in the "interposition resolution." Yet he also is known for issuing bold challenges to the racial status quo and to those who resorted to ridiculous, desperate efforts to maintain it. His handwritten response to the resolution is one example.

Though segregation remained very much alive in Florida when Collins's tenure as governor ended, there were gashes in the armor of the old system. Four black students began attending a once all-white school, Miami's Orchard Villa Elementary School, in 1959.[450] An African American man joined the ranks of University of Florida law students in 1958.[451] Lunch counters at department stores began to see integration as well.

Some activists of the last century and scholars of today have decried Collins for not ending segregation in Florida and for his initial stance supporting the practice. Certainly, it is reasonable to criticize his original support of segregation. But it is important to realize that even as Collins's views on race and segregation evolved, the state legislature was dominated by politicians of a different view. Though southeast Florida was expanding with newcomers to the Sunshine State, many of them from northern states, this rapidly growing region's influence in the legislature was extremely limited by apportionment practices outlined in the 1885 state constitution.

For example, every tiny North Florida county received at least one seat in the state House of Representatives. The Senate was not much better: Even the heavily populated southeastern counties each had no more than one state senator. [452] As a result, "By 1955, only 8 percent of Florida's voting population elected a majority of state representatives, and 17.1 percent elected a majority of state senators," Colburn wrote in a 2012 newspaper column on the issue of legislative apportionment in Florida. "This skewed representation ensured a legislative majority in both houses that opposed the U.S. Supreme Court's school desegregation decision in *Brown v. Board of Education of Topeka* in 1954 and threatened Florida's future by pursuing extremist racial policies for the rest of the decade. Only the veto of Gov.

During his campaign for a U.S. Senate seat, Collins visits an underprivileged neighborhood in Miami. *Courtesy of the State Archives of Florida, Florida Memory.*

LeRoy Collins prevented Florida from creating a private school system to avoid desegregation and jailing teachers who taught desegregated classes."[453]

Collins fought to break up the North Florida voting bloc. He pushed for reapportionment repeatedly, to no avail. It took a 1967 decision by the United States Supreme Court to reapportion the Florida legislature. "Within months a new Legislature was formed that saw the modernization

of state government, the abandonment of segregation and the rise of the Republican Party," Colburn recounted.[454]

Another outstanding example of Collins's leadership and integrity came in March 1960 when he appealed especially to white Floridians in a speech following race riots in Jacksonville. The riots had come on the heels of lunch counter sit-ins, and they peeled back the veneer of racial moderation for which Florida had become known. In comparison to places such as Alabama, Mississippi, Tennessee and Georgia, where the National Guard and other forces had been required to protect black students going into previously all-white schools, Florida had largely presented a more tepid racial climate. But the Jacksonville riots, with beatings and an inattentive police force,[455] showed that Floridians could perpetrate injustices just like those common in the Deep South.

In his speech, Collins broke the mold of midcentury southern politicians and called quite clearly for racial harmony and equality, brotherly love and civil order. He publicly questioned the morality of racial discrimination and violence and decried the tendency toward disorder and mob rule. He challenged Floridians to higher ways and, quoting a song, "new eras." In doing so, he provided just the type of leadership the Sunshine State needed. The speech, coming nine months before his second term as governor ended, is viewed today as a high point of his administration.

Following Collins's governorship, President Johnson named him director of the U.S. Department of Justice's new Community Relations Service. In this capacity, Collins helped to maintain calm amidst an atmosphere of racial violence in Selma, Alabama. He was photographed next to Martin Luther King Jr., and Collins's opponent in a 1968 bid for a U.S. Senate seat presented the image as evidence that Collins had been a leader of the march. His actual role was to mediate peace between the two sides. Regardless, segregationist Floridians were offended, and he lost the election.[456] Collins later served as undersecretary of the U.S. Department of Commerce.

Florida in the 1950s saw much less racial violence than other southern states during that decade.[457] Collins, with his consistent calls for moderation and his appeals for racial harmony, was a primary leader in keeping Florida as a whole from descending into chaos and in nurturing conditions that encouraged immigration from the North. As Florida scholar and historian Maxine D. Jones puts it, "The civil rights movement in Florida, while not as violent or as publicized as in Alabama or Mississippi, brought fully as much change, and Florida's moderate white leadership kept the state from becoming a bloody battleground."[458]

Collins expressed his opposition to the state legislature's interposition resolution, which called for defiance of the U.S. Supreme Court's ruling in *Brown v. Board of Education*, with a sternly worded handwritten note. He could not stop the legislature from passing the resolution, but he condemned it. *Courtesy of the State Archives of Florida, Florida Memory.*

"In the Deep South at that time, there were...hardly any moderate governors. And even the ones that did believe like LeRoy Collins believed, that integration was the right thing to do, nobody spoke out about it," said Andy Huse, a Florida history scholar at the University of South Florida. "...I think just by being a voice in the wilderness, he may have effected some change in the fact that it just gave people some hope."[459]

In his biography of Collins, journalist Martin Dyckman relays the perspective of an *Atlanta Constitution* editor that Collins's appeals served as fuel for journalists challenging the racist status quo of the day and also as encouragement for other politicians to embrace at least moderate views on racial matters.[460]

By building up the state's educational system and business environment and also fighting for reapportionment of the legislature, Collins laid the groundwork for a more modern and diverse Sunshine State. Absent Collins's leadership, Florida would in all likelihood have seen horrific violent conflicts throughout the 1950s and 1960s, as other states did; may well have taken the extreme step of closing public schools in favor of segregated private ones; and would have deterred hundreds of thousands of would-be residents and tourists.

His appeals to all Floridians to embrace brotherhood and unity, and to white Floridians to reject racism on moral and spiritual grounds, were a beacon of hope to people seeking better days and fair treatment. Furthermore, they were a stabilizing force in Florida during a tumultuous time for the nation and an example to other southern states. The Florida House of Representatives got it right in naming Collins "Floridian of the Twentieth Century."[461]

PEDRO MENÉNDEZ DE AVILÉS

(FEBRUARY 15, 1519–SEPTEMBER 17, 1574)

Though numerous other Europeans landed in Florida before him, Menéndez successfully established what would become the first permanent colony in North America. He also ousted the French from the peninsula, setting Florida on track to become a United States territory in 1821.

Fifty-two years after Juan Ponce de León became the first European to land in present-day Florida, a daring "captain general" named Pedro Menéndez de Avilés set foot on the shore of what would one day become the twenty-seventh state of the United States of America. The intervening years between the two landings had seen several failed attempts to establish a thriving and enduring Spanish colony in the peninsula. Ponce de León wandered aimlessly looking for gold and, some say, the fabled Fountain of Youth. He lost most of his men and was killed in a confrontation with Native Americans. For Spain, however, failure in Florida—a lynchpin in the New World because of its strategic location at the entrance to the Gulf of Mexico—was simply not an option, explains M.C. Bob Leonard, a longtime Florida history professor and author: "You had Cuba on one side, Florida on the other side and the entire wealth of the Spanish colonial system going through the Florida Straits all year long, and…the Spanish simply could not allow another country to possess Florida."[462]

Menéndez seemed perfectly suited to the job King Philip II had put before him: primarily, founding that elusive settlement and ousting the French, who had a Huguenot settlement called Fort Caroline at or near the site of

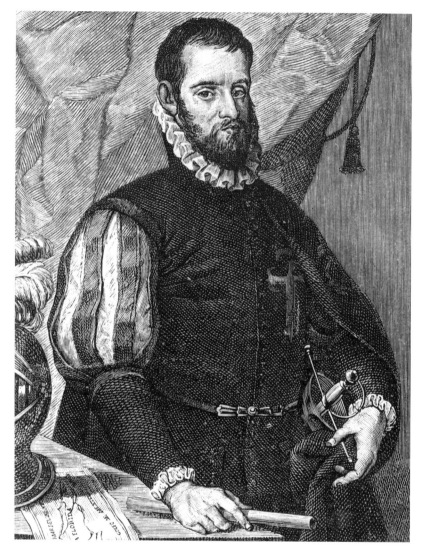

Pedro Menéndez de Avilés founded St. Augustine and routed the French from Florida. *Courtesy of the State Archives of Florida, Florida Memory.*

present-day Jacksonville. He had logged decades combating the French on the seas, including impressive defeats of French corsairs, or pirates, off the Spanish coast.

Menéndez founded St. Augustine in September 1565, soon after making landfall on the peninsula. Almost immediately, he led a daring and unexpected advance against the French at Fort Caroline. As T.D. Allman

explains in *Finding Florida*, a monstrous storm buffeting the northeast coast of Florida made a naval attack on—or an adequate marine defense of—the French fort temporarily impossible. Menéndez found another way. "In such weather an overland attack was also unthinkable—to anyone except Pedro Menéndez. The very irrationality of his latest scheme—to march overland through unknown territory in order to attack the French in the midst of a hurricane—was its most rational feature."[463]

Menéndez took advantage of the absence of several French ships from the fort during the storm and traveled with his men through the tempest for several days. The unanticipated attack succeeded, and the Spanish easily took Fort Caroline, renaming it San Mateo.

Not long afterward, Menéndez met and slaughtered the shipwrecked French Huguenot captain Jean Ribault and dozens of his men in two separate conflicts. Both took place in essentially the same location, by an inlet that became known as Matanzas Inlet. Matanzas means "slaughters" in Spanish. Fort Matanzas was built near the site of the bloodshed, about fifteen miles south of St. Augustine, approximately two hundred years later.[464] Today, it makes up Fort Matanzas National Monument, and Menéndez's butchery of the Huguenots—who already had surrendered—remains infamous.

With three ruthless massacres, Menéndez ended French settlement of the Florida peninsula and damaged the empire's chances at long-term success in what is now the southeastern United States. In doing so, he afforded Spanish ships friendlier waters through the Gulf of Mexico and the Florida Straits en route to the open Atlantic. With the critical elements of his charge from King Philip II complete, Menéndez was free to attend to the duties of a colonial governor: nurturing the nascent settlement of St. Augustine, supporting the establishment of Spanish missions, interacting with the local natives and exploring lands Spain had claimed northward, to name a few.

His swift success with his two main objectives reflected his usual style of getting the job done, regardless of the challenges that lay before him. His audacious hurricane trek to Fort Caroline fit right in with the intrepid tactics that had garnered him decades of maritime triumph in the name of the Spanish crown. He was motivated primarily by loyalty to his king and his faith, unlike many of the gold-hungry Spanish explorers who had come before him.[465]

This difference in inspiration was a significant factor in Ponce de León's failure to establish any settlements in Florida (and in his exclusion from our list of the twenty-five most influential people in the Sunshine State's history). León primarily sought riches and, if rumors are true, the fabled Fountain

of Youth. Other than being credited as the discoverer of Florida, León's contribution to the peninsula's history is limited. Upon his death, he left no lasting impact in Florida, which was still much as he had found it.

Though Menéndez spent most of his remaining years managing Spain's holdings in the present-day United States and Canada, his first mark on the continent—the city of St. Augustine—played many roles in the following several centuries of Florida history. From a fledgling Spanish settlement to one with the once-impenetrable Castillo de San Marcos, built in the 1600s, it stood as an integral part of Spain's defensive strategy in the New World. St. Augustine endured being burned and rebuilt. On two other occasions, soldiers and town residents survived the city's capture by retreating into the fort.[466]

The settlement continued to survive through the 1700s under a series of Spanish leaders. It also became a beacon of liberty in North America, as the Spanish made the decision to free and welcome any slaves who escaped from English-held Carolina and reached St. Augustine. The promise drew so many people that Governor Manuel de Montiano established a new settlement for them in 1738. It was called Fort Mose.[467]

Beginning in 1763 with the start of British command in Florida, St. Augustine served as the capital of the colony known as East Florida.[468] The English would later cede the Floridas back to Spain after losing the American Revolutionary War. Spain, in turn, would sign Florida over to the young United States with a treaty in 1819. The Adams-Onís Treaty also drew a border between the United States and Spanish territory, one that extended all the way from the newly acquired Florida to the Pacific Ocean. The treaty came about partly as a result of tensions and conflicts between the United States and Spain that continued to boil over following the War of 1812. General Andrew Jackson led U.S. troops on a raid into Spanish territory, landing himself and the United States in some hot water with his offensives against the Spanish and Seminole residents. Bearing in mind the clearly expressed interest of President James Monroe to acquire the Floridas for the United States, Secretary of State John Quincy Adams's masterful diplomacy with Spain resulted in the signing of the Adams-Onís Treaty. The United States was finally a transcontinental power.

In the late 1800s, several decades after Florida became a United States territory in 1821 and then a state in 1845, St. Augustine's charms were enough to capture the attention of magnate Henry Flagler and draw him into a decades-long dance with the Sunshine State. As a result, Florida gained a railroad that spanned its length, a collection of luxury resorts that drew

tourists, a succession of wealthy northerners eager to invest their fortunes and ambitions in the untamed state and a handful of new cities that are among its most influential.

Today, St. Augustine is a charming center of Florida culture and tourism. As the oldest standing European settlement in the nation, its architecture displays the state's Spanish colonial roots better than any other place. Though St. Augustine often is eclipsed by Florida's world-class theme parks and beach resorts, one can imagine that it might actually be the state's foremost tourist destination if Florida did not have Orlando-area attractions and glistening beaches. St. Augustine as a primary tourist attraction might look much like what Virginia has accomplished with the less historically significant Williamsburg.

The importance of Florida to Spain's New World empire begs questions about what would have unfolded if Menéndez had failed to eradicate the French from Florida. Given more time to strengthen their position in the peninsula, would the French have become so entrenched that Spain would have been unable to uproot them? With more time and a stronger hold in Florida, would France have renewed its interest in the region, making the empire less inclined to sell the Louisiana territories to the United States? Would Florida have served as a base for reinforcing French forces in Haiti

Menéndez's massacre of the French a few miles south of St. Augustine led to more than two centuries of Spanish rule of Florida. *Courtesy of the State Archives of Florida, Florida Memory. Originally published by* Liberty Magazine *(Lutheran Standard), 1985.*

(then called Saint-Domingue) during the Haitian Revolution, rather than retracting its troops? If so, perhaps French ambitions in the Americas would have been sustained by the treasure Saint-Domingue produced for the empire, enticing France to hold and expand its New World territories with more vigor and determination. Would Florida have remained in French hands and been sold as part of the Louisiana Purchase, bringing it under U.S. control nearly two decades before the date when it did become a U.S. territory? As a result, would Florida's culture today be more like that of Louisiana, with a mix of strong French and Spanish influences?

Of course, there are no certain answers to these questions. What is certain is that the development of Florida as we know it—and perhaps that of the United States—hinged on Pedro Menéndez's expulsion of the French and his establishment of the first permanent European colony in North America, four and a half centuries ago.

JAMES MONROE

(APRIL 28, 1758–JULY 4, 1831)

JOHN QUINCY ADAMS

(JULY 11, 1767–FEBRUARY 23, 1848)

Then president Monroe and future president Adams together achieved an epic victory of American expansion. Their combined use of military force and diplomatic finesse gained critical Spanish territory for the United States. In doing so, they extended the young nation "from sea to shining sea" and acquired Florida, which has become America's third most populous state.

Two and a half centuries after Pedro Menéndez founded St. Augustine, the Florida peninsula was again under Spanish control, after a brief period of British rule. Pensacola and St. Augustine remained the main settlements, and there was also St. Marks. Slaves who escaped from lands to the north still migrated to the area—now split into the separate colonies of East Florida and West Florida—to preserve their freedom. In some ways, Florida had not changed much.

But this status quo would not last long into the nineteenth century. Spanish dominion in the New World was waning, as were its resources. Once a strategic defensive holding for the Spanish, the Floridas now seemed to be somewhat of an afterthought for the once-grand empire. Historical biographer Richard Brookhiser has referred to East and West Florida as a "lawless subtropical wasteland,"[469] a description that seems apt. Following the War of 1812, tensions between Spanish Florida and the United States—particularly Georgians—remained high.

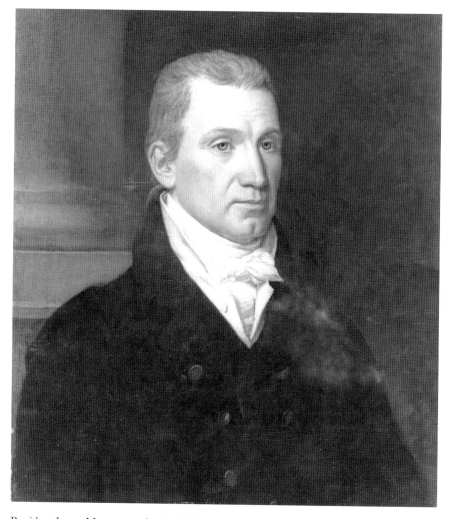

President James Monroe emphasized U.S. expansion in North America. The Adams-Onís Treaty designated Florida and other areas, stretching all the way to the Pacific, as U.S. territories. *Courtesy of the State Archives of Florida, Florida Memory.*

Some of the Spanish colonies' resident Seminoles—a group composed of Indians as well as blacks, many of the latter being escaped slaves— were attacking American settlements, farms and families in Georgia with devastating brutality, leaving corpses, damaged property and terrified people in their wake. Georgians retaliated with brutal attacks of their own. Spain failed to stand up against the raids, and some people said Spanish and British residents of the Floridas even goaded the Seminoles to violence against the

Americans. U.S. officials, who had been lobbying repeatedly to take control of the Floridas, took notice.

The cross-border conflicts obviously called for action in defense of American citizens. At the prompting of the nation's fifth president, James Monroe, Secretary of War John C. Calhoun ordered General Edmund Gaines in late 1817 to go to the Florida peninsula and "demand satisfactory reparations from the Seminoles"[470] for the attacks, as author Daniel Walker Howe put it in his Pulitzer Prize–winning tome, *What Hath God Wrought: The Transformation of America, 1815–1848*. He was instructed not to attack Spanish holdings.[471]

But Calhoun pulled Gaines away to another part of Florida, Amelia Island, before the general could fulfill the mission.[472] General Andrew Jackson—who also would one day become president of the United States—was called in to replace him in confronting the Seminoles, with the same mandate. And yet, Monroe may have compounded Jackson's instructions. Historian Harlow Giles Unger writes in his biography, simply titled *John Quincy Adams*, that Monroe communicated that "he considered acquisition of the Floridas essential to the security of the United States. With the Spanish army attempting to suppress wars of independence in Chile, Colombia, Venezuela, and Panama, Monroe did not believe Spain would be able to spare enough troops to defend the Floridas."[473]

Jackson, perhaps following Monroe's instruction or perhaps proceeding of his own will, rode against Spanish settlements. He captured the Spanish establishments of St. Marks and Pensacola, in addition to destroying Seminole forts, villages and homes.[474] He also executed two British men whom he said had aided the Seminoles in their offenses. Jackson would later claim Monroe had authorized such actions, in back-and-forth notes between the two men. The president denied it.

Thus began the First Seminole War. Whatever Jackson's authority or intentions, his attacks against the Spanish in Florida put the brakes on ongoing talks between the two nations regarding the fate of the Floridas.[475] Spain saw the raids as an affront to its sovereignty in the Floridas, as did other nations. The British were incensed, as well. Jackson's conduct also drew the attention of Congress and of Monroe's cabinet. Many in Washington decried Jackson's actions as unauthorized and a trespass against Congress's constitutionally granted power to declare war. Monroe and the general were in hot water indeed.

Monroe's secretary of state, John Quincy Adams, was Jackson's only defender. Adams cited the constitutional provision that granted the

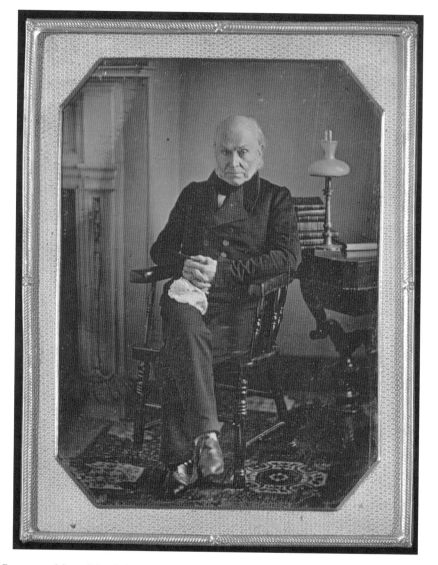

Secretary of State John Quincy Adams masterfully negotiated the treaty that bears his name. *Courtesy of the Metropolitan Museum of Art; Gift of I.N. Phelps Stokes, Edward S. Hawes, Alice Mary Hawes and Marion Augusta Hawes, 1937.*

president authority to order defensive military action without congressional involvement.[476] He crafted an official response to the situation, pointing blame away from Jackson, Monroe and the United States. Howe describes Adams's missive on the situation as "a truculent memorandum, blaming everything in Florida on Spanish weakness and British meddling, while

General Andrew Jackson invaded Spanish Florida, capturing settlements and causing an international incident that Secretary Adams artfully managed. *Courtesy of the State Archives of Florida, Florida Memory.*

completely ignoring the gross American violations of international law. This he sent to the U.S. minister in Madrid, George Erving, with instructions to show it to the Spanish government. Pensacola and St. Mark's would be returned this time; next time, Adams warned, the United States might not be so forgiving. Actually, the letter was intended at least as much for British and American consumption as for the Spaniards, in order to rebut critics of Jackson and justify the course the secretary of state was pursuing."[477]

The whole scenario underscored the great liability the Floridas posed for Spain. At a time when Spanish resources were stretched thin, the crown could no longer afford the Floridas, as Monroe well knew. When Adams and the Spanish minister, Don Luis de Onís, resumed their talks about Florida, Adams wisely and graciously allowed Spain to regain some dignity in the situation. He managed to salvage negotiations despite Jackson's overzealous bravado. The turmoil surrounding the matter in Washington settled down, too.

To suit Spain, Adams agreed that Jackson and his troops would retreat from Florida, handing the captured settlements back to the crown. The United States would take control of the Floridas, but not for a few more years. Adams also agreed that the United States would assume $5 million in claims Americans had lodged against the Spanish for damage inflicted in the attacks against Georgia. The Adams-Onís Treaty (signed in 1819), which was also known as the Transcontinental Treaty, dealt with several other matters as well. It established a border between the United States and Mexico, granted the United States land above the forty-second parallel stretching to the Pacific Ocean and settled squabbles between Spain and the United States over the Louisiana Purchase, Texas and Oregon Country. Congress ratified the treaty in 1821, and Florida officially became a U.S. territory the same year.

With enactment of the treaty, America became a nation that stretched from sea to shining sea. President Monroe's vision, following the desires of Presidents Jefferson and Madison before him, had steered military and diplomatic action toward attainment of additional territories for the United States, including the Florida peninsula. Secretary of State John Quincy Adams's unique take on Jackson's incursion into Florida, the straightforward and bold tone of his official communications with Spain and his wise, tactful negotiations with minister Onís all were instrumental in sealing the deal to draw Florida into the United States. The United States of America would never be the same.

TED ARISON

(FEBRUARY 24, 1924–OCTOBER 1, 1999)

He founded two of the world's most successful cruise lines and created a mega industry centered in Florida.

n 2014, nearly 3.2 million foreign visitors to Florida were drawn—at least in part—by destinations beyond its borders. That's the number of non-U.S. residents who traveled to the Sunshine State and then hopped on a ship bound for somewhere else at one of its five cruise home ports. In the same year, a total of 6.9 million passengers embarked from a Florida cruise port—62 percent of the industry's 11.1 million embarkations nationwide.[478] The state's 1,350-mile coastline and proximity to the Caribbean, Mexico and the Bahamas—combined with its own sunny appeal and extensive leisure offerings—have made it the hub of the cruise industry. Florida has more cruise home ports than any other state in the Union.[479] Miami is the "Cruise Capital of the World." PortMiami (as Miami-Dade County now calls it) hosted 4.9 million cruise passengers in 2016, followed by Port Canaveral (in Brevard County, serving Orlando) at 3.9 million and Port Everglades (Fort Lauderdale) at 3.7 million.[480]

Though a host of talented businesspeople have fostered the cruise industry's growth in Florida, no other person deserves as much credit—or has seen as much sustained success—as Israeli entrepreneur Ted Arison. More than anyone else, Arison played a defining role in shaping the cruise industry we know today. With Norwegian ship owner Knut Kloster, he founded what became the first major cruise line offering voyages out of

Carnival Cruise Line founder Ted Arison attends the christening of the company's second ship, *Carnivale*. Accompanying him are his daughter, Shari (*holding flowers on the left*), and his wife, Lin (*right*). *Courtesy of Carnival Cruise Line.*

the Port of Miami, with stops at nearby island destinations. Following that, he founded what is now the world's largest cruise enterprise, debuting a genre of cruising that is both appealing and accessible to middle America. In so doing, he shifted the industry's focus from luxury products to mass market ones that have brought explosive growth in cruising's popularity. These developments have been invaluable to Florida, as told in part by the economic impact figures highlighted above. Without Ted Arison, cruising and the state of Florida could very well look much different than they do today.

Travel between the United States and Europe was once primarily done via cruising. That changed in the late 1950s, when commercial transcontinental air travel offered a quicker, often more comfortable alternative. The cruise industry swiftly took a dive. Luxury cruises between the two continents seemed to be all that was left of the once-bustling business. But a small Miami-based business introduced by a man named Frank Fraser offered a different model

of cruising. Starting in the 1950s, Fraser's steamship line offered ten-day cruises from Miami to the Bahamas, the Caribbean and Central and South America[481] on ships considered tiny and simple compared to the floating mega resorts of subsequent decades. But Fraser's line and the whole notion of leisure cruises suffered after his *Yarmouth Castle* burned in 1965 on the way to Nassau. Nearly one hundred people died in the incident.[482]

Arison and his first partner in cruising, Kloster, grew their business where Fraser left off, forming their partnership in 1966. Arison had booked a slate of passengers to sail from Miami to the Caribbean on a ship the Israeli government later seized. For his part, Kloster had a ship that, due to political developments, could no longer carry passengers to Spain for their high-end vacations.[483] With Arison's passengers and Kloster's ship, the two formed Norwegian Caribbean Line, which has since been renamed Norwegian Cruise Line (NCL). Expanding on Fraser's concept, the two entrepreneurs ferried passengers to pristine tropical islands for idyllic vacations.

Within a few years of its founding, Norwegian had grown from a one-ship venture to a four-vessel operation. As cruise experts Bob Dickinson and Andy Vladimir state in their book *Selling the Sea: An Inside Look at the Cruise Industry*, "NCL's enterprise represented the beginning of the cruise business as we know it today."[484] NCL came to lead the young cruise industry in two important ways.

One was in the building of new ships, where NCL shared the spotlight with rival Royal Caribbean. After using a steamship/car ferry for its first vessel, NCL was soon commissioning the construction of ships designed specifically for cruising the Caribbean.[485] Founded in 1968, Royal Caribbean offered luxurious new ships from the start. Its first debuted in 1970.[486] Meanwhile, other lines breaking into cruising were relying on used crafts built for other purposes.

The second pioneering aspect of NCL was its marketing approach. To fill their newer, larger ships, Arison and Kloster broke from industry precedent by promoting cruises nationally, rather than just within the state. The expanded marketing strategy did more than just sell tickets, Dickinson and Vladimir explain. "NCL transformed South Florida contemporary cruising from a regionally marketed hodgepodge of very old ships, built originally to weather the North Atlantic waters, to a nationally marketed contemporary vacation product featuring brand-new vessels designed for Caribbean cruising."[487]

In 1971, the Arison-Kloster partnership soured and broke up on account of finances.[488] Kloster cancelled Arison's contract with NCL. Arison did not

jump ship from the cruise industry, nor from Miami. Rather, he took another shot at both by founding his own cruise line. "He established Carnival Cruise Lines in 1972 with a personal vision, and passion, of making cruising accessible to the average holidaymaker and not just the affluent," recounts Grenville Cartledge—a former manager for several cruise lines and a cruise industry consultant—in the book *The Business and Management of Ocean Cruises*. "It is no overstatement to say that without the creation, and development, of this North American market there would be no modern cruise industry of any consequence."[489]

Carnival experienced some rather dramatic growing pains in its inaugural year—including the very public running aground of the *Mardi Gras* in the Port of Miami, which left it stranded for twenty-eight hours[490] at the outset of its first cruise. Once freed, it made its way to Nassau but hit another snag: Arison's lack of credit to buy fuel forced crew members to scrounge through ship cash registers and slot machines for the funds to get the *Mardi Gras* back to Miami. Against all odds, the *Mardi Gras* managed to complete its maiden cruise voyage. Astonishingly, the incident did not sink Arison's young company right at the start.

With his new line, Arison was once again in a spot where he was relying on refurbished ships rather than new, purpose-built vessels. Despite this, he found ways to provide a novel, value-laden experience for passengers that also was lighter on overhead than his competitors'. Slower cruising speeds, fewer port stops, shorter and therefore less expensive trips and additional entertainment offerings (such as casinos, nightclubs, discos and movie theaters) all allowed Carnival to create a more carefree, cost-effective vacation experience for passengers, Cartledge explained. The strategy was friendly to Arison's bottom line.[491]

Carnival's revolutionary first vessel, the *Mardi Gras*, was marketed as the "fun ship" and embraced such silliness as belly flop contests and drinking games.[492] The concept stuck and transformed cruising from a vacation option only for the wealthy and retirees into one that increasingly offered products appealing to all ages and to, in the words of a 1998 *Travel Weekly* article, "middle-class Americans who wanted informality and abhorred stuffiness."[493]

The fun ship model has influenced the industry ever since, pushing cruise lines to offer voyages that are just as exciting as the destinations to which they cruise. It is easy to identify in the mega ships of today, with water slides, ice skating rinks, zip lines and myriad other amenities. In the words of Cartledge, Carnival's fun ship "gave the industry growth real impetus."[494]

Ted Arison (*front left*) and his son Micky Arison (*front right*) tour a construction site. *Courtesy of Carnival Cruise Line.*

After relying for a while on refurbished ships, Carnival in 1978 commissioned the construction of its first modern, just-for-cruising vessel, *Tropicale*.[495] Royal Caribbean and NCL no longer had the market cornered on new ships. In 1986, Carnival was the biggest brand in cruising, with 20 percent of the North American market.[496] And it just kept growing. Fifteen years after its founding, Carnival was ready for an initial public offering. The financial crisis that developed several months after Carnival's IPO produced a windfall of cash for the company that would set it decades ahead of every other player in the industry. Carnival Cruise Line's July 1987 initial public offering was an outstanding success, bringing in $365.8 million.[497] Three months later, on the eve of competitor NCL's own IPO, the bottom fell out of the world economy. Thanks to stock markets crashing around the globe on October 19, 1987, "Black Monday," NCL cancelled its offering.[498] Not until 2013 would the company succeed in going public.[499] In the wake of its withdrawn IPO, NCL was without the profits it had hoped to gain. The cruise industry as a whole also now had to contend with a recession that stretched American budgets thin.

The market downturn was a boon for Carnival, however. After the crash, the company's stock was selling at scandalously low prices, and Carnival was sitting on a pile of cash. The corporation used its IPO proceeds to purchase back its own stock. And it still had plenty left to build up its fleet. While competitors were suffering as a result of Black Monday, Carnival could afford to pay down debt and buy newer, ever more impressive ships.[500] Overnight, Carnival catapulted to the top of the industry. Next step: buying out its competitors. Carnival purchased Holland America Line, Windstar Cruises and Westours in 1989; Seabourn and Cunard Line in 1999; and Costa Cruises in 2000. With its 2003 takeover of P&O Princess Cruises, Arison's company formally became Carnival Corporation and plc.[501] "PLC" stands for public limited company and is a United Kingdom designation.

Thanks in large part to its newly minted chairman and CEO, Richard Fain, Royal Caribbean narrowly fended off a takeover attempt by Carnival in 1988.[502] Fain has led the company ever since. Under his leadership, Royal Caribbean has continued to grow into the innovative industry giant it is today. The company is Carnival's foremost competitor. Royal Caribbean also went public in 1993.

Carnival's visionary founder passed away in 1999, but his son Micky remains at the helm of the company as chairman of the board of directors. Under Micky Arison's leadership, Carnival holds its spot as the most dominant cruise provider in the world. In 2015, 48 percent of cruise

Carnival ships (*front to back*) *Festivale, Mardi Gras* and *Carnivale. Courtesy of Carnival Cruise Line.*

passengers traveled with a Carnival brand, which earned 42 percent of all cruise revenue. The other cruise line Ted Arison had a hand in establishing, NCL, clocked in as the third biggest player in the industry. NCL, which now owns Oceania Cruises and Regent Seven Seas cruises in addition to its flagship line, transported 10 percent of all 2015 cruise passengers and garnered 12 percent of the revenue. That's an astonishing 58 percent of cruise-goers in the world on a line founded by Mr. Arison. Falling between Carnival and NCL was the Royal Caribbean family of brands, with 23 percent of passengers and 22 percent of revenue.[503]

The statistics on cruising's impressive economic impact in Florida stand to improve as the industry continues growing. Demand for cruising increased by 62 percent from 2005 through 2015, according to Cruise Lines International Association. The association also reports that twenty-six new ships were expected to launch in 2017, 6 percent of the number of existing ships, and that almost half of people surveyed who had never before cruised were interested in ocean cruising.[504]

Twenty-first-century cruise ships are absolute behemoths. Royal Caribbean operated the largest six ships in the world at the time of this writing, the grandest clocking in at 226,963 gross tons.[505] Accommodating ships of this

size has required ever-greater cruise ports. And, of course, one of the most impactful effects cruising has had on the Sunshine State has been the growth of its ports. In the 1960s, a prescient Dade County Board of Commissioners anticipated an era in which cruising might contribute heavily to the county's bottom line and its development.[506] The first passenger terminal was built at the Port of Miami in 1966. Today, the port boasts seven massive cruise terminals, and its cargo and cruise operations pump $27 billion a year into Miami-Dade County.[507] Cruising's popularity has led to the proliferation of cruise home ports across the state.

The Arison family's influence in Florida extends beyond the cruise industry. In Miami, the global hub of cruising lies just across the bridge from the base of another iconic Miami brand. American Airlines Arena, home to the National Basketball Association's Miami Heat, is less than a two-mile drive from the Carnival cruise terminal at PortMiami. Ted Arison was instrumental in bringing the NBA's expansion franchise to Miami in 1988. Micky has held the reins of the team since 1995, during which time the Heat have won three championship titles.

Ted Arison also founded the National Foundation for Advancement in the Arts and his namesake family foundation, through which his legacy continues in the form of charitable giving. But the contribution for which he will always be best known is that of developing the modern cruise industry. Because of Ted Arison, Florida is the cruise ship capital of the world.

HARRY WAYNE HUIZENGA

(B. DECEMBER 29, 1937)

In creating three Fortune 500 companies, expanding Florida's professional sports scene and generously giving his talent and treasure to help others, he left an indelible mark on South Florida.

No one could have predicted, when a young H. Wayne Huizenga began managing a waste collection company for a family friend in midcentury Pompano Beach, that it was the beginning of a career that would monumentally shape Florida's worlds of commerce, sports and philanthropy. No one could have foreseen that what started out as a temporary job for the twenty-two-year-old Chicagoan fresh out of the U.S. Army Reserves would lead in a roundabout way to the creation of three Fortune 500 companies, including Florida's fourth-largest publicly owned business.

But that is just what happened. With no college degree or formal business training, Huizenga relied on his family's background in waste collection, on lessons he had learned from his father's rocky career and on the values of his Dutch heritage[508] to rapidly, yet carefully, assemble an empire of entrepreneurial genius. His accomplishments over more than six decades have made him one of the most renowned figures in American business. They also have been a boon to countless thousands of people in Florida and elsewhere, who benefited from stable jobs at Huizenga's booming commercial enterprises or profited as Huizenga purchased their operations and paid them handsomely with his company's stock.

Wayne Huizenga's southeast Florida garbage collection business later became Waste Management. He also grew Blockbuster into a global success, founded AutoNation (in Florida), successfully brought two professional sports teams to Florida and once was majority owner of the Miami Dolphins. *Courtesy of Nova Southeastern University.*

In addition, Huizenga's career brought two new sports franchises to the Sunshine State, one-quarter of the state's major professional teams as of the writing of this book.

THE FAMILY BUSINESS

Waste collection was work the Huizenga family knew well. In addition to Wayne, his grandfather and father—as well as numerous uncles and cousins—made a living hauling trash. Huizenga's grandfather, a Dutch immigrant, began a garbage hauling business in Chicago in the 1890s. Wayne's father, Harry—a carpenter and building contractor—moved his family to Fort Lauderdale in 1954 to resolve marital issues. After managing a family friend's residential collection route in Pompano Beach for some time, the younger Huizenga started his own waste collection empire in 1962. At the age of twenty-five, he borrowed $5,000 from a relative to buy twenty commercial accounts for trash pickup in Fort Lauderdale and a garbage truck that had seen better days. By 1968, he had grown the business to more than forty trucks.[509] His growth included buying out his Pompano Beach employer, thanks to a generous long-term financing deal the owner offered.[510]

Huizenga worked tirelessly on his own, both handling the actual waste collection in Fort Lauderdale and pitching the business to potential

customers. Meanwhile, his father worked for him, managing the Pompano Beach route.[511] Capitalizing on the development wave that was sweeping southeast Florida at the time, Huizenga continued buying Florida waste collection businesses and wooing new customers to enlarge his company. He also began to consider the idea of merging his enterprise with his family's waste collection business in the Midwest.

Huizenga and his partners—most notably his father and a cousin's husband—took their clan's business to a new level by recognizing the industry was ripe for consolidation. His cousin's husband, Dean Buntrock, ran the business that Huizenga's uncle had started. Over the decades, it had grown from a Chicago company to one that also served Milwaukee.[512] Huizenga and Buntrock agreed to a merger of their two companies and then worked doggedly to expand the joint venture.

Huizenga and Buntrock, however, were not the first to create a nationwide garbage company. In 1971, they were invited to visit Browning-Ferris Industries (BFI) in Houston, a public company that was gobbling up trash companies around the country using not just cash, but also stock. Such were the benefits of being a publicly traded company. BFI was targeting Waste Management, and the cash-strapped Huizenga saw the power of the public platform as he toured BFI sites in a helicopter and was wined and dined in a private club atop a Houston skyscraper.[513] Huizenga and Buntrock did not do the deal, but the model BFI had built was one they would emulate. Waste Management went public that same year. The ability to use stock, instead of cash, allowed Huizenga to go on an acquisition spree. He would later adopt the same strategy at Blockbuster and AutoNation.

Huizenga, especially, emphasized how important it was to "work fast to get the deal done,"[514] and the pair did just that, growing Waste Management, Inc. into an international colossus, the biggest waste disposal company in the world. The company had $1 billion in revenue in 1984.[515] For a variety of reasons, Huizenga left his role as vice chairman that year.[516] Fourteen years later, the company sold for a staggering $19 billion.[517]

DIVERSIFYING

Long before this sale, Huizenga had branched out into other industries. South Florida was abounding with Huizenga entities and real estate holdings. He viewed rental-based businesses as especially ripe for profit and dabbled in many of them, including renting out water coolers, billboards

and portable toilets, to name a few examples. He also invested in hotels and in dry cleaning and lawn care companies.[518] Ironically, one of his most visible and striking successes came through a business he originally was loath to consider: video rental stores.

At the prodding of a Waste Management executive, Huizenga investigated a small Texas-based chain called Blockbuster. He liked what he saw and considered the Blockbuster stores to be an improvement on the prevailing model in the industry. Always a stickler for cleanliness and customer service,[519] Huizenga was impressed that the founders had improved the customer experience with tidier stores, a more family-friendly atmosphere with no adult films and a better display strategy that helped ensure customer video selections were actually in stock.[520]

Combine the company's superior model with Huizenga's business prowess, and the potential for growth was immense. Huizenga purchased a majority stake in Blockbuster in 1987.[521] Much like Waste Management, the company grew by leaps and bounds, thanks largely to the tycoon's proficiency in territory-expanding deals. At the time Huizenga acquired the company, it had only 19 stores.[522] Two years later, he had amassed nearly 1,100 stores.[523] Over a particular seven-year period of time, a new Blockbuster store opened, on average, every seventeen hours.[524] By September 1994, the company had stores in ten foreign countries, plus 3,700 stateside.[525] Blockbuster founder David Cook credited Huizenga with the company's rapid growth and success: "Wayne has a history and it's probably as successful as anybody in business of acquiring companies. He's a magician. I mean he is the best there is at that. He did a far better job of expanding Blockbuster than I ever would have."[526]

SPORTS = RENTALS

Huizenga also jumped into the world of professional sports but viewed it from a slightly different angle than many would-be owners might. He purchased a 15 percent stake in the Miami Dolphins as part of a deal for partial ownership of the stadium, then called Joe Robbie Stadium.

"To me, sports is a rental business and it's an entertainment business. And it does everything I've ever wanted to do in life, and that is rent things," Huizenga once explained, as quoted by *Florida Trend* magazine.[527]

In another interview, he addressed the same idea, explaining that sports is a rental business because the ownership rents out seats for events, and

that the only way Mr. Robbie—then owner of the team and stadium—would allow Huizenga to buy part of the stadium was if he also would buy into the team.[528]

Once Huizenga was in the sports world, he could not resist the opportunities to add two new major professional sports franchises to South Florida: Major League Baseball's Florida Marlins, now known as the Miami Marlins, and the National Hockey League's Florida Panthers. Both began their first seasons in 1993. The Marlins team was a perfect addition to his business portfolio because it boosted the number of major sporting events for which Joe Robbie Stadium could rent out seats, catapulting the tally from a dozen or so per year to about one hundred.

Blockbuster had quickly become a household name, one that he could join with his blossoming South Florida sports holdings to create a robust, well-rounded entertainment empire. Huizenga envisioned a theme park that bore the Blockbuster name and provided sports-themed entertainment offerings, as well as other amenities. But before that could become a reality, Huizenga and the other shareholders turned over the reins of Blockbuster to Viacom for $8.4 billion.[529] Though Blockbuster was still flourishing at the time Huizenga signed the January 1994 deal, the move ultimately proved prescient. Companies such as Hulu, Netflix and Red Box, along with cable operators' on-demand services, began to dominate the movie rental space with their takes on the latest technologies, making even Blockbuster's clean, efficient video retail stores obsolete.

A New Target

In 1996, Huizenga set out to transform still another industry by forming AutoNation, then selling it to an umbrella company he owned, Republic Industries. He began buying used car dealerships and also campaigned with auto manufacturers for permission to own new car dealerships. Manufacturers had always prohibited public companies, which Republic Industries* was, from owning new car dealerships.[530]

* Huizenga retired from his role as chairman of the company's board in 2002. Today, the company is called Republic Services, Inc., and its subsidiaries operate waste collection services throughout most of the country. For the third quarter of 2017, Republic Services reported $223.3 million in net income (Republic Services, Inc., "Republic Services, Inc. Reports Third-Quarter 2017 Results," November 2, 2017. Accessed January 24, 2018, media.republicservices.com/2017-11-02-Republic-Services-Inc-Reports-Third-Quarter-2017-Results).

Eventually, the dealers caved, and AutoNation began operating only new-vehicle dealerships,[531] thus creating a new kind of publicly owned automotive retail empire. Another way that Huizenga bucked conventional dealership practices was by slowly adopting the fixed-price model of selling cars.

Rather than resorting to the infamous tactic of negotiating hard against customers, with sales staff consulting managers to approve all deals, AutoNation early on embraced the idea that customers value transparency and don't want car buying to feel like a battle. Starting with the Denver market in 1999, AutoNation rolled out "no-haggle" pricing at its dealerships and also has employed other approaches aimed at making customers' purchasing experiences more streamlined and less painful. A features-laden online shopping portal and the "Car Buying Her Way" initiative, the latter adopted in 2009 to help women feel more comfortable purchasing a vehicle, are two examples.[532]

The company runs 260 stores nationwide and is first on *Automotive News'* 2017 list of "Top 150 dealership groups based in the U.S.," as measured by sales of new vehicles.[533] As of the writing of this book, Florida has the most AutoNation stores of any U.S. state (52) and generates the highest percentage of the company's revenue (26 percent).[534]

Huizenga is a consummate businessman who is particularly adept at creating legendary corporations by acquiring other companies. Here he is with Randolph Pohlman, former dean of the H. Wayne Huizenga College of Business and Entrepreneurship at Nova Southeastern University. *Courtesy of Nova Southeastern University.*

Huizenga stepped down from the company in 2004,[535] but the retail giant, based in Fort Lauderdale, continues to thrive. With $21.6 billion in revenue and about twenty-six thousand employees in 2016, it ranks fourth on *Florida Trend*'s list of the state's biggest publicly owned companies, in terms of revenue.[536]

In 2016, AutoNation president, CEO and chairman of the board Mike Jackson announced the company's plans to once again run used-car dealerships. The company will open AutoNation USA stores for used car sales as part of a "wide-ranging $500 million–plus brand extension strategy that includes AutoNation-branded collision centers, wholesale auctions, parts and accessories," according to an article by *Automotive News*.[537]

Like Waste Management and Blockbuster, AutoNation is another example of Huizenga's talent in creating industry giants from minor existing players. "In virtually all cases, he has been attracted to companies that are part of a fragmented industry filled with small, undercapitalized operators," reads a 1991 *New York Times* article about the entrepreneur's business practices. "What he adds is a determination to cobble together a company with a national presence—plus the capital and managerial muscle to make that happen."[538]

A VAST LEGACY

For his lifetime of accomplishments, Huizenga has received a slew of accolades, some of which include the Ernst & Young's Entrepreneur of the Year US Award (2004) and World Entrepreneur of the Year Award (2005) and membership in the Horatio Alger Association of Distinguished Americans, the Automotive Hall of Fame,[539] the Florida Sports Hall of Fame and the Broward County Hall of Fame. In developing AutoNation, Huizenga achieved something no one else has done: he built his third Fortune 500 company.[540] More importantly, his ventures have employed thousands of people in Florida and beyond. He generated immense wealth for his employees and executives alike. Beginning in his garbage business days, Huizenga offered his staff ownership opportunities: Waste Management employees could buy company stock with $500 loans that were both interest free and payroll deductible. "Though a gesture of appreciation for their hard work, the offer also accomplished one of Huizenga's primary motivating strategies—ensuring others' economic

interests were aligned with his," writes Gail DeGeorge in a Huizenga biography, *The Making of a Blockbuster*.[541]

Huizenga's businesses brought new revenue and major attractions to the Sunshine State in the form of more profitable businesses, the establishment of corporate headquarters within the state and significant development of Florida's sports scene. Moreover, Huizenga and his wife, Marti Huizenga, volunteered their time and treasure to enrich a diverse slate of charitable and community organizations. Mrs. Huizenga passed away in January 2017.

While acknowledging Huizenga's unmatched business and sports contributions, Jack Seiler, mayor of Fort Lauderdale from 2009 to 2018, pinpoints the entrepreneur's charitable gifts as his most enduring.

As much as you talk about Wayne and Marti Huizenga being good business people and good sports owners and even good neighbors in Fort Lauderdale, they're both better people. They are outstanding individuals— charitable, kind, generous. And you look at the impact they've had on the arts, on culture, on charities, healthcare, universities. You know, you can't go anywhere in Fort Lauderdale and not feel that charitable impact, not feel that kind of benevolent touch from Wayne and Marti Huizenga.[542]

Mr. Huizenga's contributions to Florida have been so varied and vast that it is impossible to describe them all. He fully deserves to be called Florida's most successful businessman and one of the most impactful Floridians.

GEORGE WASHINGTON JENKINS JR.

(SEPTEMBER 29, 1907–APRIL 8, 1996)

His high standards and fresh ideas for the grocery industry endure decades later, making Publix the dominant player in the state's grocery market, Florida's largest private employer and its best-known homegrown company.

To understand why the founder of a regional grocery chain deserves a spot on a list of the twenty-five most influential people in Florida history, one must grasp the market dominance and customer loyalty Publix Super Markets has earned within the Sunshine State. Since its founding in Winter Haven, Florida, in 1930, Publix has been an industry leader in innovative technologies, superior customer service and first-class in-store comfort and appeal. With its employee-ownership structure, friendly atmosphere and generous benefits, the company also has created one of the most highly praised employee experiences in modern American business. *Fortune* magazine has consistently included Publix Super Markets in its list of "100 Best Companies to Work For" dating back to 1998, while *Forbes* recognized the corporation in its 2016 twenty-company list of "America's Best Employers."[543] Publix has earned a slew of other accolades as an employer and industry frontrunner.

Together, all that amounts to decades of corporate success, leading Publix to command a larger share of Florida's retail grocery scene than any of its competitors. Publix enjoys its highest market share in the state in South Florida, where it boasted a 49.3 percent stronghold at the time of this writing. This tops the 16.9 percent held in that region by Wal-Mart, its toughest

George Jenkins's Publix Super Markets is a top grocery chain, thanks largely to his standards for exceptional customer service. *Courtesy of the State Archives of Florida, Florida Memory.*

Sunshine State challenger. In Central Florida, Publix held 43 percent of the market, while Wal-Mart sat at 29.2 percent. Publix's 29.6 percent market share just barely lost to Wal-Mart's 30.2 percent in the North Florida/South Georgia region.[544]

Tom Jackson, former chief executive officer of the Ohio Grocers Association and a founder of the Florida Grocers Association, said that for a company to control 40 percent or more of the market in any given area is "significant." He also notes that "Florida is one of the unique states in the country where Wal-Mart doesn't have the predominant market share."[545]

National industry rankings reflect Publix's success. *Supermarket News* placed the corporation eighth on its list entitled "2016 Top 75 U.S. & Canadian Food Retailers and Wholesalers."[546]

But understanding Jenkins's place in this book requires one to know about him as a person, not just as a businessman. The son of a Georgia grocer, Jenkins built his own company in Florida from the ground up—rather than expanding his family's business—and prized positive community involvement just as much as, if not more than, professional success. The man known to many simply as "Mr. George" exhibited a passion for philanthropy and rich interpersonal relationships that continues to infuse his business empire decades after his death, imbuing Publix Super Markets with a sense of friendliness and warmth that helps the corporation consistently dwarf competitors.

A Different Kind of Grocery Store

Despite growing up working in his family's general store and later amassing a fortune through his own thriving grocery empire, Jenkins aspired as a young man to earn a living in real estate. The promise of a real estate career brought him south of the Georgia border on the heels of the Florida land boom. But like many people who sought to make lasting fortunes during this era, Jenkins's real estate dreams never came to fruition. He instead landed back in the industry he knew well, taking a menial role in the Piggly Wiggly grocery chain. He quickly moved up the ranks to become a store manager.

Jenkins decided to take a leap and launch his own grocery store shortly after another company bought out Piggly Wiggly. For his motive, most sources point to an incident in which Jenkins traveled to Georgia to meet with an executive of the new parent company, only to be turned away.[547]

Jenkins was told the man was too busy with important business to see him but could hear the man discussing golf on the phone. Jenkins left without a meeting, and it wasn't long before he decided to launch his own store,[548] right next to the Piggly Wiggly he had managed in Winter Haven. This Piggly Wiggly would later close due to Jenkins's outstanding success. It was September 1930, and the young entrepreneur was three weeks shy of twenty-three years old.[549]

Not far removed from the era of individually owned small grocery and general stores that typically stocked a limited selection and often offered a less-than-appealing ambiance,[550] Jenkins's standards exceeded customer expectations and imaginations. He emphasized unparalleled product offerings, cleanliness, aesthetics and customer service. Jenkins opened his second store in 1935 but five years later closed both locations to create the first Publix Super Market.

This new "food palace," as Jenkins called it, wowed the masses with a plethora of attractive, novel features. "The revolutionary design of that store," the *New York Times* reported decades later in Jenkins's obituary, "included several features that at the time had been rarely seen in a grocery store in Florida or anywhere else: electric-eye doors that would open automatically, fluorescent lighting, air-conditioning, 11,000 square feet of selling area, wide aisles, frozen-food cases, open-air dairy cases and a paved parking lot."[551] Jenkins's next major move was to buy a Florida grocery chain with nineteen stores and transform them into Publix locations.

The corporation's growth has continued through almost nine decades of business. The years have seen the addition of delis, pharmacies and bakeries to Publix stores, as well as the introduction of technology such as checkout scanners and ATMs. The chain expanded north into Jenkins's home state of Georgia in 1991 and has since moved into Alabama, Tennessee, South Carolina and North Carolina. In early 2016, Publix announced upcoming store openings in Virginia.[552]

Despite a substantial presence in much of the Southeast, the company and its charitable arm are irrevocably woven into the fabric of Florida. In addition to the nearly 800 Publix stores throughout the state (as of mid-2016, of about 1,100 total stores), Florida also is home to seven of the corporation's eight distribution centers. Publix manufacturing sites are divided between Florida and Georgia, with Deerfield Beach, Jacksonville and Lakeland being the Florida locations.[553] The corporate headquarters is in Lakeland. Of course, all these Sunshine State stores and corporate sites mean ample Florida jobs. As of July 2016, about 133,000 people worked

for Publix in Florida, making it the state's largest private employer.[554] The company's public relations department reports that Publix has never had a layoff.[555]

Research group Brand Finance named the supermarket giant as Florida's most valuable brand in July 2016. Publix ranked eighty-ninth on the group's U.S. 500 2016 list of most valuable brands nationwide, with a brand valuation of $6 billion.[556] Of traditional grocery retailers—not including drugstores, discount clubs and general retailers that sell some grocery products—Publix sits highest on this list.[557] The company's retail sales also are flourishing and hit $32.4 billion in 2015.[558]

Employee Relations and Philanthropy

It has taken more than innovative features, well-stocked shelves and pleasant ambiance to help Publix thrive since that first store opened in 1930. Jenkins's consistent, meaningful investment in both his employees and in the communities his stores served also has given the company staying power in an industry that has its fair share of mergers and acquisitions. The practices of regularly giving stock to employees and, as Jackson points out, calling them "associates," rather than employees, motivate workers to seek the company's success.

It also gives Floridians another reason to return to Publix stores. "That's a $35-, $40-billion company that's owned by the employees of the company," Jackson noted. Such an arrangement, given the enormous number of Publix employee-owners in Florida, is bound to produce immense loyalty and a strong emotional tie to the grocer throughout the state, he reasoned.[559] Jenkins's maxim proved true: "If you take care of your people, they will take care of your business."[560]

Jenkins's generosity to his employees was mirrored by his benevolence to charitable causes. In 1966, he formed the George W. Jenkins Foundation, now known as Publix Super Markets Charities. He did not track how much he gave to others throughout his life,[561] but he was known for his penchant for giving. That legacy lives on through Publix's sizable donations to national and local organizations, in-store campaigns to elicit customer giving and volunteer activities such as Publix Serves Day. Though Jenkins valued giving for the good it did for others, such contributions to the communities of the Sunshine State also help to endear his company to Floridians.

The first Publix Super Market, in Winter Haven, set a new bar for grocers with its cleanliness and use of novel technologies, such as electric-eye doors. *Courtesy of the State Archives of Florida, Florida Memory.*

Thanks in part to strong family leadership, Publix Super Markets has managed to maintain the superior standards Jenkins set for the organization. The values he championed during his life remain essential to the corporation more than two decades after his passing.

"The grocery business was founded on some really basic things: freshness and quality and value and friendliness and truly, truly being an asset to the community," said Jackson, who referred to Jenkins as "an industry icon." "These are the things that George Jenkins is noted for in this industry. So that's why Publix is…doing as well as they are, and they're doing extraordinarily well. A lot of George Jenkins is still there in Publix today."

Without Publix, Floridians would certainly not go hungry. But they would suffer from the lack of Florida's largest private-sector employer, as well as the economic benefits of being the home state of such a thriving player in the national grocery scene. They would surely, as Jackson pointed out, have to choose from a larger patchwork of competitors. In addition, a slew of charitable organizations would miss the volunteer time and donations Publix provides. In big ways and small, Publix helps to brighten the communities and the day-to-day lives of people all across Florida. For that we can thank George Jenkins's unique vision, business sense and benevolence. If there is one company that epitomizes Florida's growth, innovation, popularity and inviting spirit, it is, without a doubt, Publix.

JULIUS FREDERICK STONE JR.

(APRIL 18, 1901–1967)

With a hopeful vision and a practical plan, he saved the city of Key West from languishing in poverty—and from being forcibly evacuated and converted to a national park.

Key West in the first two decades of the twentieth century was one of America's wealthiest cities and one of Florida's largest. Pineapple canneries, cigar factories, shipping and sponge diving operations filled the city with vibrant, quirky character and steady jobs. U.S. Army, Naval and Coast Guard installations were stalwarts of the local economy. At a population of 17,144 in 1900—tenfold the number of residents in Miami at the time—Key West fell behind Jacksonville and Pensacola as the third most populous city in Florida.[562] The first train from Henry Flagler's Overseas Railroad had puffed into town in 1912 to great fanfare, drawing widespread attention to Key West and its new so-called eighth wonder of the world. The city's future, Floridians would have surely said, would be equally as bright.

But in 1933, the city went bankrupt.[563] Financial difficulties had begun to beset the city in 1919, after the impact of that year's hurricane,[564] a full ten years before the Great Depression commenced. For various reasons, the pineapple canners, sponge divers, salvage workers and cigar rollers—all of whom had once helped to make the city one of America's wealthiest—began closing down or moving their work elsewhere. For various reasons, U.S. Army, Navy and Coast Guard installments left town or severely

Julius Stone (*top left*) was instrumental in Key West's revival, saving it from being forcibly turned into a park. Here, he is pictured with other officials working on a project in California. *uclamss_1429_10062, Los Angeles Times Photographic Archives (Collection 1429). Library Special Collections, Charles E. Young Research Library, UCLA.*

contracted operations.[565] One by one, the blows just kept coming, and the struggling national economy only made matters worse. Basic municipal services ground to a halt due to lack of funds. Neither the city nor its people was bringing in any money to speak of. Garbage went uncollected for eighteen months.[566] Several factors had converged to create a perfect storm of financial destruction for the island, but the bottom line was that Key West had not been prepared for changing times: "Even without the ripple-effect ravages of the depression," explained journalist Garry Boulard in a *Florida Historical Quarterly* article, "Key West would undoubtedly have faced a troubled financial future in the mid-1930s due to its inability to diversify economically, its reliance upon several dying local industries, and the drop in property values relating to the Florida land boom and bust of the 1920s."[567]

Over time, the city's population dwindled from a healthy twenty-five thousand to ten thousand.[568]

Hapless city and county officials ceded their authority over the city to Governor David Sholtz in 1934. The governor immediately turned to Julius Stone Jr., the Federal Emergency Relief Administration's director for the southeastern United States. Stone stepped in to assess the situation. He considered several options for addressing the mess. One involved shutting down the city entirely and moving the residents to Tampa, then turning the Florida Keys into a national park.[569] Another, more optimistic idea drew upon the New Deal strategies of President Franklin D. Roosevelt and on Key West's greatest assets: its undeniably beautiful and refreshing natural surroundings and the resiliency of its people.

This route called for a deluge of projects to convert Key West from both a center of trade and local industry, as it had been before the Great Depression, and from the eyesore of filth and poverty it had recently become, into a tourism hotspot. In her book *Down in the Dumps: Place, Modernity, American Depression*, author Jani Scandura writes, "Stone sought to revise the American population's view of the island-city—and, more important, to bring it into its consciousness in the first place. Under his direction, FERA [Federal Emergency Relief Administration] produced Key West as a test site and laboratory for the 'unique experiment' of New Deal Progressivism."[570]

Stone's plan hinged on utilizing Key West's vastly unemployed population, most of whom were depending on federal aid for survival, to complete improvement projects in Key West. Recruiting the workforce was not a problem.

Directed by Stone, the residents set to work addressing the needs of the island, dumping the backed-up trash into the ocean (such a move obviously would be prohibited today but for that time was a quick, tolerable answer) and fixing up or demolishing derelict buildings. They built new schools, recreational beach facilities, playgrounds and other structures. They improved existing housing for use as tourist rentals[571] and completed the partially built open-air aquarium. They swapped outhouses for a sewer system[572] and converted a then-unused portion of the navy facility into a home for visiting yachts.

The federal government's Works Progress Administration also brought in artists, writers and performers to infuse the city with cultural richness. The administration established an art center that was a hub for artists and art education, and the city began to attract more and more artists with its growing creative scene.[573]

It wasn't long before the city's makeover began to have its desired effect. Key West quickly became known as a desirable place to relax and

rejuvenate. "During the 1934–35 season, the city's hotels registered eight thousand guests, double the four thousand of the previous year," writes author Maureen Ogle in her book *Key West: History of an Island of Dreams*. "The inundation overwhelmed the hotels, and the overflow rented the newly refurbished guesthouses. When the season ended, the total number of tourists had risen by seven thousand over the previous year, a remarkable accomplishment at a time when the nation's economy remained mired in depression."[574]

Amidst the island's renewed vibrancy, it suffered another setback in 1935 when a major hurricane, which has become known as the Labor Day Hurricane, struck the Florida Keys. Henry Flagler's Overseas Railroad connecting mainland Florida to Key West was destroyed. Rather than rebuilding it, the focus shifted to constructing a complete Overseas Highway. A version of the highway with gaps passable only by ferry had already existed but also had been damaged in the storm. The highway was finally finished in 1938, securing an easy route for anyone who wanted to jump in an automobile and head down to the continental United States' southernmost point for a bit of subtropical paradise.[575] Thanks to the work of Julius Stone managing the rehabilitation of Key West, there were hotels, restaurants, a vibrant art scene and a hospitable population to receive these travelers.

A UNIQUE DESTINATION

The work of Julius Stone and the Federal Emergency Relief Administration and Works Progress Administration teams that cleaned up and beautified Key West saved the city from being essentially wiped off the map. They also spared the state the great hassle of relocating Key West residents, a task that Tom Hambright, Monroe County historian, believes would have been ugly and unfruitful. Tampa had been the proposed site for relocation.

"The trouble was the economy was just as bad in Tampa as it was here," Hambright said. "...So you're talking about moving people. Nobody wants 'em; in fact, they probably would've met armed resistance had they tried."[576]

Instead, with a talented team and a gregarious, outspoken personality, Stone led the way in achieving the resurrection of a defunct but once great city. Unfortunately, Stone fell into deep debt later in his life and out of favor with the city he had saved. He had become an attorney (and also worked in real estate), practiced in Key West and handled clients' money poorly. In

addition, he owed more than $125,000 to the Internal Revenue Service. He fled to Australia, where he later died.[577]

Ever since his work saving Key West, the New Deal foundations of the city's lively artist community and tourism scene have been a boon to the island. Today, in addition to the economic benefits brought by the island's once again robust and stable U.S. Navy and Coast Guard establishments, Key West's main industry is tourism. This has worked out well for the island city, which continues to grow in global popularity among vacationers[578] and also is increasingly seen as a luxury travel destination, not merely a wild party scene.[579]

Believe it or not, there is hard work that goes on in Key West. From there, legendary American author Ernest Hemingway produced iconic works of literature, including *A Farewell to Arms*, *For Whom the Bell Tolls* and others.[580] His travels from Key West to Cuba and his fishing expeditions were reflected in *The Old Man and the Sea*, which won him both a Pulitzer Prize and a Nobel Prize. Another novel, *To Have and Have Not*, features characters said to be based on specific people from Key West.[581] It's not hard to see how the island city—with its quaint architecture, expanse of turquoise waters wrapping

Stone's workers through the Federal Emergency Relief Administration removed garbage that had piled up throughout the city. *Courtesy of the State Archives of Florida, Florida Memory.*

around it and lush flora lacing through it—could coax an author into producing some of his most inspired work. Hemingway had other writing havens, but one can't help but wonder: What if there was no Key West for Hemingway to write from? How many of his works would simply have never been produced? Would Key West have become the literary capital it is, boasting more authors per capita than any other place, and the home of thirteen Pulitzer Prize winners? Famed authors who at one time lived here include Shel Silverstein, Robert Frost, Annie Dillard, Tennessee Williams and others.

Some might ask whether Floridians truly would have missed having yet another tourist mecca on its shores, in the case that Key West had fully collapsed during the Great Depression. But where else can one get fresh key lime pie, a glimpse into the life of Ernest Hemingway and a sunset schooner cruise at the tip of the continental United States, all in one day? Thanks largely to Julius Stone, there really is no place quite like Key West.

CHIEF JAMES EDWARD BILLIE

(B. MARCH 20, 1944)

His leadership, though at times controversial, moved the Seminole Tribe of Florida from a modest level of financial stability and business enterprise to become an incredibly lucrative, global brand.

The most influential Seminole Indian of the twentieth century narrowly escaped infanticide. After his birth, tiny James Billie was the target of traditionalist tribal members loath to tolerate a half-white person—even a newborn—in their midst. Thanks to the intervention of a few compassionate fellow Seminoles, Billie was spared abandonment on a riverbank[582] and would grow up to become the longtime chairman of an organization that did not yet exist at the time of his birth: the federally recognized Seminole Tribe of Florida. Billie first took the role of chairman at a time when the tribe was just beginning to see meaningful income from a handful of tax-free smoke shops. He would help the Seminoles transcend those few shops to operate a gaming and hotel enterprise rivaling the state's most wealthy and powerful corporations and, in the first decade of the twenty-first century, a global empire and worldwide brand. This drastic rise of fortune has hinged on the Seminoles' foray into the gambling industry and on careful maneuvering with both the State of Florida and the U.S. federal government.

After a transient childhood marked by the total absence of his Caucasian father and by his mother's death when he was nine years old, Billie attended college and served in the U.S. Army during the Vietnam War. His postwar

Longtime chairman of the Seminole Tribe James Billie led the Seminoles to become the most successful Native American tribe in the nation. *By Donn Dughi, courtesy of the State Archives of Florida, Florida Memory.*

years included stints in a variety of occupations: hair dresser, wannabe landscaper, alligator wrestler and tribal administrative employee.[583] He was eleven years removed from his military service when, in 1979, he was elected chairman of the Seminole Tribe of Florida.

Billie lost no time in setting the Seminoles on a path to greater profitability. He picked up where his predecessor had left off, taking the already-introduced idea of Seminole bingo and spearheading it through the Tribal Council approval process.[584] The tribe opened its first bingo hall in 1979, on the Hollywood Reservation. The hall offered jackpots in excess of the state's $100 limit, putting the operation in the "high-stakes" bingo category and, state officials contended, in violation of state law.[585] Leaning on the view that the Seminole Tribe is a sovereign nation, the Seminole leader felt no need to heed the state's prohibitions. The sheriff of Broward County threatened to arrest those who failed to comply, and the two parties ended up in court over the matter. In 1981, a U.S. District Court ruled that the state did not have the authority to enforce its own civil regulations on a federally recognized Indian tribe. The case rose all the way to the Supreme Court, where the Seminole Tribe of Florida won a landmark victory in 1981. The tribe's sovereignty had prevailed at a

national level, and the message from the highest court in the land could not be clearer: on their reservations, the Seminoles had the right to largely do as they pleased.

Energized by the court's decision, the Seminoles opened a high-stakes bingo casino on their newly created Tampa Reservation in 1982.[586] Bingo in Hollywood and Tampa was so lucrative that the Indians contacted the state about moving into class III gaming,[587] the tier above bingo and similar games (class II). The Indian Gaming Regulatory Act, signed into federal law in 1988, established the three classes of gaming, with the third essentially comprising banked card games (e.g., blackjack) and other forms of gambling that are not in the bingo category. The act also required Indian tribes to establish agreements called compacts with the states in which they reside before they could host class III games.[588] It would be 2007 before the two parties agreed to the Seminole Gaming Compact, which the state legislature modified and ratified in 2010.[589] Today, the tribe owns casinos at six locations in South and Central Florida.

Though gaming is the most visible, and arguably farthest-reaching, element of Billie's legacy, the Vietnam War veteran and former alligator wrestler has led the tribe through myriad other matters. His administrations saw the addition of three Seminole Indian reservations in Florida. By 2016, there were about four thousand members of the tribe and six reservations in total: Big Cypress, Tampa, Immokalee, Hollywood, Brighton and Fort Pierce. Beginning early in his tenure as chairman, Billie was instrumental in navigating complex, years-long discussions between his tribe and numerous other parties—two Florida groups separated from but related to the Seminoles, the Miccosukee Indians and independent Indians; Freedmen's groups from Oklahoma; the Seminole Nation of Oklahoma; and the federal government—over a settlement afforded to Seminole Indians by the Indian Land Claims Commission. He also was involved in negotiations with the State of Florida and the U.S. government for the East Big Cypress Case, which led to a water rights compact of great importance.[590]

Another key aspect of Billie's legacy is the tribe's own civil court system. According to Andrew Frank, a Florida State University associate professor of history who studies the Seminoles, the court largely deals with family law cases, such as adoption and child custody cases.[591]

Though he was not chairman at the time the $965 million deal took place, the Seminole Tribe's 2007 purchase of Hard Rock International—with its global collection of hotels, restaurants, casinos and concert venues—is

undoubtedly part of Billie's legacy. He was the one who opted to license the Hard Rock brand, rather than Jimmy Buffett's Margaritaville, in 2000 for the tribe's new hotels and casinos in Hollywood and Tampa.[592]

The Hard Rock deal provided for the tribe something that Billie had long sought: greater diversification of its revenue streams. Should Seminole gaming become less profitable for one reason or another, the tribe can leverage and grow Hard Rock's other offerings. Since the acquisition, and under the management of renowned gaming executive Jim Allen, the brand has added sixty-seven new properties, most significantly in the hotel sphere. They have waded into the all-inclusive resort category, with openings in Mexico and the Dominican Republic.[593] According to deposition transcripts obtained by news outlet *Politico Florida*, the tribe brought in about $2.4 billion in total revenue in 2015, with most of that—almost $2.2 billion—coming from gaming.[594]

All this income has done more than simply enrich individual members of the tribe, though it has certainly done that. An October 2016 *Forbes* article estimated the annual dividend for a Seminole "member," as they are called, at $128,000.[595] Money from the tribe's enterprises pays for reservation schools and infrastructure, senior care facilities, tribal government operations and cultural resources. Language programs, the Tribal Historic Preservation Office and the Ah-Tah-Thi-Ki Museum all are supported by the Seminoles' commercial ventures.[596]

The tribe also supports the Florida economy by directly employing more than 2,000 people who are not members of the tribe and buying "from more than 850 Florida vendors a year," spending in excess of $24 million, the tribe's website states.[597] Factor in the people employed in Hard Rock facilities worldwide, and the tribe's economic footprint balloons.

Money pulled in through Seminole casinos has flowed to the State of Florida as well, in excess of $300 million annually from the gaming compact's 2010 adoption until 2015.[598] In 2015, a key clause of the compact expired, and the two parties afterward became bogged down in a legal quagmire. The tribe held the state's money in escrow until the two parties reached a settlement in 2017. The compact will expire in 2030.[599]

But Billie's legacy is not without its blemishes, including two impeachments from office and a collection of accusations and complaints lodged against him over the decades. The tribal council first removed him from office in 2001, capping off more than two decades of his continuous leadership. He won reelection in 2011 and remained in office until he was again removed in September 2016 in a tribal council vote prompted by a recall. The Seminole

Billie at the Florida Folk Festival in 1985. *Courtesy of the State Archives of Florida, Florida Memory.*

Bingo was the starting point of the Seminoles' now expansive gaming empire. *By Sandra Wallus Sammons and Robert Sammons, courtesy of the State Archives of Florida, Florida Memory.*

people elected a new chairman, Marcellus Osceola Jr., in October 2016. Billie, who ran for reelection, lost by only twenty-two votes.[600]

In her book *Warriors without War: Seminole Leadership in the Late Twentieth Century*, Patricia Riles Wickman, a historian who has lived among the Seminoles in Florida, describes the traditional Seminole culture as one that valued and revolved in many ways around war. Battle, she writes, was a critical element in their social structure. Bereft of this central cog in their society after the end of the Seminole Wars between the United States and the tribe, Seminoles sought new ways to find purpose and to order their society.[601]

In all the aspects of his legacy, Frank points out, Billie has championed the tribe's sovereignty, pushing the concept to a level not before seen. "He and his legal team figured out how to test the limits of what sovereignty could and could not do," Frank noted, "and…that had to do with gaming, that had to do with water rights, environmental protection, lots of different issues."[602] In doing so, Billie has, perhaps better than anyone else, learned how to fight for his people in modern ways and also to provide a new avenue for accomplishment and independence—an avenue into which the Seminoles, in a group sense, can pour their energy. Success in the gaming

market, achieved mostly under Billie's leadership, offers sustenance and a fresh source of pride for a once-beleaguered people.

To describe the Seminole Tribe of Florida as the most successful Native American tribe in the United States is not an overstatement. Today, the Seminoles are not only a global brand but a relevant, well-respected and powerful group operating in the state from which European powers and the American government repeatedly tried to eradicate them. The leadership of James Billie has had much to do with that outcome.

CONCLUSION

Florida has certainly come a long way since Pedro Menéndez founded St. Augustine, America's oldest city. In the four and a half centuries that have passed, the peninsula has gone from being Europeans' first frontier in the present-day United States to becoming the launching point for mankind's journey to the moon and beyond.

Much has transpired. James Monroe and John Quincy Adams deftly maneuvered to make Florida a U.S. territory with the 1819 signing of the Adams-Onís Treaty. Florida officially became a territory in 1821 and, twenty-four years later, the nation's twenty-seventh state.

Thanks to Drs. Joseph Porter and John Gorrie, and their respective contributions of effective mosquito control and air conditioning, humans gained the upper hand in the constant battle against two of the state's most insufferable threats to human health and comfort: its suffocating heat and its disease-carrying, flying bloodsuckers. With these major challenges at bay, the potential the Sunshine State's earliest visionaries saw here is becoming reality, likely in grander ways than even they imagined.

Hamilton Disston and Governor Napoleon Bonaparte Broward drained large portions of the Florida Everglades, making extensive development of southeast Florida possible. Disston also rescued the state from financial ruin with his massive land purchase, thus opening the door for magnates such as Henry Flagler, Henry Plant, Carl Fisher, Barron Collier and others to bring their dreams of Florida development to fruition. Julia Tuttle and Julius Stone cast the vision for and put into motion the plans that created two of the state's most well-known destinations.

But none of these dreamers and doers could have imagined the scientific advancements, political developments and entrepreneurial genius that would follow them.

Building on the foundations these pioneers laid, Captain Washington Irving Chambers and Dr. Kurt Debus brought Florida to the forefront of American military innovation and aerospace technology. Doing so enhanced the state's business environment and also brought millions of people to the Sunshine State in service to their country. Of course, many could not resist the urge to return and make Florida home.

In the meantime, Douglas Dummett, Walt Disney, George Jenkins, Ted Arison, Wayne Huizenga and Chief James Billie created agricultural, cultural and business institutions that transformed Florida and garnered the attention of tourists, investors and business leaders the world over.

Courageous social leaders such as Marjory Stoneman Douglas, Mary McLeod Bethune and Governor LeRoy Collins challenged Floridians and Americans to better treatment of the environment and of one another. Without Douglas's influence, the Everglades might well be a thing of the past and, with it, any hope of sustaining a sizable society in southeast Florida. Bethune and Collins shepherded Florida through the tumultuous civil rights era with generous measures of grace and wisdom, making the state an example of how to embrace change—even wade through reluctance and resistance—with more open hearts and less violence than other states in the South experienced.

While American society was experiencing its own growing pains, Cuban rebel Fidel Castro's revolution, rise to power and implementation of socialist policies transformed Florida forever, as generations of Cubans sought refuge and built new lives in southeast Florida.

All these contributions have led Florida to the position—socially, demographically and economically—in which we find it today: the nation's third largest state in terms of population, with great promise for the future.

As Travis H. Brown described in his book *How Money Walks*, the Sunshine State saw an influx of $86.4 billion in adjusted gross income from 1995 to 2010. That is, people moving to Florida from somewhere else carried $86.4 billion of income with them.[603] Florida's lack of a state income tax, as Brown points out, is a major draw, on top of all the other things the state has going for it.

This massive movement of money—the biggest chunks of it coming from New Jersey and New York[604]—coupled with a steady flow of money and people into the state from Latin America, make Florida (Miami most

specifically) a center of international banking and commerce. The Sunshine State deserves its moniker as the Gateway to Latin America and, perhaps one day, even the Capital of the Americas.

The state's impressive growth seems destined to continue. And with all Florida has to offer residents, businesses and investors, there is no mystery as to why. Consider the following descriptions of Florida assets and accolades, sourced from a variety of organizations and included in a 2017 Enterprise Florida fact sheet. Florida:

- "accounts for 24% of total U.S. trade with Latin America and the Caribbean."
- "ranks 7th in the nation in state-origin exports (i.e. those actually produced, or with significant value-added, in the state), which reached $52 billion in 2016."
- "is a diplomatic hub with consulates from over 87 countries, 78 bi-national chamber of commerce, and over 250 sister-city relationships."
- "is the world's telecommunications gateway to Latin America and the Caribbean: a multitude of undersea and terrestrial fiber optic cables converge in Florida, ensuring unparalleled global connectivity."
- "sits at the nexus of transportation links in the Americas. The state's 15 deepwater seaports, 19 commercial airports, and 50+ officially-designated multimodal connectors ensure the seamless movement of people and goods between any two points on the planet."[605]

In addition to these impressive facts, Florida also enjoys the best business tax climate of any of the nation's populous states. Florida ranks fourth nationwide, behind Wyoming, South Dakota and Alaska.[606] It has the fourth largest gross domestic product of any U.S. state and, if it was its own country, would rank as the seventeenth largest economy in the world.[607] Florida is on pace to match Mexico's GDP by 2019.[608] Lastly, the Sunshine State accounts for nearly 25 percent of foreign national real estate ownership in the United States.[609]

How far Florida's growth will go is anyone's guess. Will Florida surpass New York as the financial capital of the world? Will it overtake California and Texas—as it did New York in 2014[610]—to become the Union's most populous state?

Even as we contemplate these possibilities, we must remember that just as Florida's past is about more than statistics, so is its future. More than money, infrastructure or population growth, the greatest potential of the Sunshine State lies with its people. How will they change not only their state for the better, but also the world?

Who will be the next social leaders possessing the right combination of moxie and moral clarity to step forward in Florida and guide the population through sticky issues, to find the paths of integrity and greatest benefit for the state as a whole? What devices or processes will future innovators design to transform our daily lives in ways we cannot yet conceive? Which industries will be turned upside down by companies founded or matured in Florida's business-friendly climate? Where will visionaries create or re-create the state's next great tourist hotspot?

We will have to wait and see. But if the roster of those who built Florida is any indication, the men and women who will shape the Sunshine State's future will be colorful, controversial and more consequential than even the pioneers who came before them.

NOTES

Introduction

1. Gannon, *Florida*, Kindle location 83; Cusick, "Spanish Florida."
2. A + E Networks, "How Florida Got Its Shape."
3. Forstall, *Population of States*, 3.
4. Visit Florida, "Orlando Thanks Visitors in a Big Way for Making It No. 1 Destination in U.S."

Number 1

5. Dineen, "Florida Welcomed Nearly 113 Million Tourists in 2016."
6. Florida Department of Environmental Protection, "Learn About Your Watershed."
7. Forstall, *Population of States*, 3.
8. Graham, *Mr. Flagler's St. Augustine*, Kindle locations 646–49.
9. Ibid., Kindle location 85.
10. *San Francisco Call*, "Henry Clews"; *Washington Post*, "Estimate of Fortunes," cited in Graham, *Mr. Flagler's St. Augustine*, Kindle locations 85–87.
11. Graham, *Mr. Flagler's St. Augustine*, Kindle location 810.
12. Flagler Museum, "Henry Morrison Flagler Biography."
13. Henry B. Plant Museum, "Henry B. Plant Biography."
14. Graham, *Mr. Flagler's St. Augustine*, Kindle locations 991–1010.
15. *Jacksonville News Herald*, "Mr. Flagler Talks," June 20, 1887, 6, cited in Graham, *Mr. Flagler's St. Augustine*, Kindle locations 1028–30.

16. Henry Morrison Flagler to Ellen Call Long, March 20, 1902, Florida Memory, State Library & Archives of Florida, www.floridamemory.com/onlineclassroom/railroads/documents/flagler.
17. Florida Memory Blog, "'Shocking' Ponce de Leon Hotel."
18. Flagler College, "Hotel to College."
19. Martin, *Florida's Flagler*, 117.
20. Allman, *Finding Florida*, page 12 of unnumbered photo pages.
21. Seth H. Bramson, "History," Florida East Coast Railway, Historical Gallery, caption for image 6; Flagler Museum, "Henry Morrison Flagler Biography."
22. Historical Society of Palm Beach County, "Introduction: Flagler Era."
23. Flagler Museum, "Henry Morrison Flagler Biography."
24. Forstall, *Population of States*, 30.
25. Flagler Museum, "Henry Morrison Flagler Biography."
26. Borucki, in discussion with coauthor.
27. Ibid.
28. Graham, in discussion with coauthor.
29. Putnam, "Long Term Water Policy for Florida."
30. Graham, in discussion with coauthor.
31. Ibid.
32. Allman, *Finding Florida*, 321–22.
33. PBS Online, "Fidel Castro."
34. U.S. Census Bureau, "North Carolina Becomes Ninth State With 10 Million or More People."

Number 2

35. Clark, in discussion with coauthor.
36. Conradt, "Why Walt Disney Built a Theme Park."
37. Gabler, *Walt Disney*, 604.
38. Ibid., 603; Clark, in discussion with coauthor.
39. Gabler, *Walt Disney*, 602–4.
40. Ibid., 604.
41. Weiss, "Is that Really Walt's Plane at Disney's Hollywood Studios?"
42. Conradt, "Why Walt Disney Built a Theme Park"; Florida's Turnpike, "Florida's Turnpike"; AARoads, "Interstate 75"; AARoads, "Interstate 95"; AARoads, "Interstate 4."
43. Storbeck, "Windows on Main Street."

44. Grunwald, *The Swamp*, 82–97.
45. Clark, in discussion with coauthor.
46. Gabler, *Walt Disney*, 605.
47. Ibid.
48. Ibid., 607.
49. Ibid.
50. Walt Disney Company, *EPCOT*.
51. Gabler, *Walt Disney*, 610.
52. Walt Disney Company, *EPCOT*.
53. Gabler, *Walt Disney*, 611.
54. Ibid., 609.
55. Walt Disney Company, *EPCOT*.
56. Gabler, *Walt Disney*, 610.
57. Ibid., 630.
58. Fogelsong, in discussion with coauthor.
59. Ibid.
60. Clark, in discussion with coauthor.
61. Fogelsong, in discussion with coauthor.
62. Walt Disney Company, "Walt Disney World in Brief."
63. Themed Entertainment Association, *2015 Theme Index*.
64. Visit Orlando, "Orlando at a Glance."
65. Visit Florida Research, "Research."
66. Fogelsong, in discussion with coauthor.
67. Ibid.
68. Clark, in discussion with coauthor.

Number 3

69. Cordoba, "Little Havana."
70. Walker, "Cuba Before Castro."
71. Martinez, "Cuba Before Fidel Castro."
72. Walker, "Cuba Before Castro."
73. Martinez, "Cuba Before Fidel Castro."
74. Ibid.
75. Butts and Schwartz, *Fidel Castro*, 14.
76. Biography.com editors, "Fidel Castro."
77. History.com staff, "Fidel Castro Born."
78. BBC News, "Cuba Profile—Timeline."

79. Sanchez, Curtis and Klapheke, "Remembering the Cuban Revolution."

80. BBC News, "Cuba Profile—Timeline."

81. Amnesty International, "Cuba: Human Rights at a Glance."

82. PBS Online, "Fidel Castro."

83. Ibid.

84. Moreno, in discussion with coauthor.

85. Migration Policy Institute, "State Immigration Data Profiles: Florida"; Migration Policy Institute, "U.S. Immigrant Population by State and County."

86. Migration Policy Institute, "U.S. Immigrant Population by State and County."

87. Moreno, in discussion with coauthor.

88. Abraham, in discussion with coauthor.

89. Moreno, in discussion with coauthor.

90. U.S. Census Bureau, "Table 19"; Abouhalkah, "New Population Figures"; Smith and Allen, "Urban Decline."

91. Levine and Asís, *Cuban Miami*, 5.

92. Yad Vashem, "The Holocaust."

93. *Global Trade*, "Top 50 Cities for Global Trade."

94. Miami-Dade Aviation Department Marketing Division, *Miami International Airport*, 3.

95. Abraham, in discussion with coauthor.

96. Bacardi Limited, "The Early Years."

97. Hernández, *Cubans*, 104–10.

98. Ibid.

99. *Time*, "15 Famous Cuban-Americans."

100. History.com staff, "Castro Announces Mariel Boatlift."

101. Yoo, "Mariel Boatlift."

102. Moreno, in discussion with coauthor.

103. Pugh, "Governor Vows to Thwart Those Who Prey on Tourists."

104. Abraham, in discussion with coauthor.

105. Human Rights Watch, "Cuba: Events of 2016."

106. Levine and Asís, *Cuban Miami*, 21.

107. U.S. Census Bureau, "QuickFacts: Miami-Dade County, Florida—Table."

108. Forstall, *Population of States*, 2.

109. Smith and Allen, "Urban Decline," Table 2.

110. U.S. Census Bureau, "Florida Passes New York."

Number 4

111. Kite-Powell, "Grand Hotels."
112. Harner, *Florida's Promoters*, 22.
113. Ibid.
114. Kite-Powell, "Grand Hotels."
115. *New York Times*, "Henry B. Plant Dead."
116. Reynolds, *Henry Plant*, 9.
117. Henry B. Plant Museum, "Henry Plant's Southern Empire"; National Park Service, "Tampa Bay Hotel."
118. Port Tampa Bay, "Location and History of Port Tampa Bay."
119. Brotemarkle, "Historic Ybor City"; Harner, *Florida's Promoters*, 23–24.
120. Harner, *Florida's Promoters*, 24.
121. Port Tampa Bay, "Location and History of Port Tampa Bay."
122. Reynolds, *Henry Plant*, 164.
123. Harner, *Florida's Promoters*, 24.
124. Florida Industrial and Phosphate Research Institute, "Discovery of Phosphate in Florida."
125. Beavers, "Overview of Phosphate Mining," 5.
126. Shaw, "Top Phosphate Production by Country"; Padhy, "Phosphate Mining in the US and Canada."
127. National Park Service, "Tampa Bay Hotel."
128. Reynolds, *Henry Plant*, 164.
129. Zucco, "Grand Hotel Checkout."
130. Kite-Powell, "Grand Hotels."
131. University of Tampa, "History."
132. Harner, *Florida's Promoters*, 25.
133. Henry B. Plant Museum, "Henry Plant Hotel 1891."
134. National Park Service, "Tampa Bay Hotel."
135. Ibid.
136. "Tampa as Port of Embarkation for Spanish American War," text of historical marker located in Hillsborough County, in Florida Department of State Division of Historical Resources, "Florida Historical Markers Programs—Marker: Hillsborough."
137. Hawes, "Tampa at the Turn of the Century," 69.
138. Sorey, "Atlantic Coast Line Railroad."
139. U.S. Air Force, *History of MacDill*.
140. *History of MacDill Air Force Base*, 2.
141. Ibid.

142. Ibid., 13.
143. Altman, "Report: MacDill's Economic Impact."
144. Enterprise Florida, "Florida Defense Industry."
145. U.S. Coast Guard, "Air Station Clearwater."
146. *Forbes*, "Best Places for Businesses and Careers."
147. U.S. Census Bureau, "Exhibit 1a: U.S. Exports, Domestic and Foreign Merchandise."
148. McMorris, "Tampa Gets a Second, Year-Round Cruise Ship."
149. Tourism Economics, "Economic Impact of Tourism in Hillsborough County," 2.
150. Hillsborough County Economic Development Department, "Quarterly Economic Indicators Report," 4.
151. Hodges, Rahmani and Stevens, *Economic Contributions of Agriculture*, 2.
152. Tampa Bay Partnership, "Major Employers."
153. U.S. Census Bureau, "Annual Estimates of the Resident Population."

Numbers 5 and 6

154. Florida Department of Environmental Protection, "Learn About Your Watershed."
155. Clement, "Everglades Biographies: Napoleon Bonaparte Broward"; Digital Scholarship Lab, "Hamilton Disston."
156. Grunwald, *The Swamp*, 84.
157. Harner, *Florida's Promoters*, 16.
158. Ibid., 13.
159. DiBiase, in discussion with coauthor.
160. Grunwald, *The Swamp*, 87.
161. Digital Scholarship Lab, University of Richmond, "Hamilton Disston."
162. Harner, *Florida's Promoters*, 17.
163. St. Cloud Main Street, "History."
164. Hollander, *Raising Cane in the 'Glades*, 24.
165. Harner, *Florida's Promoters*, 16.
166. Grunwald, *The Swamp*, 96.
167. National Governors Association, "Napoleon Bonaparte Broward."
168. Grunwald, *The Swamp*, 130–31.
169. Clement, "Everglades Timeline: Everglades Drainage in Earnest."
170. DiBiase, in discussion with coauthor.
171. Grunwald, *The Swamp*, 120–28.

172. St. John's River Water Management District, "Florida Water Management History."
173. Grunwald, *The Swamp*, 136.
174. Fort Lauderdale Historical Society, "Governor Broward and the Empire of the Everglades Exhibit."
175. Gannon, *Florida*, 70.
176. Florida Department of Environmental Protection, "Brief History of Lake Okeechobee."
177. Grunwald, *The Swamp*, 149.
178. DiBiase, in discussion with coauthor.
179. Grunwald, *The Swamp*, 89.
180. DiBiase, in discussion with coauthor.
181. Florida Memory Blog, "Land by the Gallon."
182. U.S. Army Corps of Engineers, "About Herbert Hoover Dike."
183. Galloway, Jones and Ingbritsen, *Land Subsidence in the United States*, 97.
184. Clement, "Everglades Timeline: Depression, the New Deal & the War Years in the Everglades."
185. Florida Department of Agriculture and Consumer Services, "Florida Agriculture Overview."
186. Hodges, Rahmani and Stevens, *Economic Contributions of Agriculture*, 1.
187. Ibid., 20.
188. Forstall, *Population of States*, 31.
189. Ibid., 30–31.
190. Sieg and Winston, *Insiders' Guide to Greater Fort Lauderdale*, 22.
191. *Forbes*, "Best Places for Business and Careers: Miami, FL"; *Forbes*, "Best Places for Business and Careers: Fort Lauderdale, FL."
192. U.S. Census Bureau, "QuickFacts."
193. DiBiase, in discussion with coauthor.
194. Davis, in discussion with coauthor.
195. Stern, *Everglades Restoration*.

Number 7

196. *United States Insect Pest Bulletin* 12, no. 10 (1932): 428, quoted in Patterson, *Mosquito Wars*, 10–11.
197. Florida Department of Agriculture and Consumer Services, *Public Health Pest Control*, 1–2.
198. Ibid.

199. Patterson, *Mosquito Wars*, 30.
200. Ernest Carroll Faust, "Malaria Incidence in North America," in *Malariology: A Comprehensive Survey of All Aspects of This Group of Diseases from a Global Standpoint*, edited by Mark F. Boyd (Philadelphia: W.B. Saunders Company, 1949), 751, cited in Patterson, *Mosquito Wars*, 30.
201. Florida Coordinating Council on Mosquito Control, *Florida Mosquito Control 2009*, 22.
202. Florida Department of Health, "Episode #1: Origins."
203. Centers for Disease Control and Prevention, "History of Malaria."
204. Allman, *Finding Florida*, 9.
205. Harner, *Florida's Promoters*, 24.
206. Florida Memory Blog, "Dreaded Yellow Jack."
207. Contagion: Historical Views of Diseases and Epidemics, "Yellow Fever Epidemic in Philadelphia"; History.com staff, "Yellow Fever Breaks Out in Philadelphia."
208. Centers for Disease Control and Prevention, "History of Malaria."
209. National Museum of Health and Medicine, "U.S. Army Maj. Walter Reed."
210. Ibid.
211. Gorgas, *Few General Directions*, 9–10.
212. Ibid., 8–10.
213. Phalen, "Chiefs of the Medical Department," 88–93.
214. Patterson, *Mosquito Wars*, 25.
215. Dr. William C. Gorgas to Dr. Joseph Y. Porter, July 25, 1902, Florida State Board of Health Subject Files, 1875–1975, Series 900, Carton 6, Folder 89, State Archives of Florida.
216. Patterson, *Mosquito Wars*, 25.
217. Ibid., 25–27.
218. Florida Coordinating Council on Mosquito Control, *Florida Mosquito Control 2009*, 22.
219. Patterson, *Mosquito Wars*, 29–30.
220. Florida Department of Health, "Episode #4: Health Train."
221. State Board of Health of Florida, *Twenty-Eighth Annual Report of the State Board of Health of Florida*, 13.
222. Patterson, *Mosquito Wars*, 34; Florida Department of Health, *State Health Officers*.
223. Florida Mosquito Control Association, "History of the FMCA."
224. Patterson, *Mosquito Wars*, 35.
225. Ibid., 36–44.

226. Florida Coordinating Council on Mosquito Control, *Florida Mosquito Control 2009*, 22.
227. Forstall, *Population of States*, 30.
228. Bureau of the Census Library, Introduction to *Census of Housing*, xix–xx.
229. Forstall, *Population of States*, 30.
230. U.S. Department of Commerce, Bureau of the Census, "Florida" 11-10, table 6.

Number 8

231. Burnett, *Florida's Past*, Kindle location 672.
232. Cooper, *Air-Conditioning America*, 8.
233. Johnson, *How We Got to Now*, 62.
234. Ibid., 64–65.
235. Ibid., 65; Chapel, "Dr. John Gorrie"; Taylor, "Catalog of the Mechanical Collections."
236. Chapel, "Dr. John Gorrie."
237. Taylor, "Catalog of the Mechanical Collections."
238. Johnson, *How We Got to Now*, 65.
239. Morse, "Chilly Reception"; Johnson, *How We Got to Now*, 65.
240. Howe, "Father of Modern Refrigeration," 21.
241. Ibid.
242. Johnson, *How We Got to Now*, 66–67.
243. Oremus, "History of Air Conditioning."
244. Green, "Brief History of Air Conditioning."
245. Forstall, *Population of States*, 30.
246. Smith, *Florida Population Growth*, 6.
247. Lang and Rengert, *Hot and Cold Sunbelts*, 4.
248. National Archives and Records Administration, "Distribution of Electoral Votes."
249. Johnson, *How We Got to Now*, 72–73.
250. Cassanello, *Episode 38: Citrus Industry*.
251. Center for Land Use Interpretation, "Refrigerated Nation."
252. Florida Department of Agriculture and Consumer Services, "Florida Agriculture Overview."
253. Rosen, "Keepin' It Cool"; Green, "Brief History of Air Conditioning."
254. Rosen, "Keepin' It Cool."
255. Barringer, "White Roofs Catch On."

256. Rosen, "Keepin' It Cool."

257. Nagengast, "100 Years of Air Conditioning," 46.

258. Enterprise Florida, "Florida Defense Industry Had $79.8 Billion Impact."

Number 9

259. Stein, *From Torpedoes to Aviation*, 5–7.

260. U.S. Navy, "The Carriers"; University of Alabama Press, "From Torpedoes to Aviation: About the Book."

261. Stein, *From Torpedoes to Aviation*, 157–59.

262. Ibid., 160.

263. Ibid., 161.

264. Ibid., 160–62.

265. Miller, *U.S. Navy*, 176; National Air and Space Museum, "Eugene Ely."

266. Miller, *U.S. Navy*, 176.

267. "U.S. Congress House Committee on Naval Affairs, Sundry Legislation Affecting the Naval Establishment, 1929–1930, v. 2, p. 2191–2266," 2215, from Library of Congress, Washington Irving Chambers collection, container 20, Naval Aviation Progress, accessed March 28, 2017.

268. Hendrickson, "Naval Rivalry," Kindle location 5932; Naval Aviation Museum, "Closing of Pensacola Navy Yard"; Naval Aviation Museum, "Naval Aviation Arrives in Pensacola"; Naval Aviation Museum, "Naval Aviation at Greenbury Point."

269. Stein, *From Torpedoes to Aviation*, 185–94.

270. MyBaseGuide, "NAS Pensacola History."

271. Commander, Naval Installation Command, "Naval Air Station Key West: History."

272. Gannon, *Florida*, 74.

273. Florida Center for Instructional Technology, "Florida During World War II."

274. Piehler, in discussion with coauthor; Chapman, in discussion with coauthor.

275. Coles, "Keep the Home Fires Burning."

276. Piehler, in discussion with coauthor; Florida Memory Blog, "Preparing for D-Day."

277. University of South Florida College of Education Florida Center for Instructional Technology, "Florida During World War II."

278. Piehler, in discussion with coauthor.
279. Ibid.
280. National Park Service, "Florida in World War II," 1.
281. Ibid., 2.
282. Enterprise Florida, "Florida—The Future Is Here."
283. Department of Defense, Base Structure Report—2015 Baseline, 19–28.
284. Roberts, "Statewide Impact of Florida's Military Economy."
285. Florida's Military Profile (Tallahassee: Enterprise Florida, 2013), 2.
286. Ammerman, in discussion with coauthor.
287. *Florida's Military Profile*, 2.
288. Kiersz, "Here's How Much Land Military Bases Take Up in Each State."
289. Bender, Kiersz and Rosen, "Some States Have Much Higher Enlistment Rates than Others."

Number 10

290. Burnett, *Florida's Past*, 18.
291. Akin, "Cleveland Connection," 57.
292. Campbell, "Julia Tuttle."
293. Martin, *Florida's Flagler*, 152.
294. Campbell, "Julia Tuttle."
295. Martin, *Florida's Flagler*, 153.
296. Bramson, *Miami: The Magic City*, 7.
297. Allman, *Finding* Florida, 320.
298. Nijman, *Miami: Mistress of America*, 11; Burnett, *Florida's Past*, Kindle location 481–90.
299. Miami-Dade County, "About Miami-Dade County History."
300. Carson, "Recollections of a Chaplain."
301. Burnett, *Florida's Past*, 17.
302. Diaz, "Last Will."

Number 11

303. Foster, *Castles in the Sand*, 3.
304. Weingroff, "Lincoln Highway."
305. Harner, *Florida's Promoters*, 62.

306. Swift, *Big Roads*, 34.
307. Harner, *Florida's Promoters*, 63; Swift, *Big Roads*, 81.
308. Swift, *Big Roads*, 81.
309. Florida Memory Blog, "Welcome to Florida, Mr. President!"
310. Swift, *Big Roads*, 44.
311. Florida Memory Blog, "Dixie Highway Comes to Florida."
312. Sharp, "Dixie Highway Association."
313. State Library & Archives of Florida, "Map of the Dixie Highway System."
314. Marshall, "We Take a Look Back at the Road that Created Florida."
315. Rogers, "Fortune and Misfortune," 290.
316. Foster, *Castles in the Sand*, 177.
317. Grunwald, *The Swamp*, 177.
318. Drye, *For Sale—American Paradise*, Kindle location 2373.
319. Ibid., Kindle locations 2373–85.
320. Swift, *Big Roads*, 44–45; Weingroff, "Lincoln Highway."
321. Klein, "Epic Road Trip."
322. Carl Fisher letter, cited in Weingroff, "Lincoln Highway."
323. VisitJacksonville.com, "Fast Facts."

Number 12

324. McPhee, *Oranges*, 90.
325. Indian River Citrus League, "History."
326. Palmer, "Like a Day Without Sunshine."
327. Ibid.
328. Indian River Citrus League, "History."
329. Ibid.
330. Indian River Citrus League, e-mail message to coauthor, February 1, 2017.
331. Bournique, in discussion with coauthor.
332. Indian River Citrus League, e-mail message to coauthor, February 1, 2017.
333. Meyer, "Edmund Hall Hart"; U.S. Department of Agriculture National Agriculture Statistics Service, "2015 State Agriculture Overview: Florida."
334. Helm, "Claude Everett Street."
335. University of Florida Citrus Research and Education Center, "Brief History of Frozen Concentrate."

336. Helm, "Lee Bronson Skinner."
337. Narvaez, "Ben Hill Griffin Jr., 79, Is Dead."
338. Thomas, "Jack Berry, Florida Citrus Baron, Dies at 81."
339. U.S. Department of Agriculture Foreign Agricultural Service, "Citrus: World Markets and Trade," 1; Florida Department of Agriculture and Consumer Services, "Florida Citrus Statistics 2014–2015," 51.
340. U.S. Department of Agriculture National Agriculture Statistics Service, "2015 State Agriculture Overview: Florida."
341. Florida Department of Agriculture and Consumer Services, "Florida Citrus Statistics 2014–2015," 10.
342. *Florida Trend* news release, "USDA Announces Additional Support for Florida Citrus Growers."

Number 13

343. Teitel, "Project Hermes."
344. NASA Public Affairs, "Origins."
345. Ibid.
346. Faherty, *Florida's Space Coast*, 12, 22–23.
347. Ibid., 12.
348. NASA Public Affairs, "Origins."
349. Feinberg, e-mail message to coauthor.
350. Benson and Faherty, "Recommending a Launch Site."
351. Feinberg, e-mail message to coauthor.
352. Benson and Faherty, "Questions Begin."
353. Faherty, *Florida's Space Coast*, 23–27.
354. NASA Public Affairs, "Origins."
355. Granath, "Vehicle Assembly Building Prepared."
356. Herridge, "NASA's Giant Crawlers Turn 50 Years Old."
357. *Encyclopaedia Britannica*, "Apollo Space Program."
358. Kennedy Space Center, "History of Kennedy Space Center Visitor Complex."
359. NASA, "Kennedy Space Center's Annual Report FY 2014," 42.
360. U.S. Fish & Wildlife Service Merritt Island National Wildlife Refuge, "About the Refuge"; U.S. Fish & Wildlife Service Merritt Island National Wildlife Refuge, "Wildlife & Habitat."
361. U.S. Fish & Wildlife Service Merritt Island National Wildlife Refuge, "Wildlife & Habitat."

362. Walters, in discussion with coauthor.

363. Ibid.

364. Mormino and Arsenault, foreword to *Florida's Space Coast*, xiv.

365. Forstall, *Population of States*, 30.

366. Patterson, "Countdown to College."

367. *U.S. News & World Report*, "University of Central Florida"; Friedman, "10 Universities with the Most Undergraduate Students."

368. U.S. News & World Report, "Florida Institute of Technology."

369. Enterprise Florida, "Aviation & Aerospace," 4.

370. Space Florida, "Florida's Commercial Spaceport Network"; Green, "Space Florida Presses Ahead with Plans for Shiloh Spaceport"; O'Neil, "Can the Commercial Space Industry and National Parks Get Along?"

371. Walters, in discussion with coauthor.

Number 14

372. U.S. Census Bureau, "20 Fastest-Growing Metro Areas."

373. State Library & Archives of Florida, "How Collier County Got its Name."

374. Harner, *Florida's Promoters*, 57–58.

375. Gable, in discussion with coauthor.

376. Proverbs, "We Built That: The Lost Fight for Florida's Cross State Highway," 333, figure 4.

377. Ibid., 334, figure 5.

378. Ibid., 344–45.

379. Everglades Foundation, "Projects: Tamiami Trail."

380. Collier County Museum exhibit, "Trail Builders"; Davis, *Tamiami Trail*, 2.

381. Davis, *Tamiami Trail*, 2.

382. Ibid.

383. Harner, *Florida's Promoters*, 58.

384. Ibid., 57–59.

385. Gable, in discussion with coauthor.

386. Ibid.

387. U.S. Census Bureau, "20 Fastest-Growing Metro Areas."

388. U.S. Census Bureau, "Annual Estimates of the Resident Population."

389. Moody's Analytics report cited in Badenhausen, "10 Best Cities for Future Job Growth."

390. Davidson-Peterson Associates, "2015 Annual Visitor Profile and Occupancy Analysis."

391. Lee County Visitor and Convention Bureau, "Value of Tourism: Tourism Is the Backbone of Our Economy."

392. Gallup-Healthways Well-Being Index, "Well-Being of 190 Communities Nationwide Compared in New Report from Gallup-Healthways."

393. Mohl and Mormino, "Big Change in the Sunshine State," 431.

394. Seminole Tribe of Florida, "Survival in the Swamp."

395. State Library & Archives of Florida, "Florida Seminoles: Timeline."

396. Gable, in discussion with coauthor.

Number 15

397. Davis, "Up from the Sawgrass," 147–65.

398. Ibid., 155.

399. National Park Service, "Everglades National Park Florida."

400. Douglas with Rothchild, *Marjory Stoneman Douglas*, 191.

401. Grunwald, *The Swamp*, 203.

402. DiBiase, in discussion with coauthor.

403. Douglas, *The Everglades*, 349.

404. Douglas with Rothchild, *Marjory Stoneman Douglas*, 194.

405. Davis, "Up from the Sawgrass," 164.

406. Grunwald, *The Swamp*, 257–58.

407. DiBiase, in discussion with coauthor.

408. National Park Service, Big Cypress National Preserve, "Timeline."

409. Davis, "Up from the Sawgrass," 164–65.

410. National Park Service, Big Cypress National Preserve, "Timeline"; National Park Service, "East Everglades Expansion Area"; Govtrack.US, "H.R. 1727 (101st)"; Stern, *Everglades Restoration*.

411. National Park Service, "Everglades National Park Florida, Wilderness 101."

412. DiBiase, in discussion with coauthor.

413. Salisbury, "Everglades Area Farmers Exceed Phosphorous Reduction Requirements."

414. Staletovich, "What Do You Give the Everglades for Earth Day?"; Kimball, "Tamiami Trail Modifications."

415. Mather Economics, "Summary."

416. National Park Service, "National Park Service Visitor Use Statistics—Everglades NP."

417. National Park Service, "Inventory of Threatened and Endangered Species."
418. Handwerk, "U.S. Crocodiles Shed 'Endangered' Status."
419. SevenNaturalWonders.org, "Seven Natural Wonders of North America."

Number 16

420. Jones, "African-American Experience in Twentieth Century Florida," 384.
421. Ibid.
422. State Library & Archives of Florida, "Mary McLeod Bethune."
423. McCluskey and Smith, *Mary McLeod Bethune*, 47.
424. Ibid., 53–54, 68.
425. Edwards, *Women in American Education*, 118.
426. Robertson, *Mary McLeod Bethune in Florida*, Kindle location 169.
427. State Library & Archives of Florida, "Daytona Normal and Industrial Institute Doing Laundry."
428. Edwards, *Women in American Education*, 119.
429. Bethune-Cookman University, "History."
430. Robertson, *Mary McLeod Bethune in Florida*, Kindle location 383; Schulman, "Bethune Set the Stage to Break Baseball's Color Barrier"; Jones, "Florida's African American Female Activists," 272.
431. Schulman, "Bethune Set the Stage to Break Baseball's Color Barrier"; Wyatt, "Bethune Helped Clear Path for Jackie Robinson."
432. Schulman, "Bethune Set the Stage to Break Baseball's Color Barrier."
433. Robertson, *Mary McLeod Bethune in Florida*, Kindle location 358.
434. Ibid.
435. Jones, "Florida's African American Female Activists," 272–73.
436. Edwards, *Women in American Education*, 119.
437. National Park Service, "Bethune Résumé."
438. Edwards, *Women in American Education*, 119–20.
439. Bethune-Cookman University, "History: Our Founder—Dr. Bethune."
440. Bethune-Cookman University, "Fall 2016 Institutional Profile—Preliminary."
441. Jones, "African-American Experience in Twentieth Century Florida," 384–85.
442. Lempel, "Toms and Bombs," 87.

443. Ibid., 87–99.
444. Ibid., 104.

Number 17

445. Bickel, "LeRoy Collins."
446. FloridaGovernorsMansion.com, "Thomas LeRoy Collins."
447. LeRoy Collins Leon County Public Library, "Governor LeRoy Collins."
448. Colburn, "Florida Politics in the Twentieth Century," 363.
449. Florida Legislature and Gov. LeRoy Collins, "Interposition Resolution."
450. Smiley, "Miami Teachers, Students, Parents Remember"; Southern Regional Council, "Background Report on School Desegregation."
451. Florida Memory Blog, "Virgil Hawkins."
452. Brotemarkle, "Florida Frontiers Radio Program #241."
453. Colburn, "Florida's Legacy of Misdirected Reapportionment."
454. Ibid.
455. Huse, in discussion with coauthor.
456. Ibid.; Berman, "How a Little-Known Government Agency Kept the Peace in Selma."
457. Colburn, "Florida Politics in the Twentieth Century," 363.
458. Jones, "African-American Experience in Twentieth Century Florida," 389.
459. Huse, in discussion with coauthor.
460. Dyckman, *Floridian of His Century*, Kindle location 4972.
461. Gannon, *Florida*, 130.

Number 18

462. Leonard, in discussion with coauthor.
463. Allman, *Finding Florida*, 41.
464. National Park Service, Fort Matanzas National Monument, "Massacre of the French."
465. Leonard, in discussion with coauthor.
466. Coker and Shofner, "St. Augustine and La Florida," 1–14.
467. Ibid., 9-10.
468. State Library & Archives of Florida, "Timeline."

Numbers 19 and 20

469. Brookhiser, *America's First Dynasty*, 88.
470. Howe, *What Hath God Wrought*, 98.
471. Cusick, in discussion with coauthor.
472. Howe, *What Hath God Wrought*, 98.
473. Unger, *John Quincy Adams*, 202, Kindle location 3214.
474. Ibid., 203, Kindle location 3231.
475. Cusick, in discussion with coauthor.
476. Unger, *John Quincy Adams*, 203, Kindle location 3231.
477. Howe, *What Hath God Wrought*, 107.

Number 21

478. Business Research & Economic Advisors, "Contribution of the International Cruise Industry," 45.
479. All Things Cruise, "Cruise Departure Ports."
480. Statistics from Cruise Industry News, cited in the *Telegraph*, "15 Cities with the Most Cruise Tourists."
481. Garin, *Devils on the Deep Blue Sea*, 23.
482. University of Alaska Fairbanks, Slideshow.
483. Ibid., 5–6, slide labeled 18–19.
484. Dickinson and Vladimir, *Selling the Sea*, 24.
485. Blum, "From Transportation to Destination."
486. Saltzman, "Royal Caribbean Cruise Line History."
487. Blum, "From Transportation to Destination."
488. University of Alaska Fairbanks, Slideshow, 7, slide labeled 20.
489. Cartledge, "Cruise Packages," 146.
490. University of Alaska Fairbanks, Slideshow.
491. Cartledge, "Cruise Packages," 146.
492. Garin, *Devils on the Deep Blue Sea*, 88.
493. Blum, "From Transportation to Destination."
494. Cartledge, "Cruise Packages," 146.
495. Blum, "From Transportation to Destination."
496. Stieghorst, "Smooth Sailing Carnival."
497. Ibid.
498. Garin, *Devils on the Deep Blue Sea*, 145–46.
499. Krantz and Sloan, "Norwegian Cruise Line IPO Soars 31%."

500. Garin, *Devils on the Deep Blue Sea*, 145–47.
501. Carnival Corporation, "Corporate Timeline."
502. Garin, *Devils on the Deep Blue Sea*, 158–79.
503. Cruisemarketwatch.com, "Market Share."
504. Cruise Lines International Association, Inc., "2017 Cruise Industry Outlook."
505. *Cruise Critic*, "Biggest Cruise Ships in the World."
506. Garin, *Devils on the Deep Blue Sea*, 28–31.
507. Cepero, "PortMiami Sets Global Passenger Record."

Number 22

508. Huizenga, Oral History Interviews with Julian Pleasants, 1–2.
509. DeGeorge, *Making of a Blockbuster*, 2–14.
510. Huizenga, Oral History Interviews with Julian Pleasants, 3.
511. Ibid.
512. DeGeorge, *Making of a Blockbuster*, 25.
513. Ibid., 29–30.
514. Ibid., 35.
515. Isikoff, "War Over Waste."
516. Sandomir, "Entrepreneurs: Wayne Huizenga's Growth Complex."
517. Wilson, "Waste Management Inc."
518. Sandomir, "Entrepreneurs: Wayne Huizenga's Growth Complex."
519. DeGeorge, *Making of a Blockbuster*, 16.
520. Sandomir, "Entrepreneurs: Wayne Huizenga's Growth Complex."
521. Nova Southeastern University, "Huizenga on Acquiring Blockbuster."
522. Jacobs, "Blockbuster Growth."
523. DeGeorge, *Making of a Blockbuster*, 126.
524. Martin, Wayne Huizenga interview.
525. Seal, *Wayne*, 204.
526. DeGeorge, *Making of a Blockbuster*, 108.
527. From an unspecified *Florida Trend* article, quoted in Seal, *Wayne*, 78.
528. Huizenga, Oral History Interviews with Julian Pleasants, 37.
529. *Forbes*, "Profile: H. Wayne Huizenga."
530. Huizenga, Oral History Interviews with Julian Pleasants, 53.
531. Ibid.; Wilson, "AutoNation Revives Its Used-Only Stores."
532. AutoNation, "John Elway AutoNation USA Introduced"; AutoNation, "AutoNation Direct Earns WomenCertified® Seal."

533. AutoNation, "2016 AutoNation Annual Report," 1; *Automotive News*, "Top 150 Dealership Groups Based in the U.S."
534. AutoNation, "2016 AutoNation Annual Report," 4.
535. AutoNation, "Biography: H. Wayne Huizenga, Founder."
536. AutoNation, "2016 AutoNation Annual Report," 8–21; *Florida Trend*, "Florida's 350 Biggest Companies 2017."
537. Wilson, "AutoNation Revives Its Used-Only Stores."
538. Sandomir, "Entrepreneurs: Wayne Huizenga's Growth Complex."
539. Automotive Hall of Fame, "H. Wayne Huizenga: Inducted 2006."
540. Nova Southeastern University, "H. Wayne Huizenga."
541. DeGeorge, *Making of a Blockbuster*, 31.
542. Seiler, in discussion with coauthor.

Number 23

543. Publix Super Markets, "Awards & Achievements."
544. Figures from *The Shelby Report*, cited by Jackson, in discussion with coauthor.
545. Jackson, in discussion with coauthor.
546. *Supermarket News*, "2016 Top 75 U.S. & Canadian Food Retailers."
547. *Forbes*, "America's Richest Families: Jenkins Family."
548. Watters, excerpt of "The Publix Story: George Jenkins's 50 Years of Pleasure."
549. Publix Super Markets, "History."
550. Gwynn, "Quick History of the Supermarket."
551. *New York Times*, "George Jenkins, 88, Founder of $9 Billion Grocery Chain."
552. Holland, "Publix Supermarkets Are Coming to Virginia."
553. Publix Super Markets, "Facts & Figures."
554. West, e-mail message to coauthor, August 25, 2016.
555. West, e-mail message to coauthor, August 22, 2016.
556. Griffin, "Publix No. 1 on List of Florida's Most Valuable Brands"; Brand Finance, "US 500 2016: The Most Valuable US Brands of 2016."
557. Brand Finance, "US 500 2016: The Most Valuable US Brands of 2016."
558. Publix Super Markets, "Facts & Figures."
559. Jackson, in discussion with coauthor.
560. Smith, "George W. Jenkins."
561. West, e-mail message to coauthor, August 22, 2016.

Number 24

562. U.S. Census Bureau, "Table 5."
563. Long, "Key West and the New Deal," 210.
564. Hambright, in discussion with coauthor.
565. Ibid.
566. Scandura, *Down in the Dumps*, 72–74.
567. Boulard, "State of Emergency," 167.
568. Stone, "Key West Is to Be Restored by Free Labor."
569. Hambright, in discussion with coauthor.
570. Scandura, *Down in the Dumps*, 72.
571. Long, "Key West and the New Deal," 215.
572. Carlisle and Carlisle, *Key West in History*, 86.
573. Ibid., 87.
574. Ogle, *Key West*, 176.
575. Ibid., 181.
576. Hambright, in discussion with coauthor.
577. McIver, "The Kingfish of Key West."
578. *Fodors*, "Where Do Travelers Want to Go in 2015?"
579. Kirkman, "Key West: America's Hottest New Luxury Destination for 2015."
580. Grout, "Rich Literary Heritage Draws Writers to Key West."
581. FloridaKeys.com, "Famous Key West Artists & Painters."

Number 25

582. Wickman, *Warriors without War*, 63, Kindle location 1456.
583. Ibid., 75, Kindle location 1722.
584. Cattelino, *High Stakes*, 15.
585. Klas, "Timeline of Gambling in Florida."
586. Wickman, *Warriors without War*, 117, Kindle location 2672.
587. Ibid., 118, Kindle location 2698.
588. Capriccioso, "Legal Distinction Between Class II and III Gaming Causes Innovation, Anguish."
589. State Library & Archives of Florida, "Florida Seminoles"; Gillin, "New Gaming Compact Offers Florida Biggest Guaranteed Share."
590. Wickman, *Warriors without War*, 82–88, Kindle location 1873–999.
591. Frank, in discussion with coauthor.

592. Gensler, "Alligator Wrestler."
593. Herrera, "How the Seminole Tribe Came to Rock."
594. Ducassi, "Unredacted Deposition Reveals $2.2B."
595. Gensler, "Alligator Wrestler."
596. Seminole Tribe of Florida, "Who Are the Seminole People?"
597. Seminole Tribe of Florida, "Tourism/Enterprises."
598. Herrera, "The State of the Seminole Tribe's Compact."
599. Klas, "Florida Hits $340 Million Jackpot by Settling Gambling Dispute with Seminole Tribe."
600. Sortal, "Marcellus Osceola Wins Election."
601. Wickman, *Warriors without War*, 1–3.
602. Frank, in discussion with coauthor.

Conclusion

603. Brown, *How Money Walks*, Kindle location 170–91.
604. Ibid., Kindle location 241.
605. Enterprise Florida, "International Business Facts about Florida."
606. Walczak, Drenkard and Henchman, "2017 State Business Tax Climate Index."
607. U.S. Bureau of Commerce, Bureau of Economic Analysis, "Gross Domestic Product by State"; World Bank, "Gross Domestic Product 2016."
608. World Bank, "Gross Domestic Product 2016"; Pounds, "Florida Could Be Heading toward $1 Trillion Economy."
609. National Association of Realtors, "Profile of International Activity in U.S. Residential Real Estate."
610. U.S. Census Bureau, "Florida Passes New York to Become the Nation's Third Most Populous State."

BIBLIOGRAPHY

A+E Networks. "How Florida Got Its Shape." History.com video, 2:18, March 28, 2016. www.history.com/topics/us-states/florida/videos/how-florida-got-its-shape.

AARoads. "Interstate 4." InterstateGuide.com, July 7, 2015. Accessed September 25, 2015. www.interstate-guide.com/i-004.html.

———. "Interstate 75." InterstateGuide.com, February 1, 2016. Accessed March 14, 2016. www.interstate-guide.com/i-075.html.

———. "Interstate 95." InterstateGuide.com, January 25, 2016. Accessed March 14, 2016. www.interstate-guide.com/i-095.html.

Abouhalkah, Yael T. "New Population Figures Reveal Omaha Is Catching Kansas City Plus Other Distressing Facts." *Kansas City Star*, July 13, 2015. Accessed March 28, 2016. www.kansascity.com/opinion/opn-columns-blogs/yael-t-abouhalkah/article27165205.html.

Abraham, David (professor, University of Miami School of Law), in discussion with coauthor, October 2015.

Akin, Edward N. "The Cleveland Connection: Revelations from the John D. Rockefeller–Julia D. Tuttle Correspondence." Tequesta (1982), 57. Accessed July 1, 2016. digitalcollections.fiu.edu/tequesta/files/1982/82_1_03.pdf.

Allman, T.D. *Finding Florida: The True History of the Sunshine State*. New York: Grove Press, 2013.

All Things Cruise. "Cruise Departure Ports." Accessed February 3, 2017. allthingscruise.com/cruise-research/cruise-departure-ports.

Altman, Howard. "Report: MacDill's Economic Impact Jumps in Tampa Area." *Tampa Tribune*, October 14, 2015. Accessed February 23, 3017. www.tbo.com/list/military-news/report-details-macdills-impact-on-tampa-economy-20151014.

Ammerman, Mark (lieutenant, helicopter pilot, U.S. Navy), in discussion with coauthor, April 2016.

Amnesty International. "Cuba: Human Rights at a Glance." Amnesty.org, September 17, 2015. Accessed March 28, 2016. www.amnesty.org/en/latest/news/2015/09/cuba-human-rights-at-a-glance.

Automotive Hall of Fame. "H. Wayne Huizenga: Inducted 2006." www.automotivehalloffame.org/honoree/h-wayne-huizenga.

Automotive News. "Top 150 Dealership Groups Based in the U.S." March 27, 2017, 5. Accessed August 23, 2017. www.autonews.com/assets/PDF/CA109608327.PDF.

AutoNation. "AutoNation Direct Earns WomenCertified® Seal, Launches Car Buying Her Way." News release, March 17, 2009. investors.autonation.com/phoenix.zhtml?c=85803&p=irol-newsArticle&ID=1267014.

———. "Biography: H. Wayne Huizenga, Founder." Accessed October 3, 2016. investors.autonation.com/phoenix.zhtml?c=85803&p=irol-govBio&ID=216323.

———. "John Elway AutoNation USA Introduced by Advertising Featuring John Elway and the 'Guys in Plaid.'" News release, December 24, 1999. investors.autonation.com/phoenix.zhtml?c=85803&p=irol-newsArticle&ID=100290.

———. "2016 AutoNation Annual Report," 1. Accessed August 23, 2017. investors.autonation.com/phoenix.zhtml?c=85803&p=irol-reportsannual.

Bacardi Limited. "The Early Years." Accessed October 14, 2016. www.bacardilimited.com/our-heritage/the-early-years.

Badenhausen, Kurt. "The 10 Best Cities for Future Job Growth." *Forbes*, October 19, 2016. Accessed December 12, 2016. www.forbes.com/sites/kurtbadenhausen/2016/10/19/the-10-best-cities-for-future-job-growth.

Barringer, Felicity. "White Roofs Catch on As Energy Cost Cutters." *New York Times*, July 29, 2009. Accessed March 1, 2017. www.nytimes.com/2009/07/30/science/earth/30degrees.html?_r=0.

BBC News. "Cuba Profile—Timeline." BBC.com, July 22, 2015. Accessed October 25, 2015. www.bbc.com/news/world-latin-america-19576144.

Beavers, Casey. "An Overview of Phosphate Mining and Reclamation in Florida." Accessed December 30, 2015. soils.ifas.ufl.edu/docs/pdf/academic/papers/beavers_casey_no_embargo.pdf, 5.

Bender, Jeremy, Andy Kiersz and Armin Rosen. "Some States Have Much Higher Enlistment Rates than Others." *Business Insider*, July 20, 2014. Accessed March 19, 2016. www.businessinsider.com/us-military-is-not-representative-of-country-2014-7.

Benson, Charles D., and William Barnaby Faherty. "The Questions Begin." In *Moonport: A History of Apollo Launch Facilities and Operations* (NASA, 1978). Accessed July 12, 2017. www.hq.nasa.gov/office/pao/History/SP-4204/ch5-5.html.

———. "Recommending a Launch Site." In *Moonport: A History of Apollo Launch Facilities and Operations* (NASA, 1978). Accessed July 12, 2017. www.hq.nasa.gov/office/pao/History/SP-4204/ch5-4.html.

Berman, Eliza. "How a Little-Known Government Agency Kept the Peace in Selma." *Time*, March 25, 2015. Accessed June 21, 2017. time.com/3733726/leroy-collins-selma.

Bethune-Cookman University. "Fall 2016 Institutional Profile— Preliminary." Accessed January 11, 2017. www.cookman.edu/academics/IE/research/Institutional%20Profile%20Fall%202016%20-%20Preliminary.pdf.

———. "History." Accessed January 5, 2017. www.cookman.edu/about_BCU/history/index.html.

———. "History: Our Founder—Dr. Bethune." Accessed January 5, 2017. www.cookman.edu/about_BCU/history/our_founder.html.

Bickel, Robert, ed. "LeRoy Collins: A Florida Governor's Role in the Civil Rights Movement." Stetson University College of Law. Accessed January 12, 2017. www.stetson.edu/law/faculty/bickel/civilrights/media/Floridas%20Governor.pdf.

Biography.com editors. "Fidel Castro—Mini Biography." Biography.com video, 4:22, March 28, 2016. www.biography.com/people/fidel-castro-9241487/videos/fidel-castro-mini-biography-2079117496.

Blum, Ernest. "From Transportation to Destination." *Travel Weekly*, March 26, 1998. Accessed February 8, 2017. www.travelweekly.com/Cruise-Travel/From-Transportation-to-Destination.

Borucki, Wes (associate professor of history, Palm Beach Atlantic University), in discussion with coauthor, September 2015.

Boulard, Garry. "State of Emergency: Key West in the Great Depression." *Florida Historical Quarterly* 67, no. 2 (1988). Accessed October 12, 2016. www.jstor.org/stable/30147949?seq=1#page_scan_tab_contents.

Bournique, Doug (executive vice president, Indian River Citrus League), in discussion with coauthor, January 2017.

Bramson, Seth H. *Miami: The Magic City.* Mount Pleasant, SC: Arcadia Publishing, 2007.

Brand Finance. "US 500 2016: The Most Valuable US Brands of 2016." Table. Accessed August 3, 2016. brandirectory.com/league_tables/table/us-500-2016.

Brookhiser, Richard. *America's First Dynasty: The Adamses, 1735–1918.* New York: The Free Press, 2002.

Brotemarkle, Ben, prod. "Florida Frontiers Radio Program #241." Florida Historical Society 28, no. 59. Accessed January 21, 2017. myfloridahistory.org/frontiers/radio/program/241.

———. "Historic Ybor City." *Florida Today,* January 27, 2015. Accessed via the Florida Historical Society, December 18, 2015. myfloridahistory.org/frontiers/article/53.

Brown, Travis H. *How Money Walks: How $2 Trillion Moved Between the States, and Why It Matters.* Stevens Point, WI: Worzalla, 2013. Kindle edition.

Bureau of the Census Library. Introduction to *Census of Housing: 1950, Volume I: General Characteristics, Part 2: Alabama-Georgia.* Washington, D.C.: United States Government Printing Office, 1953), xix–xx. Accessed December 14, 2015. www.census.gov/prod/www/decennial.html.

Burnett, Gene. *Florida's Past.* Vol. 1: *People and Events that Shaped the State.* Sarasota, FL: Pineapple Press, 1986, 2011. Kindle edition, Kindle location 672.

Business Research & Economic Advisors. "The Contribution of the International Cruise Industry to the U.S. Economy in 2014." September 2015, 45. Accessed August 18, 2017. cruising.org/docs/default-source/market-research/us-economic-impact-study-2014.pdf.

Butts, Ellen R., and Joyce R. Schwartz. *Fidel Castro.* A&E Biography. Minneapolis: Lerner Publications Company, 2005.

Campbell, Janie. "Julia Tuttle, the 'Mother of Miami,' Was One Awesome Lady." *Huffington Post,* May 12, 2013. Accessed April 20, 2016. www.huffingtonpost.com/2013/05/12/julia-tuttle-miami-mother-of-miami_n_3262488.html.

Capriccioso, Rob. "Legal Distinction Between Class II and III Gaming Causes Innovation, Anguish." *Indian Country Today Media Network,* October 4, 2011. Accessed December 9, 2016. indiancountrytodaymedianetwork.com/2011/10/04/legal-distinction-between-class-ii-and-iii-gaming-causes-innovation-anguish-55045.

Carlisle, Rodney, and Loretta Carlisle. *Key West in History: A Guide to More than 50 Sites in Historical Context.* Sarasota, FL: Pineapple Press, 2015.

Carnival Corporation. "Corporate Timeline." Accessed February 10, 2017. phx.corporate-ir.net/phoenix.zhtml?c=200767&p=irol-corporatetimeline.

Carson, H.R. "Recollections of a Chaplain in the Volunteer Army." January 25, 1899, in "The Second Louisiana Volunteer Infantry in Miami," Florida Memory. Accessed February 25, 2017. www.floridamemory.com/onlineclassroom/spanish-american-war/documents/carson.

Cartledge, Grenville. "Cruise Packages." In *The Business and Management of Ocean Cruises*, edited by Michael Vogel, Alexis Papathanassis and Ben Wolber. Oxfordshire, UK: CAB International, 2012.

Cassanello, Robert, prod. *Episode 38: Citrus Industry (A History of Central Florida Series)*. Podcast documentary, Regional Initiative for Collecting the History, Experiences and Stories of Central Florida, YouTube Video Clip, March 2, 2015. Accessed January 19, 2016. www.youtube.com/watch?v=VJEJ_Tz4ZO0.

Cattelino, Jessica R. *High Stakes: Florida Seminole Gaming and Sovereignty.* Durham, NC: Duke University Press, 2008, 15. Accessed via Google Play.

Center for Land Use Interpretation. "Refrigerated Nation." *Lay of the Land Newsletter* (Winter 2014). Accessed March 16, 2016. clui.org/newsletter/winter-2014/refrigerated-nation.

Centers for Disease Control and Prevention. "The History of Malaria, an Ancient Disease." March 11, 2016. Accessed March 29, 2016. www.cdc.gov/malaria/about/history.

Cepero, Camila. "PortMiami Sets Global Passenger Record." *Miami News Today*, February 7, 2017. Accessed February 13, 2017. www.miamitodaynews.com/2017/02/07/portmiami-sets-global-passenger-record.

Chapel, George L. "Dr. John Gorrie: Refrigeration Pioneer." Department of Physics, College of Liberal Arts and Sciences, University of Florida. Accessed January 10, 2016. www.phys.ufl.edu/~ihas/gorrie/fridge.htm.

Chapman, Roger (associate professor of history, Palm Beach Atlantic University), in discussion with coauthor, March 2016.

Chicago Tribune. "Blockbuster Merger with Viacom Okd." September 30, 1994. Accessed August 24, 2017. articles.chicagotribune.com/1994-09-30/business/9409300267_1_blockbuster-stockholders-package-of-viacom-shares-blockbuster-chairman-wayne-huizenga.

Clark, James C. (lecturer, University of Central Florida history department), in discussion with the coauthor, September 2015.

Clement, Gail. "Everglades Biographies: Napoleon Bonaparte Broward." Reclaiming the Everglades: South Florida's Natural History, 1884 to

1934, Everglades Information Network & Digital Library at Florida International University Libraries. Accessed December 6, 2015. everglades.fiu.edu/reclaim/bios/broward.htm.

————. "Everglades Timeline: Depression, the New Deal & the War Years in the Everglades." Reclaiming the Everglades: South Florida's Natural History, 1884 to 1934, Everglades Information Network & Digital Library at Florida International University Libraries. Accessed December 8, 2015. everglades.fiu.edu/reclaim/timeline/timeline8.htm.

————. "Everglades Timeline: Everglades Drainage in Earnest (1900–1919)." Reclaiming the Everglades: South Florida's Natural History, 1884 to 1934, Everglades Information Network & Digital Library at Florida International University Libraries. Accessed December 6, 2015. everglades.fiu.edu/reclaim/timeline/timeline6.htm.

Coker, William S., and Jerrell H. Shofner. "St. Augustine and La Florida, 1600–1763." *Florida from the Beginning to 1992: A Columbus Jubilee Commemorative*. N.p.: Pioneer Publications, 1991. Accessed October 28, 2016, via University of Florida Digital Collections: Spanish Colonial St. Augustine, ufdc.ufl.edu/UF00025122/00005/9x.

Colburn, David R. "Florida Politics in the Twentieth Century." In *The New History of Florida*, edited by Michael Gannon. Gainesville: University Press of Florida, 1996.

————. "Florida's Legacy of Misdirected Reapportionment." *Ocala Star-Banner*, May 13, 2012. Accessed January 21, 2017. www.ocala.com/news/20120513/floridas-legacy-of-misdirected-reapportionment.

Coles, David J. "Keep the Home Fires Burning: Florida's World War II Experience." Florida's World War II Memorial website. Accessed February 21, 2016. www.museumoffloridahistory.com/exhibits/permanent/wwii/history.cfm.

Collier County Museum exhibit. "The Trail Builders." Accessed December 6, 2016.

Commander, Naval Installation Command. "Naval Air Station Key West: History." U.S. Navy. Accessed April 6, 2016. www.cnic.navy.mil/regions/cnrse/installations/nas_key_west/about/history.html.

Conradt, Stacy. "Why Walt Disney Built a Theme Park on Swampland." MentalFloss.com, 2011. Accessed September 25, 2015. mentalfloss.com/article/28174/why-walt-disney-built-theme-park-swampland.

Contagion: Historical Views of Diseases and Epidemics. "The Yellow Fever Epidemic in Philadelphia, 1793." Harvard University Library Open

Collections Program. Accessed November 4, 2015. ocp.hul.harvard.edu/contagion/yellowfever.html.

Cooper, Gail. *Air-Conditioning America: Engineers and the Controlled Environment, 1900–1960.* Baltimore: Johns Hopkins University Press, 1998, 8.

Cordoba, Hilton. "Little Havana: A Latin American Gateway." American Association of Geographers, October 1, 2013. Accessed October 23, 2015. www.aag.org/cs/news_detail?pressrelease.id=3074.

Cruise Critic. "The Biggest Cruise Ships in the World." Accessed February 11, 2017. www.cruisecritic.com/articles.cfm?ID=1431.

Cruise Lines International Association, Inc. "2017 Cruise Industry Outlook." December 2016, 12–22. Accessed February 11, 2017. www.cruising.org/about-the-industry/research/2017-state-of-the-industry.

Cruisemarketwatch.com. "Market Share: 2015 World Wide Market Share." Accessed February 11, 2017. www.cruisemarketwatch.com/market-share.

Cusick, James (curator, P.K. Yonge Library of Florida History at the University of Florida), in discussion with coauthor, November 2016.

———. "Spanish Florida." *Oxford Bibliographies*, October 28, 2011. Accessed October 2, 2017. www.oxfordbibliographies.com/view/document/obo-9780199766581/obo-9780199766581-0051.xml.

Davidson-Peterson Associates. "2015 Annual Visitor Profile and Occupancy Analysis." March 7, 2016. Accessed December 30, 2016. www.leevcb.com/media/1515/2015-visitor-profile-and-occupancy-analysis.pdf.

Davis, Doris. *The Tamiami Trail—Muck, Mosquitoes and Motorists: A Photo Essay.* Report held by the Collier County Museum Research Library. Accessed December 6, 2016, 2.

Davis, Jack E. (professor, Department of History, University of Florida College of Liberal Arts and Sciences), in discussion with coauthor, December 2015.

———. "Up from the Sawgrass: Marjory Stoneman Douglas." In *Making Waves: Female Activists in Twentieth-Century Florida*, edited by Jack E. Davis and Kari Frederickson. Gainesville: University Press of Florida, 2003.

DeGeorge, Gail. *The Making of a Blockbuster: How Wayne Huizenga Built a Sports and Entertainment Empire from Trash, Grit, and Videotape.* Hoboken, NJ: John Wiley & Sons, Inc., 1996.

Department of Defense, Base Structure Report—2015 Baseline: A Summary of the Real Property Inventory, Department of Defense, 19–28. Accessed April 7, 2016. www.acq.osd.mil/eie/Downloads/Reports/Base%20Structure%20Report%20FY15.pdf.

Diaz, Johnny. "Last Will: Digitized Documents Reveal What Famous Floridians Left Behind." *South Florida Sun-Sentinel*, October 12, 2015. Accessed August 4, 2016. www.sun-sentinel.com/features/fl-digital-wills-south-florida-residents-20151012-story.html.

DiBiase, Ben (director of educational resources, Florida Historical Society), in discussion with coauthor, September 2016, December 2015.

Dickinson, Bob, and Andy Vladimir. *Selling the Sea: An Inside Look at the Cruise Industry.* New York: John Riley & Sons, Inc., 1997.

Digital Scholarship Lab, University of Richmond. "Hamilton Disston: The Man Who Reshaped Florida." The History Engine. Accessed December 4, 2015. historyengine.richmond.edu/episodes/view/6142.

Dineen, Caitlin. "Florida Welcomed Nearly 113 Million Tourists in 2016." *Orlando Sentinel*, February 16, 2017. Accessed February 22, 2017. www.orlandosentinel.com/travel/os-bz-visit-florida-tourism-2016-story.html.

Douglas, Marjory Stoneman. *The Everglades: River of Grass.* Sarasota, FL: Pineapple Press, Inc., 1997.

Douglas, Marjory Stoneman, with John Rothchild. *Marjory Stoneman Douglas: Voice of the River.* Sarasota, FL: Pineapple Press, Inc., 1987.

Drye, Willie. *For Sale—American Paradise: How Our Nation Was Sold an Impossible Dream in Florida.* Guilford, CT: Lyons Press, 2015. Kindle edition.

Ducassi, Daniel. "Unredacted Deposition Reveals $2.2B in Seminole Gambling Revenue Last Year." *Politico*, May 13, 2016. Accessed December 7, 2016. www.politico.com/states/florida/story/2016/05/unredacted-deposition-reveals-22b-in-seminole-gambling-revenue-last-year-101710.

Dyckman, Martin A. *Floridian of His Century: The Courage of Governor LeRoy Collins.* Gainesville: University Press of Florida, 2006. Kindle edition.

Edwards, June. *Women in American Education, 1820–1955: The Female Force and Educational Reform.* Westport, CT: Greenwood Press, 2002.

Encyclopaedia Britannica. "Apollo Space Program." 2016. Accessed February 19, 2016. www.britannica.com/topic/Apollo-space-program.

Enterprise Florida. "Aviation & Aerospace." Accessed March 27, 2017. www.enterpriseflorida.com/wp-content/uploads/brief-aviation-aerospace-florida.pdf.

———. "Florida Defense Industry Had $79.8 Billion Impact in 2014 Despite Federal Government's Decline in Funding." News release, October 2, 2015. Accessed February 23, 2017. www.enterpriseflorida.com/news/florida-defense-industry-had-79-8-billion-impact-in-2014-despite-federal-governments-decline-in-funding.

———. "Florida—The Future Is Here: Defense/Homeland Security." 2015. Accessed April 7, 2016. www.enterpriseflorida.com/wp-content/uploads/brief-defense-homeland-security-florida.pdf.

———. "International Business Facts about Florida." Accessed September 27, 2017. www.enterpriseflorida.com/wp-content/uploads/International-Business-Facts-About-Florida.pdf.

Everglades Foundation. "Projects: Tamiami Trail." Accessed February 26, 2017. www.evergladesfoundation.org/what-we-do/projects/tamiami-trail.

Faherty, William Barnaby. *Florida's Space Coast: The Impact of NASA on the Sunshine State.* Gainesville: University Press of Florida, 2002.

Feinberg, Al (Kennedy Space Center Communications Office representative), e-mail message to coauthor, July 26, 2017.

Fisher, Carl. Letter, cited in "The Lincoln Highway," by Richard R. Weingroff. U.S. Department of Transportation Federal Highway Administration website, November 18, 2015. Accessed February 16, 2017. www.fhwa.dot.gov/infrastructure/lincoln.cfm.

Flagler College. "Hotel to College." Accessed September 14, 2015. www.flagler.edu/about-flagler/hotel-to-college.

Flagler Museum. "Henry Morrison Flagler Biography." Accessed September 11, 2015. www.flaglermuseum.us/history/flagler-biography.

Florida Center for Instructional Technology. "Florida During World War II." Exploring Florida: A Social Studies Resource for Students and Teachers, University of South Florida College of Education, 2002. Accessed February 21, 2016. fcit.usf.edu/florida/lessons/ww_ii/ww_ii1.htm.

Florida Coordinating Council on Mosquito Control. *Florida Mosquito Control 2009: The State of the Mission as Defined by Mosquito Controllers, Regulators and Environmental Managers.* C.R. Connelly and D.B. Carlson, eds. Vero Beach: University of Florida, Institute of Food and Agricultural Sciences, Florida Medical Entomology Laboratory, 2009.

Florida Department of Agriculture and Consumer Services. "Florida Agriculture Overview and Statistics." Accessed March 16, 2016. www.freshfromflorida.com/Divisions-Offices/Marketing-and-Development/Education/For-Researchers/Florida-Agriculture-Overview-and-Statistics.

———. "Florida Citrus Statistics 2014–2015." February 2016. Accessed February 1, 2017. www.nass.usda.gov/Statistics_by_State/Florida/Publications/Citrus/Citrus_Statistics/2014-15/fcs1415.pdf.

Florida Department of Environmental Protection. "Brief History of Lake Okeechobee." Accessed December 8, 2015. www.dep.state.fl.us/evergladesforever/about/lakeo_history.htm.

———. "Learn About Your Watershed: Everglades Watershed." Accessed December 7, 2015. www.protectingourwater.org/watersheds/map/everglades.

———. *Public Health Pest Control: Applicator Training Manual*, 1–2. Accessed September 15, 2017. freshfromflorida.s3.amazonaws.com/PublicHealthManual2011.pdf.

Florida Department of Health. "Episode #1: Origins." 125 Years of Florida Public Health: Historical Podcasts. FloridaHealth.gov, 5:37. soundcloud.com/floridahealth/floridahealth125-episode-1.

———. "Episode #4: Health Train." 125 Years of Florida Public Health: Historical Podcasts. FloridaHealth.gov, 5:03. www.floridahealth.gov/about-the-department-of-health/125-years-of-florida-public-health/historical-podcasts.html.

———. *State Health Officers*. Tallahassee: Florida Department of Health, n.d. Accessed November 14, 2015. www.floridahealth.gov/about-the-department-of-health/125-years-of-florida-public-health/_documents/125-state-health-officers.pdf.

Florida Department of State Division of Historical Resources. "Florida Historical Markers Programs—Marker: Hillsborough." Accessed February 28, 2017. apps.flheritage.com/markers/markers.cfm?ID=hillsborough.

FloridaGovernorsMansion.com. "Thomas LeRoy Collins." Accessed January 14, 2017. www.floridagovernorsmansion.com/the_people_s_house/former_residents/thomas_leroy_collins.

Florida Industrial and Phosphate Research Institute. "Discovery of Phosphate in Florida." Accessed December 30, 2015. www.fipr.state.fl.us/about-us/phosphate-primer/discovery-of-phosphate-in-florida.

———. "Phosphate Primer." Accessed February 23, 2017. www.fipr.state.fl.us/about-us/phosphate-primer/other-phosphate-deposits.

FloridaKeys.com, "Famous Key West Artists & Painters." Accessed February 26, 2017. www.floridakeys.com/keywest/keywestarts.htm.Florida Legislature and Governor LeRoy Collins. "Interposition Resolution in Response to *Brown v. Board of Education*, 1957." Florida Memory, State Library & Archives of Florida. Accessed June 22, 2017. www.floridamemory.com/exhibits/floridahighlights/collins.

Florida Memory Blog. "The Dixie Highway Comes to Florida." May 10, 2016. Accessed February 17, 2017. www.floridamemory.com/blog/2016/05/10/the-dixie-highway-comes-to-florida.

————. "The Dreaded Yellow Jack." March 22, 2015. www.floridamemory. com/blog/2015/05/22/the-dreaded-yellow-jack/#more-11817.

————. "How Collier County Got Its Name." March 30, 2015. Accessed December 11, 2016. www.floridamemory.com/blog/2015/03/30/how-collier-county-got-its-name.

————. "Land by the Gallon." www.floridamemory.com/blog/2015/05/29/ land-by-the-gallon/#more-11821.

————. "Mary McLeod Bethune." February 27, 2012. Accessed January 4, 2017. www.floridamemory.com/blog/2012/02/27/mary-mcleod-bethune.

————. "Preparing for D-Day: Camp Gordon Johnston Near Carrabelle." June 6, 2014. www.floridamemory.com/blog/2014/06/06/preparing-for-d-day-camp-gordon-johnston-near-carrabelle.

————. "The 'Shocking' Ponce de Leon Hotel." in January 21, 2015. www. floridamemory.com/blog/2015/01/21/the-shocking-ponce-de-leon-hotel.

————. "Virgil Hawkins and the Fight to Integrate the University of Florida Law School." June 25, 2014. Accessed January 23, 2017. www. floridamemory.com/blog/2014/06/25/virgil062514.

————. "Welcome to Florida, Mr. President!" January 28, 2015. Accessed February 17, 2017. www.floridamemory.com/blog/2015/01/28/ welcome-to-florida-mr-president.

Florida Mosquito Control Association. "History of the FMCA." Accessed November 15, 2015. floridamosquito.org/Mission/History.aspx.

Florida's Military Profile. Tallahassee: Enterprise Florida, 2013.

Florida's Turnpike. "Florida's Turnpike: Providing Transportation Alternatives for 55 Years!" 2005. Accessed September 27, 2015. www. floridasturnpike.com/about_history.cfm.

Florida Trend. "Florida's 350 Biggest Companies 2017: 125 Biggest Public Companies, Ranked by Revenue." June 28, 2017. Accessed August 23, 2017. www.floridatrend.com/article/22390/floridas-125-biggest-public-companies.

————. "USDA Announces Additional Support for Florida Citrus Growers Impacted by Greening." September 22, 2016. Accessed January 29, 2017. www.floridatrend.com/article/20723/usda-announces-additional-support-for-florida-citrus-growers-impacted-by-greening.

Fodors. "Where Do Travelers Want to Go in 2015?" February 2, 2015. Accessed October 13, 2016. www.fodors.com/news/where-do-travelers-want-to-go-in-2015-11157.

Fogelsong, Rick (professor of political science, Rollins College), in discussion with coauthor, September 2015.

Forbes. "America's Richest Families: Jenkins Family." Accessed August 22, 2016. www.forbes.com/profile/jenkins.

———. "The Best Places for Business and Careers: Miami, FL." Accessed December 2, 2015. www.forbes.com/places/fl/miami.

———. "The Best Places for Businesses and Careers—2016 Ranking: Tampa–St. Petersburg, FL." Accessed August 16, 2017. www.forbes.com/places/fl/tampa-st-petersburg.

———. "Profile: H. Wayne Huizenga." Accessed August 24, 2017. www.forbes.com/profile/h-wayne-huizenga.

Forstall, Richard L. *Population of States and Counties of the United States: 1790–1990.* Washington, D.C.:U.S. Bureau of the Census, 1996, 3.

Fort Lauderdale Historical Society. "Governor Broward and the Empire of the Everglades Exhibit." Accessed December 7, 2015. www.fortlauderdalehistoricalsociety.org/events/governor-broward-and-the-empire-of-the-everglades-exhibit.

Foster, Mark S. *Castles in the Sand: The Life and Times of Carl Graham Fisher.* Gainesville: University Press of Florida, 2000.

Frank, Andrew (associate professor of history, Florida State University), in discussion with coauthor, December 2016.

Friedman, Jordan. "10 Universities with the Most Undergraduate Students." *U.S. News & World Report*, September 22, 2016. Accessed March 27, 2017. www.usnews.com/education/best-colleges/the-short-list-college/articles/2016-09-22/10-universities-with-the-most-undergraduate-students.

Gable, Blake (chief executive officer, Barron Collier Companies), in discussion with coauthor, December 2016.

Gabler, Neal. *Walt Disney: The Triumph of the American Imagination.* New York: Random House, 2006.

Galloway, Devin, David R. Jones and S.E. Ingbritsen, eds. *Land Subsidence in the United States: U.S. Geological Survey Circular 1182.* Reston, VA: U.S. Department of the Interior, 1999.

Gallup-Healthways Well-Being Index. "Well-Being of 190 Communities Nationwide Compared in New Report from Gallup-Healthways." February 22, 2016. www.well-beingindex.com/2015-community-rankings.

Gannon, Michael. *Florida: A Short History.* Gainesville: University Press of Florida, 2003.

Garin, Kristoffer A. *Devils on the Deep Blue Sea: The Dreams, Schemes and Showdowns that Built America's Cruise-Ship Empires.* New York: Penguin Group, 2005.

Gensler, Lauren. "An Alligator Wrestler, a Casino Boss and a $12 Billion Tribe." *Forbes*, October 19, 2016. Accessed December 2, 2016. www.

forbes.com/sites/laurengensler/2016/10/19/seminole-tribe-florida-hard-rock-cafe/2/#2ff22bc26806.

Gillin, Joshua. "New Gaming Compact Offers Florida Biggest Guaranteed Share of Any State, Seminoles Say." *Politifact Florida*, February 11, 2016. Accessed December 10, 2016. www.politifact.com/florida/statements/2016/feb/11/seminole-tribe-florida/new-gaming-compact-offers-florida-biggest-guarante.

Global Trade. "Top 50 Cities for Global Trade." July 30, 2012. Accessed October 16, 2015. www.globaltrademag.com/features/top-50-cities-for-global-trade.

Gorgas, Dr. William C., to Dr. Joseph Y. Porter, July 25, 1902. Florida State Board of Health Subject Files, 1875–1975. Series 900, Carton 6, Folder 89, State Archives of Florida.

Gorgas, W.C. *A Few General Directions with Regard to Destroying Mosquitoes, Particularly the Yellow Fever Mosquito* Washington, D.C.: Government Printing Office, 1904. Accessed November 1, 2015, University of Alabama digital archives, purl.lib.ua.edu/19713.

Govtrack.US. "H.R. 1727 (101st): Everglades National Park Protection and Expansion Act of 1989." Accessed September 27, 2016, www.govtrack.us/congress/bills/101/hr1727.

Graham, Thomas (professor of history, Flagler College humanities department), in discussion with coauthor, September 2015.

———. *Mr. Flagler's St. Augustine.* A Florida Quincentennial Book. Gainesville: University Press of Florida, 2014. Kindle edition.

Granath, Bob. "Vehicle Assembly Building Prepared for Another 50 Years of Service." NASA, July 18, 2013. Accessed February 17, 2016. www.nasa.gov/content/vehicle-assembly-building-prepared-for-another-50-years-of-service.

Green, Amanda. "A Brief History of Air Conditioning." *Popular Mechanics*, January 1, 2015. Accessed January 11, 2016. www.popularmechanics.com/home/how-to/a7951/a-brief-history-of-air-conditioning-10720229.

Green, Amy. "Space Florida Presses Ahead with Plans for Shiloh Spaceport." WMFE, September 7, 2015. Accessed February 18, 2016. www.wmfe.org/space-florida-presses-ahead-with-plans-for-shiloh-spaceport/52500.

Griffin, Justine. "Publix No. 1 on List of Florida's Most Valuable Brands." *Tampa Bay Times*, July 11, 2016. Accessed July 12, 2016. www.tampabay.com/news/business/retail/publix-tops-the-list-of-floridas-most-valuable-brands/2284957.

Grout, Pam. "Rich Literary Heritage Draws Writers to Key West." Huffington Post, July 25, 2012. Accessed February 26, 2017. www.huffingtonpost. com/pam-grout/rich-literary-heritage-key-west_b_1541147.html.

Grunwald, Michael. *The Swamp: The Everglades, Florida and the Politics of Paradise.* New York: Simon & Schuster Paperbacks, 2006, 82–97.

Gwynn, David. "A Quick History of the Supermarket." Groceteria.com. Accessed August 24, 2016. www.groceteria.com/about/a-quick-history-of-the-supermarket.

Hambright, Tom (Monroe County historian), in discussion with coauthor, October 2016.

Handwerk, Brian. "U.S. Crocodiles Shed 'Endangered' Status." *National Geographic News*, March 21, 2007. Accessed September 28, 2016. news. nationalgeographic.com/news/2007/03/070321-crocodiles.html.

Harner, Charles E. *Florida's Promoters: The Men Who Made It Big.* Tampa, FL: Trend House, 1973.

Hawes, Leland M., Jr. "Tampa at the Turn of the Century: 1899." *Sunland Tribune* 25 (1999): 69.

Helm, Justin. "Claude Everett Street (1868–1945)." Florida Citrus Hall of Fame. Accessed January 26, 2017. floridacitrushalloffame.com/index. php/inductees/inductee-name/?ref_cID=89&bID=0&dd_asId=1074.

———. "Lee Bronson Skinner (1861–1936)." Florida Citrus Hall of Fame. Accessed January 26, 2017. floridacitrushalloffame.com/index.php/ inductees/inductee-name/?ref_cID=89&bID=0&dd_asId=1069.

Hendrickson, Jon K. "Naval Rivalry and World War I at Sea, 1900–1920." In *America, Sea Power and the World*, edited by James C. Bradford. Chichester, UK: John Wiley & Sons, 2016. Kindle edition.

Henry B. Plant Museum. "Henry B. Plant Biography." Accessed September 11, 2015. plantmuseum.com/henry-plant-museum/bio.

———. "Henry Plant Hotel 1891." Accessed December 21, 2015. hbp. sunstyledesign.com/?page_id=173.

———. "Henry Plant's Southern Empire." Accessed December 21, 2015. hbp.sunstyledesign.com/?page_id=170.

Hernández, Fernando "Fernan." *The Cubans: Our Legacy in the United States.* Mountain View, CA: Floricanto Press, 2012, 104–10.

Herrera, Chabeli. "How the Seminole Tribe Came to Rock the Hard Rock Empire." *Miami Herald*, May 22, 2016. Accessed December 6, 2016. www. miamiherald.com/news/business/biz-monday/article79172817.html.

———. "The State of the Seminole Tribe's Compact with the Florida." *Miami Herald*, May 22, 2016. Accessed December 7, 2016. www.

miamiherald.com/news/business/tourism-cruises/article79199997. html.

Herridge, Linda. "NASA's Giant Crawlers Turn 50 Years Old, Pivot Toward Future Exploration." NASA, updated July 30, 2015. Accessed February 17, 2016. www.nasa.gov/content/nasas-giant-crawlers-turn-50-years-old-pivot-toward-future-exploration.

Hillsborough County Economic Development Department. "Quarterly Economic Indicators Report—October 2015," 4. Accessed February 23, 2017. www.hillsboroughcounty.org/library/hillsborough/media-center/documents/economic-development/indicator-reports/october-2015-quarterly-indicators.pdf.

Historical Society of Palm Beach County. "Introduction: Flagler Era." Accessed September 16, 2015. www.pbchistoryonline.org/page/flagler-era.

History.com staff. "Castro Announces Mariel Boatlift." A+E Networks, 2009. Accessed October 17, 2015. www.history.com/this-day-in-history/castro-announces-mariel-boatlift.

———. "Fidel Castro Born." A+E Networks, 2010. Accessed March 28, 2016. www.history.com/this-day-in-history/fidel-castro-born.

———. "Yellow Fever Breaks Out in Philadelphia." A+E Networks, 2009. Accessed November 5, 2015. www.history.com/this-day-in-history/yellow-fever-breaks-out-in-philadelphia.

History of MacDill Air Force Base: Home of the 6th Air Mobility Wing. United States Air Force, 2.

Hodges, Alan W., Mohammad Rahmani and Thomas J. Stevens. *Economic Contributions of Agriculture, Natural Resources, and Food Industries in Florida in 2013.* Gainesville: University of Florida—IFAS, Food & Resource Economics Department, 2015. fred.ifas.ufl.edu/pdf/FE969-FullReport.pdf.

Hollander, Gail M. *Raising Cane in the 'Glades: The Global Sugar Trade and the Transformation of Florida.* Chicago: University of Chicago Press, 2008. Accessed via Google Books, December 4, 2015. books.google.com/books?id=L61EXdbA0tMC&pg=PA24&lpg=PA24&dq=%22florida+sugar+manufacturing+company%22&source=bl&ots=Qi9QU1VVRZ&sig=FSzY-1vTAOe49CbOKvEfIYpCq-o&hl=en&sa=X&ved=0ahUKEwj4zO3A3MrJAhUJWx4KHV1PCTQQ6AEIJTAD#v=onepage&q=%22florida%20sugar%20manufacturing%20company%22&f=false.

Holland, Tiffany. "Publix Supermarkets Are Coming to Virginia." In *Storefront*, a blog by the *Roanoke Times*, February 4, 2016. www.roanoke.com/business/columns_and_blogs/blogs/storefront/publix-

supermarkets-are-coming-to-virginia/article_c8025245-42ee-5a61-81aa-dd292f33c419.html.

Howe, Daniel Walker. *What Hath God Wrought: The Transformation of America, 1815–1848*. New York: Oxford University Press, 2007.

Howe, George D. "The Father of Modern Refrigeration." *Publications of the Florida Historical Society* 1, no. 4 (January 1909): 21. www.jstor.org/stable/30138674?seq=1#page_scan_tab_contents.

Huizenga, Wayne. Transcript, Oral History Interviews with Julian Pleasants, October 28, 1999, and January 13, 2000. Samuel Proctor Oral History Program Collection, P.K. Yonge Library of Florida History, University of Florida. ufdc.ufl.edu/UF00005459/00001/pdf?search=huizenga.

Human Rights Watch. "Cuba: Events of 2016." In *World Report 2017: Events of 2016*. Accessed February 22, 2017. www.hrw.org/world-report/2017/country-chapters/cuba.

Huse, Andy (University of South Florida assistant librarian specializing in Florida history), in discussion with the coauthor, January 2017.

Indian River Citrus League. E-mail message to coauthor, February 1, 2017.
———. "History." Accessed January 28, 2017. ircitrusleague.org/history.

Isikoff, Michael. "The War Over Waste." *Washington Post*, July 15, 1984. Accessed August 29, 2017. www.washingtonpost.com/archive/business/1984/07/15/the-war-over-waste/6a34b1e8-f355-4ee3-a31b-9d4b5c14a044/?utm_term=.3648e12d2a8f.

Jackson, Tom (co-founder of Florida Grocers Association), in discussion with coauthor, August 2016.

Jacobs, Daniel G. "Blockbuster Growth." *Smart Business Miami/Broward/Palm Beach*, September 2005. Accessed August 24, 2017. www.business.nova.edu/about/BlockbusterGrowth.pdf.

Johnson, Steven. *How We Got to Now: Six Innovations that Made the Modern World*. New York: Penguin Group, 2014, 62.

Jones, Maxine D. "The African-American Experience in Twentieth Century Florida." In *The New History of Florida*, edited by Michael Gannon. Gainesville: University Press of Florida, 1996.
———. "Florida's African American Female Activists." In *Making Waves: Female Activists in Twentieth-Century Florida*, edited by Jack E. Davis and Kari Frederickson. Gainesville: University Press of Florida, 2003.

Kennedy Space Center. "History of Kennedy Space Center Visitor Complex." Accessed February 19, 2016. www.kennedyspacecenter.com/nasa-news-and-history/nasa-history/kennedy-space-center-visitor-complex-history.aspx.

Kiersz, Andy. "Here's How Much Land Military Bases Take Up in Each State." *Business Insider*, November 10, 2014. Accessed March 19, 2016. www.businessinsider.com/how-much-land-military-bases-take-up-in-each-state-2014-11.

Kimball, Dan B. "Tamiami Trail Modifications: Next Steps Project/EIS." National Park Service. Accessed February 26, 2017. parkplanning.nps.gov/projectHome.cfm?parkId=374&projectId=26159.

Kirkman, Alexandra. "Key West: America's Hottest New Luxury Destination for 2015." *Forbes*, February 23, 2015. Accessed October 13, 2016. www.forbes.com/sites/alexandrakirkman/2015/02/23/key-west-americas-hottest-new-luxury-destination-for-2015/#f971d6368167.

Kite-Powell, Rodney. "Grand Hotels." TBO.com, September 18, 2011. Accessed December 20, 2015. www.tbo.com/special_section/history/2011/sep/18/banewso10-grand-hotels-ar-258328.

Klas, Mary Ellen. "Florida Hits $340 Million Jackpot by Settling Gambling Dispute with Seminole Tribe." *Miami Herald*, July 5, 2017. Accessed January 15, 2018. www.miamiherald.com/news/local/community/broward/article159823589.html.

———. "A Timeline of Gambling in Florida." *Tampa Bay Times*, November 25, 2009. Accessed December 7, 2016. www.tampabay.com/news/perspective/a-timeline-of-gambling-in-florida/1054345.

Klein, Christopher. "The Epic Road Trip that Inspired the Interstate Highway System." June 29, 2016. Accessed September 22, 2017. www.history.com/news/the-epic-road-trip-that-inspired-the-interstate-highway-system.

Krantz, Matt, and Gene Sloan. "Norwegian Cruise Line IPO Soars 31%." *USA Today*, January 17, 2013. Accessed February 10, 2017. www.usatoday.com/story/travel/cruises/2013/01/17/norwegian-cruise-ipo-prices/1843051.

Lang, Robert E., and Kristopher M. Rengert. *The Hot and Cold Sunbelts: Comparing State Growth Rates, 1950–2000.* Fannie Mae Foundation Census Note 02, April 2001. Washington, D.C.: Fannie Mae Foundation, 2001. PDF e-report, 4. Accessed March 1, 2017. www.energybc.ca/cache/globalconsumereconomy/www.knowledgeplex.org/kp/facts_and_figures/facts_and_figures/relfiles/sunbelt_note.pdf.

Lee County Visitor and Convention Bureau. "Value of Tourism: Tourism Is the Backbone of Our Economy." Accessed December 30, 2016. www.leevcb.com/education-and-resources/statistics/value-of-tourism.

Lempel, Leonard R. "Toms and Bombs: The Civil Rights Struggle in Daytona Beach." In *Old South, New South, or Down South? Florida and the*

Modern Civil Rights Movement, edited by Irvin D.S. Winsboro. Morgantown: West Virginia University Press, 2009.

Leonard, M.C. Bob (history educator, author and McGraw-Hill textbook editor), in discussion with coauthor, November 2016.

LeRoy Collins Leon County Public Library. "Governor LeRoy Collins." Accessed January 22, 2017. cms.leoncountyfl.gov/Library/LibraryInformation/About-LeRoy-Collins.

Levine, Robert M., and Moisés Asís. *Cuban Miami* Piscataway, NJ: Rutgers University Press, 2000, 5.

Long, Durward. "Key West and the New Deal, 1934–1936." *Florida Historical Quarterly* 46, no. 3 (1968): 209–18. Accessed October 12, 2016. www.jstor.org/stable/30147763.

Marshall, Barbara. "We Take a Look Back at the Road that Created Florida." *Palm Beach Post*, January 13, 2016. Accessed February 18, 2017. www.mypalmbeachpost.com/lifestyles/take-look-back-the-road-that-created-florida/GW1RlpS1FYRzlMUg1Wz1EJ.

Martinez, Gladys P., trans. "Cuba Before Fidel Castro." ChristusRex.org, originally published by Contacto. Accessed October 6, 2015. www.christusrex.org/www2/fcf/cubaprecastro21698.html.

Martin, Justin. Wayne Huizenga interview. *Fortune Small Business*, May 1, 2003. Accessed August 24, 2017. money.cnn.com/magazines/fsb/fsb_archive/2003/05/01/343414.

Martin, Sidney Walter. *Florida's Flagler*. Athens: University of Georgia Press, n.d.

Mather Economics. "Summary." In *Measuring the Economic Benefits of America's Everglades Restoration: An Economic Evaluation of Ecosystem Services Affiliated with the World's Largest Ecosystem Restoration Project* (Roswell). Accessed February 26, 2017. www.evergladesfoundation.org/wp-content/uploads/2012/04/Report-Measuring-Economic-Benefits-Exec-Summary.pdf.

McCluskey, Audrey Thomas, and Elaine M. Smith, eds. *Mary McLeod Bethune: Building a Better World—Essays and Selected Documents*. Bloomington: Indiana University Press, 1999.

McIver, Stuart. "Kingfish of Key West." *Sun Sentinel*, July 7, 1991. Accessed January 10, 2018. articles.sun-sentinel.com/1991-07-07/features/9101240980_1_julius-stones-cuba-organic-chemistry.

McMorris, Frances. "Tampa Gets a Second, Year-Round Cruise Ship." *Tampa Bay Business Journal*, November 3, 2016. Accessed February 23, 2017. www.bizjournals.com/tampabay/news/2016/11/03/tampa-gets-a-second-year-round-cruise-ship.html.

McPhee, John. *Oranges.* New York: Farrar, Straus and Giroux, 1967, 90.

Meyer, Rebecca. "Edmund Hall Hart (1839–1898)." Florida Citrus Hall of Fame. Accessed January 26, 2017. floridacitrushalloffame.com/index. php/inductees/inductee-name/?ref_cID=89&bID=0&dd_asId=987.

Miami-Dade Aviation Department Marketing Division. *Miami International Airport: U.S. and Worldwide Airport Rankings: Passengers and Freight 2015.* Miami-Dade Aviation Department Marketing Division, 2016, 3. Accessed February 22, 2017. www.miami-airport.com/pdfdoc/2015_Rankings-US_and_Worldwide_(Final).pdf.

Miami-Dade County. "About Miami-Dade County History." Wayback Machine Internet Archive. web.archive.org/web/20080225012927/ http://www.miamidade.gov/infocenter/about_miami-dade_history.asp.

Migration Policy Institute. "State Immigration Data Profiles: Florida— Demographics & Social." Accessed February 22, 2017. www. migrationpolicy.org/data/state-profiles/state/demographics/FL.

———. "U.S. Immigrant Population by State and County." Accessed February 22, 2017. www.migrationpolicy.org/programs/data-hub/ charts/us-immigrant-population-state-and-county.

Miller, Nathan. *The U.S. Navy: A History.* 3rd ed. Annapolis, MD: Naval Institute Press, 1997, 176.

Mohl, Raymond A., and Gary R. Mormino. "The Big Change in the Sunshine State: A Social History of Modern Florida." In *The New History of Florida*, edited by Michael Gannon. Gainesville: University Press of Florida, 1996.

Moreno, Dario (associate professor, Steven J. Green School of International and Public Affairs, Florida International University), in discussion with coauthor, October 2015.

Mormino, Gary R., and Raymond Arsenault. Foreword to *Florida's Space Coast: The Impact of NASA on the Sunshine State*, by William Barnaby Faherty. Gainesville: University Press of Florida, 2002.

Morse, Minna Scherlinder. "Chilly Reception." *Smithsonian Magazine*, July 2002. Accessed January 12, 2016. www.smithsonianmag.com/history/ chilly-reception-66099329/?no-ist.

MyBaseGuide. "NAS Pensacola History." Updated January 25, 2016. Accessed March 10, 2016. mybaseguide.com/navy/1-540/nas_ pensacola_history.

Nagengast, Bernard. "100 Years of Air Conditioning." *ASHRAE Journal* (June 2002): 46. bookstore.ashrae.biz/journal/donwload.php?file=nagengast. pdf.

Narvaez, Alfonso A. "Ben Hill Griffin Jr., 79, Is Dead; Leader in Florida Citrus Industry." *New York Times*, March 2, 1990. Accessed February 1, 2017. www.nytimes.com/1990/03/02/obituaries/ben-hill-griffin-jr-79-is-dead-leader-in-florida-citrus-industry.html.

NASA. "Kennedy Space Center's Annual Report FY 2014," 42. Accessed February 19, 2016. www.nasa.gov/centers/kennedy/about/annual_rpt/annual_rpt-index.html.

NASA Public Affairs. "Origins." In *The Kennedy Space Center Story* (1991). Accessed February 18, 2016. www.nasa.gov/centers/kennedy/about/history/story/kscstory.html.

National Air and Space Museum. "Eugene Ely and the Birth of Naval Aviation—January 18, 1911." January 18, 2011. blog.nasm.si.edu/aviation/eugene-ely-and-the-birth-of-naval-aviation%E2%80%94january-18-1911.

National Archives and Records Administration. "Distribution of Electoral Votes." December 10, 2010. Accessed January 10, 2016. www.archives.gov/federal-register/electoral-college/allocation.html.

National Association of Realtors. "Profile of International Activity in U.S. Residential Real Estate." Cited in Scholastica Cororaton, "Major U.S. Destinations of Foreign Buyers in April 2015–March 2016," Economist's Outlook Blog, National Association of Realtors, July 11, 2016. Accessed October 18, 2017. economistsoutlook.blogs.realtor.org/2016/07/11/major-u-s-destinations-of-foreign-buyers-in-april-2015-march-2016.

National Governors Association. "Napoleon Bonaparte Broward." Florida: Past Governors Bios. Accessed December 3, 2015. www.nga.org/cms/home/governors/past-governors-bios/page_florida/col2-content/main-content-list/title_broward_napoleon.default.html.

National Museum of Health and Medicine. "U.S. Army Maj. Walter Reed." U.S. Department of Defense, May 14, 2012. Accessed November 4, 2015. www.medicalmuseum.mil/index.cfm?p=about.directors.reed.

National Park Service. "Bethune Résumé." Accessed January 21, 2018. www.nps.gov/mamc/learn/historyculture/bethune-resume.htm.

———. "East Everglades Expansion Area." Accessed September 28, 2016, www.nps.gov/ever/learn/nature/eeea.htm.

———. "Everglades National Park Florida." Accessed September 28, 2016. www.nps.gov/ever/index.htm.

———. "Everglades National Park Florida, Wilderness 101." Accessed September 28, 2016. www.nps.gov/ever/learn/nature/wilderness101.htm.

———. "Florida in World War II," 1. Accessed April 8, 2016. www.nps. gov/casa/planyourvisit/upload/World%20War%202.pdf.

———. "Inventory of Threatened and Endangered Species in Everglades National Park." Accessed September 28, 2016. www.nps.gov/ever/learn/ nature/techecklist.htm.

———. "National Park Service Visitor Use Statistics—Everglades NP." Accessed September 26, 2016. irma.nps.gov/Stats/ SSRSReports/Park%20Specific%20Reports/Annual%20Park%20 Recreation%20Visitation%20(1904%20-%20Last%20Calendar%20 Year)?Park=EVER.

———. "Tampa Bay Hotel, Tampa, Florida." Accessed December 20, 2015. www.nps.gov/nr/travel/american_latino_heritage/tampa_bay_ hotel.html.

National Park Service, Big Cypress National Preserve, Florida. "Timeline of Historic & Significant Events." Accessed September 27, 2016. www. nps.gov/bicy/learn/historyculture/timeline-of-historic-events.htm.

National Park Service, Fort Matanzas National Monument. "The Massacre of the French." Accessed November 5, 2016. www.nps.gov/foma/learn/ historyculture/the_massacre.htm.

Naval Aviation Museum. "Closing of Pensacola Navy Yard Was an End and a Beginning." January 9, 2014. Accessed April 22, 2017. www. navalaviationmuseum.org/history-up-close/nas-pensacola-100th/ closing-navy-yard-end-beginning.

———. "Naval Aviation Arrives in Pensacola." January 17, 2014. Accessed April 22, 2017. www.navalaviationmuseum.org/history-up-close/nas-pensacola-100th/naval-aviation-arrives-pensacola.

———. "Naval Aviation at Greenbury Point." July 6, 2015. Accessed January 20, 2018. www.navalaviationmuseum.org/history-up-close/ naval-aviation-at-greenbury-point/

New York Times. "George Jenkins, 88, Founder of $9 Billion Grocery Chain." April 10, 1996. Accessed July 4, 2016. www.nytimes.com/1996/04/10/ us/george-jenkins-88-founder-of-9-billion-grocery-chain.html.

———. "Henry B. Plant Dead." June 24, 1899. Accessed December 18, 2015. query.nytimes.com/mem/archive-free/pdf?res=9C04E0DA1430 E132A25757C2A9609C94689ED7CF.

Nijman, Jan. *Miami: Mistress of America.* Philadelphia: University of Pennsylvania Press, 2011. Accessed via Google Books. books.google.com/ books?id=H8uArxdvJNcC&pg=PA11&lpg=PA11&dq=julia+tuttle+deb t&source=bl&ots=_cvpr3onRA&sig=Y9vI3zXktI88rLhwHE2Tmi_oMs

4&hl=en&sa=X&ved=0ahUKEwiPzNn9i8TYAhUGOSYKHWxWDN A4ChDoAQhGMAQ#v=onepage&q=julia%20tuttle%20debt&f=false.

Nova Southeastern University Huizenga College of Business and Entrepreneurship. "H. Wayne Huizenga on Acquiring Blockbuster." YouTube video, September 3, 2009. Accessed August 23, 2017. www.youtube.com/watch?v=13XIdWavY7U&app=desktop.

Ogle, Maureen. *Key West: History of an Island of Dreams*. Gainesville: University Press of Florida, 2003.

O'Neil, Devin. "Can the Commercial Space Industry and National Parks Get Along?" *Outside*, February 3, 2016. Accessed February 18, 2016. www.outsideonline.com/2052236/commercial-space-industry-going-ruin-national-parks.

Oremus, Will. "A History of Air Conditioning." *Slate*, July 15, 2013. Accessed January 11, 2016. www.slate.com/articles/arts/culturebox/2011/07/a_history_of_air_conditioning.html.

Padhy, Siv. "Phosphate Mining in the US and Canada." *Investing News*, August 30, 2017. Accessed January 19, 2018. investingnews.com/daily/resource-investing/agriculture-investing/phosphate-investing/phosphate-mining-in-north-america.

Palmer, Darryl. "Like a Day Without Sunshine: The Past and Future of Florida Citrus." University of Florida Institute of Food and Agricultural Sciences Communications blog, September 12, 2014. Accessed January 27, 2017. blogs.ifas.ufl.edu/ifascomm/2014/09/12/like-a-day-without-sunshine-the-past-and-future-of-florida-citrus.

Patterson, Gordon. "Countdown to College: Launching Florida Institute of Technology." *Florida Historical Quarterly* 77 (1998): 163. Accessed February 20, 2016. www.jstor.org/stable/30152246.

———. *The Mosquito Wars: A History of Mosquito Control in Florida*. Gainesville: University Press of Florida, 2004.

PBS Online. "Fidel Castro—Cuban Exiles in America." Last modified December 21, 2004. Accessed March 28, 2016. www.pbs.org/wgbh/amex/castro/peopleevents/e_exiles.html.

Phalen, James M. "Chiefs of the Medical Department, U.S. Army 1775–1940, Biographical Sketches." *Army Medical Bulletin* 52 (1940): 88–93, excerpt republished by U.S. Army Medical Department Office of Medical History. history.amedd.army.mil/surgeongenerals/W_Gorgas.html.

Piehler, Kurt (director, Institute on World War II and the Human Experience, Florida State University), in discussion with coauthor, March 2016.

Port Tampa Bay. "Location and History of Port Tampa Bay." Accessed December 19, 2016. www.tampaport.com/about-port-tampa-bay/about-port-tampa-bay/history.aspx.

Pounds, Marcia Heroux. "Florida Could Be Heading toward $1 Trillion Economy, Forecast Says." *Sun Sentinel,* June 26, 2016. Accessed October 18, 2017. www.sun-sentinel.com/business/careers/fl-florida-economy-snaith-forecast-20160628-story.html.

Proverbs, Theresa Hamilton. "We Built That: The Lost Fight for Florida's Cross State Highway." *Journal of Planning History* 14 (2015): 333, figure 4. Accessed December 15, 2016. doi: 10.1177/1538513214552995.

Publix Super Markets. "Awards & Achievements." Accessed August 3, 2016. corporate.publix.com/about-publix/company-overview/awards-achievements.

———. "Facts & Figures." Accessed August 3, 2016. corporate.publix.com/about-publix/company-overview/facts-figures.

———. "History." Accessed August 24, 2106. corporate.publix.com/about-publix/culture/history.

Pugh, Carol. "Governor Vows to Thwart Those Who Prey on Tourists." *Ocala Star Banner*, September 13, 1993. Accessed via Google News, October 17, 2015. news.google.com/newspapers?nid=1356&dat=19930913&id=V8hPAAAAIBAJ&sjid=3gcEAAAAIBAJ&pg=5179,2298599&hl=en.

Putnam, Adam. "Long Term Water Policy for Florida." Lecture, Palm Beach County Convention Center, West Palm Beach, FL, September 24, 2015.

Reynolds, Kelly. *Henry Plant: Pioneer Empire Builder.* Cocoa: Florida Historical Society Press, 2003.

Roberts, Melissa. "The Statewide Impact of Florida's Military Economy Is More than $70 Billion." Florida Chamber of Commerce. Accessed February 27, 2017. www.flchamber.com/know-statewide-impact-floridas-military-economy-70-billion.

Robertson, Ashley N. *Mary McLeod Bethune in Florida: Bringing Social Justice to the Sunshine State.* Charleston, SC: The History Press, 2015. Kindle edition.

Rogers, William W. "Fortune and Misfortune: The Paradoxical Twenties." In *The New History of Florida*, edited by Michael Gannon. Gainesville: University Press of Florida, 1996.

Rosen, Rebecca J. "Keepin' It Cool: How the Air Conditioner Made Modern America." *The Atlantic*, July 14, 2011. Accessed January 11, 2016. www.theatlantic.com/technology/archive/2011/07/keepin-it-cool-how-the-air-conditioner-made-modern-america/241892.

Salisbury, Susan. "Everglades Area Farmers Exceed Phosphorous Reduction Requirements." *Palm Beach Post*, August 10, 2016. Accessed February 26, 2017. www.mypalmbeachpost.com/business/ everglades-area-farmers-exceed-phosphorus-reduction-requirements/ qHh7aTxaP2BRlIWZCoaVfM.

Saltzman, Dori. "Royal Caribbean Cruise Line History." *Cruise Critic*, September 26, 2017. www.cruisecritic.com/articles.cfm?ID=3043.

Sanchez, Rebecca, Elissa Curtis and Rachelle Klapheke. "Remembering the Cuban Revolution." MSNBC slideshow, MSNBC.com, July 28, 2015. Accessed March 28, 2016. www.msnbc.com/msnbc/remembering-fidel-castro-and-the-cuban-revolution.

Sandomir, Richard. "Entrepreneurs: Wayne Huizenga's Growth Complex." *New York Times*, June 9, 1991. Accessed August 24, 2017. www.nytimes. com/1991/06/09/magazine/entrepreneurs-wayne-huizenga-s-growth-complex.html?pagewanted=all.

Scandura, Jani. *Down in the Dumps: Place, Modernity, American Depression.* Durham, NC: Duke University Press, 2008. Accessed via GoogleBooks, books.google.com/books?id=mwI_rO-LQtcC&printsec=frontcover& dq=down+in+the+dumps+book&hl=en&sa=X&ved=0ahUKEwiSj-2ay9HPAhUFXB4KHWAnBA0Q6AEIKjAA#v=snippet&q=key%20 west&f=false.

Schulman, Bill. "Bethune Set the Stage to Break Baseball's Color Barrier." *Daytona Beach News-Journal*, April 21, 2013. Accessed January 8, 2017. www.news-journalonline.com/news/20130421/bethune-set-the-stage-to-break-baseballs-color-barrier.

Seal, Mark. *Wayne: The Extraordinary Story of a Consummate Entrepreneur.* Bainbridge Island, WA: Fenwick Publishing Group, 2012.

Seiler, Jack (mayor of Fort Lauderdale, Florida), in discussion with coauthor, September 2016.

Seminole Tribe of Florida. "Survival in the Swamp." Accessed December 30, 2016. www.semtribe.com/History/SurvivalInTheSwamp.aspx.

———. "Tourism/Enterprises." Accessed December 10, 2016. www. semtribe.com/TourismAndEnterprises.

———. "Who Are the Seminole People? A Brief History." Tribal Historic Preservation Office. Accessed December 7, 2016. www.stofthpo.com/ History-Seminole-Tribe-FL-Tribal-Historic-Preservation-Office.html.

SevenNaturalWonders.org. "Seven Natural Wonders of North America." Accessed February 25, 2017. sevennaturalwonders.org/index_/wonders-by-continent/north-america.

Sharp, Leslie N. "Dixie Highway Association." *The Tennessee Encyclopedia of History and Culture 2.0*, January 1, 2010. Accessed February 18, 2017. tennesseeencyclopedia.net/entry.php?rec=382.

Shaw, Melissa. "Top Phosphate Production by Country." *Investing News*, May 18, 2017. Accessed January 19, 2018. investingnews.com/daily/resource-investing/agriculture-investing/phosphate-investing/top-phosphate-producing-countries.

The Shelby Report, cited by Tom Jackson (co-founder of Florida Grocers Association), in discussion with coauthor, August 2016.

Sieg, Caroline, and Steve Winston. *Insiders' Guide to Greater Fort Lauderdale: Fort Lauderdale, Hollywood, Pompano, Dania & Deerfield Beaches.* Guilford, CT: Morris Book Publishing, 2011. Accessed December 7, 2015, via Google Books. books.google.com/books?id=RE2alajKDjgC&pg=PA22&lpg=PA22&dq=accomplishments+napoleon+bonaparte+broward&source=bl&ots=mIjx_eTk_c&sig=52cpiz1mK7UesewAJVtAKbFCQJ4&hl=en&sa=X&ved=0ahUKEwikqvTy2tHJAhVFKCYKHU68ALEQ6AEITzAH#v=onepage&q=accomplishments%20napoleon%20bonaparte%20broward&f=false.

Smiley, David. "Miami Teachers, Students, Parents Remember Brown v. Board 60 Years Later." *Miami Herald*, May 17, 2014. Accessed January 23, 2017. www.miamiherald.com/news/local/community/miami-dade/article1964609.html.

Smith, Diana. "George W. Jenkins: The Legacy of a Leader." *The Lakelander*, October 9, 2014. Accessed February 25, 2017. thelakelander.com/george-w-jenkins.

Smith, Fred, and Sarah Allen. "Urban Decline (and Success) in the United States." EH.net Encyclopedia, edited by Robert Whaples, Table 2, June 5, 2008. Accessed March 24, 2016. eh.net/encyclopedia/urban-decline-and-success-in-the-united-states.

Smith, Stanley K. *Florida Population Growth: Past, Present and Future.* Gainesville: Bureau of Economic and Business Research, University of Florida, 2005. PDF e-report, 6. www.bebr.ufl.edu/sites/default/files/Research%20Reports/FloridaPop2005_0.pdf.

Sorey, Steve. "Atlantic Coast Line Railroad." RailGa.com. Accessed February 23, 2017. railga.com/acl.html.

Sortal, Nick. "Marcellus Osceola Wins Election to Head Seminole Tribe." *Miami Herald*, November 1, 2016. Accessed December 9, 2016. www.miamiherald.com/news/local/community/broward/article111849112.html.

Southern Regional Council. "A Background Report on School Desegregation for 1959–1960." 1959. Florida Governor (1955–1961: Collins—

Correspondence, 1955–1961), Series 776B, Carton 116, State Archives of Florida.

Space Florida. "Florida's Commercial Spaceport Network." Accessed February 18, 2016. www.spaceflorida.gov/commerciallaunch.

Staletovich, Jenny. "What Do You Give the Everglades for Earth Day? How about a Bridge?" *Miami Herald*, April 22, 2016. Accessed February 26, 2017. www.miamiherald.com/news/local/environment/article73390062.html.

State Board of Health of Florida. *Twenty-Eighth Annual Report of the State Board of Health of Florida: 1916*. Jacksonville, FL: Drew Press, 1917, 13. Accessed via Google Books, November 1, 2015. books.google.com/books?id=QVhNAAAAMAAJ&pg=PA13&lpg=PA13&dq=florida+%22health+train%22&source=bl&ots=PND0nBgRKq&sig=UXK26e1DhBE2B8cGm0AOIhO3hs8&hl=en&sa=X&ved=0CB4Q6AEwATgKahUKEwiJxNGpr53JAhUIYiYKHSfxAOQ#v=onepage&q=florida%20%22health%20train%22&f=false.

State Library & Archives of Florida. "Daytona Normal and Industrial Institute Doing Laundry: General Note." Accessed January 4, 2017. www.floridamemory.com/items/show/757.

———. "The Florida Seminoles: Timeline." Florida Memory. Accessed December 9, 2016. www.floridamemory.com/onlineclassroom/seminoles/timeline.

———. "Map of the Dixie Highway System, 1919." Accessed February 18, 2017. www.floridamemory.com/items/show/318848.

———. "Timeline." Accessed January 4, 2017. www.floridamemory.com/exhibits/timeline.

St. Cloud Main Street. "History." Accessed April 28, 2016. www.stcloudmainstreet.org/history.html.

Stein, Stephen K. *From Torpedoes to Aviation: Washington Irving Chambers & Technological Innovation in the New Navy 1876 to 1913*. Tuscaloosa: University of Alabama Press, 2007, 5–7.

Stern, Charles V. *Everglades Restoration: Federal Funding and Implementation Progress*. Washington, D.C.: Congressional Research Service, 2014. Accessed December 10, 2015. nationalaglawcenter.org/wp-content/uploads/assets/crs/R42007.pdf.

Stieghorst, Tom. "Smooth Sailing Carnival Cruise Lines' Initial Stock Offering Gets a Fair Wind from Investors." *Sun Sentinel*, July 25, 1987. Accessed February 10, 2017. articles.sun-sentinel.com/1987-07-25/business/8703020284_1_carnival-cruise-lines-carnival-ships-million-shares.

St. John's River Water Management District. "Florida Water Management History: Water Management in the 1900s: 1900 through 1949." Accessed April 28, 2016. www.sjrwmd.com/history/1900-1949.html.

Stone, Julius, Jr. "Key West Is to Be Restored by Free Labor of Her Citizens." *New York Times*, August 12, 1934. Accessed October 13, 2016. timesmachine.nytimes.com/timesmachine/1934/08/12/95054337. html?pageNumber=144.

Storbeck, Jon. "Windows on Main Street, U.S.A., at Disneyland Park: Elias Disney." DisneyParks Blog, June 13, 2013. Accessed September 24, 2015. disneyparks.disney.go.com/blog/2013/06/windows-on-main-street-u-s-a-at-disneyland-park-elias-disney.

Supermarket News. "2016 Top 75 U.S. & Canadian Food Retailers & Wholesalers." Accessed August 24, 2016. supermarketnews.com/2016-top-75-us-canadian-food-retailers-wholesalers.

Swift, Earl. *The Big Roads: The Untold Story of the Engineers, Visionaries, and Trailblazers Who Created the American Superhighways* (Boston: Houghton Mifflin Harcourt, 2011).

Tampa Bay Partnership. "Major Employers." Accessed December 28, 2015. www.tampabay.org/site-selection/major-employers.

Taylor, Frank A. "Catalog of the Mechanical Collections of the Division of Engineering, United States National Museum, Bulletin 173." Accessed via "Gorrie Ice Machine, Patent Model," the National Museum of American History. Accessed March 1, 2017. americanhistory.si.edu/collections/search/object/nmah_846192.

Teitel, Amy Shira. "Project Hermes: America's V-2 Rocket Program." *Discovery News*, April 22, 2013. Accessed March 15, 2016. news.discovery. com/space/history-of-space/project-hermes-americas-v-2-rocket-program-130422.htm.

Telegraph. "15 Cities with the Most Cruise Tourists—Where Does Venice Rank?" July 28, 2017. Accessed August 17, 2017. www.telegraph.co.uk/travel/cruises/galleries/the-worlds-busiest-cruise-ports.

Themed Entertainment Association. *2015 Theme Index and 2015 Museum Index: Global Attractions Attendance Report*. (Themed Entertainment Association and AECOM, 2015), 12. Accessed April 23, 2017. www.teaconnect.org/images/files/TEA_160_611852_160525.pdf.

Thomas, Robert McG, Jr. "Jack Berry, Florida Citrus Baron, Dies at 81." *New York Times*, November 30, 1997. Accessed February 1, 2017. www.nytimes.com/1997/11/30/us/jack-berry-florida-citrus-baron-dies-at-81.html.

Time. "15 Famous Cuban-Americans." *Time* slideshow, December 17, 2014. time.com/3638191/famous-cuban-americans-photos-cameron-diaz-rosario-dawson-jose-canseco.

Tourism Economics. "Economic Impact of Tourism in Hillsborough County—2015." September 2016, 2. Accessed February 23, 2017. res-1.cloudinary.com/simpleview/image/upload/v1/clients/tampabay/Tampa_EIS_CY2015_6dd6b4ef-e3a4-4e4e-91de-e875b64f5acd.pdf.

Unger, Harlow Giles. *John Quincy Adams*. Boston: Da Capo Press, 2012, 202. Kindle edition.

United States Insect Pest Bulletin, 12.10 (1932): 428. Quoted in *The Mosquito Wars: A History of Mosquito Control in Florida*, by Gordon Patterson. Gainesville: University Press of Florida, 2004, 10–11.

University of Alabama Press. "From Torpedoes to Aviation: About the Book." Accessed April 5, 2016. www.uapress.ua.edu/product/From-Torpedoes-to-Aviation,1835.aspx.

University of Alaska Fairbanks, Osher Lifelong Learning Institute. Slideshow. Accessed February 8, 2017. www.uaf.edu/files/olli/2015Sscoundrelsweek4b.pdf.

University of Florida Citrus Research and Education Center. "Brief History of Frozen Concentrate." Accessed July 12, 2017. www.crec.ifas.ufl.edu/about/History/frozenconcentrate.shtml.

University of South Florida College of Education Florida Center for Instructional Technology. "Florida During World War II." *Exploring Florida: A Social Studies Resource for Students and Teachers*, 2002. Accessed February 27, 2017. fcit.usf.edu/florida/lessons/ww_ii/ww_ii1.htm.

University of Tampa. "History." Accessed February 28, 2017. www.ut.edu/history.

U.S. Air Force. *History of MacDill: 1939–Present*. N.p.: U.S. Air Force, 2014, 1. Accessed February 28, 2017. www.macdill.af.mil/Portals/26/documents/AFD-160727-003.pdf?ver=2016-07-28-121159-130.

U.S. Army Corps of Engineers. "About Herbert Hoover Dike." Accessed December 9, 2015. www.saj.usace.army.mil/Missions/CivilWorks/LakeOkeechobee/HerbertHooverDike.aspx.

U.S. Bureau of Commerce, Bureau of Economic Analysis. "Gross Domestic Product by State." Accessed October 18, 2017. www.bea.gov/iTable/iTable.cfm?reqid=70&step=10&isuri=1&7003=200&7035=-1&7004=sic&7005=1&7006=xx&7036=-1&7001=1200&7002=1&7090=70&7007=-1&7093=levels#reqid=

70&step=10&isuri=1&7003=200&7035=-1&7004=naics&7005=1&7006=xx&7036=-1&7001=1200&7002=1&7090=70&7007=-1&7093=levels.

U.S. Census Bureau. "Annual Estimates of the Resident Population: April 1, 2010 to July 1, 2016—United States—Metropolitan Statistical Area; and for Puerto Rico." Accessed August 21, 2017. factfinder.census.gov/faces/tableservices/jsf/pages/productview.xhtml?src=bkmk.

———. "Exhibit 1a: U.S. Exports, Domestic and Foreign Merchandise, U.S. Port of Export and Method of Transportation, FT 920—U.S. Merchandise Trade: Selected Highlights." December 2016, 3. Accessed August 16, 2017. www.census.gov/foreign-trade/Press-Release/2016pr/12/ft920/ft920.pdf.

———. "Florida Passes New York to Become the Nation's Third Most Populous State, Census Bureau Reports." News release, December 23, 2014. www.census.gov/newsroom/press-releases/2014/cb14-232.html.

———. "North Carolina Becomes Ninth State With 10 Million or More People, Census Bureau Reports." News release, December 22, 2015. www.census.gov/newsroom/press-releases/2015/cb15-215.html.

———. "QuickFacts." Florida map by counties. Accessed April 29, 2016. www.census.gov/quickfacts/map/PST045215/12086,12,12099,00.

———. "Table 5.—Population of Incorporated Places of 10,000 or More from Earliest Census to 1960." In *Number of Inhabitants: Florida.* Accessed February 26, 2017. www2.census.gov/prod2/decennial/documents/11085788v1p11ch2.pdf.

———. "Table 19. Population of the 100 Largest Urban Places: 1960." Census.gov, June 15, 1998. Accessed March 28, 2016. www.census.gov/population/www/documentation/twps0027/tab19.txt.

———. "The 20 Fastest-Growing Metro Areas: July 1, 2014 to July 1, 2015." Accessed December 29, 2016. www.census.gov/content/dam/Census/newsroom/releases/2016/cb16-cn43_table_4.pdf.

U.S. Coast Guard. "Air Station Clearwater: The Largest and Busiest Air Station." December 21, 2016. Accessed February 23, 2017. www.uscg.mil/d7/airstaclearwater.

"U.S. Congress House Committee on Naval Affairs, Sundry Legislation Affecting the Naval Establishment, 1929–1930, v. 2, p. 2191–2266," 2215. From Library of Congress, Washington Irving Chambers collection, container 20, Naval Aviation Progress. Accessed March 28, 2017.

U.S. Department of Agriculture Foreign Agricultural Service. "Citrus: World Markets and Trade." January 2017. Accessed February 1, 2017. apps.fas.usda.gov/psdonline/circulars/citrus.pdf.

U.S. Department of Agriculture National Agriculture Statistics Service. "2015 State Agriculture Overview: Florida." Accessed January 29, 2017. www.nass.usda.gov/Quick_Stats/Ag_Overview/stateOverview.php?state=FLORIDA.

U.S. Department of Commerce, Bureau of the Census. "Florida" in *1960 Census of Housing: Volume I: States and Small Areas, Part 3: Delaware-Indiana*, Florida document, 11-10, table 6. Accessed December 15, 2015. www2.census.gov/prod2/decennial/documents/41962442v1p3.zip.

U.S. Fish & Wildlife Service Merritt Island National Wildlife Refuge. "About the Refuge." Accessed February 20, 2016. www.fws.gov/refuge/Merritt_Island/about.html.

———. "Wildlife & Habitat." Accessed February 20, 2016. www.fws.gov/refuge/Merritt_Island/wildlife_and_habitat.html.

U.S. Navy. "The Carriers: A Brief History of U.S. Navy Aircraft Carriers, Part I—The Early Years." Updated June 15, 2009. Accessed April 5, 2016. www.navy.mil/navydata/nav_legacy.asp?id=1.

U.S. News & World Report. "Florida Institute of Technology." Accessed February 19, 2016. colleges.usnews.rankingsandreviews.com/best-colleges/florida-tech-1469.

———. "University of Central Florida." Accessed February 17, 2016. colleges.usnews.rankingsandreviews.com/best-colleges/ucf-3954.

Visit Florida. "Orlando Thanks Visitors in a Big Way for Making It No. 1 Destination in U.S." News release, May 11, 2017. Accessed August 30, 2017. media.visitorlando.com/pressrelease/index.cfm/2017/5/11/Orlando-Thanks-Visitors-in-a-Big-way-for-Making-it-No-1-Destination-in-US.

Visit Florida Research. "Research." Accessed February 22, 2017. www.visitfloridamediablog.com/home/florida-facts/research.

VisitJacksonville.com. "Fast Facts." Accessed February 18, 2017. www.visitjacksonville.com/media/fast-facts.

Visit Orlando. "Orlando at a Glance." Accessed February 22, 2017. media.visitorlando.com/press-kits/english-press-kit/orlando-overview.

Vogel, Ruthanne. "Everglades Biographies: James Edmunson Ingraham." Reclaiming the Everglades: South Florida's Natural History, 1884 to 1934. Everglades Information Network & Digital Library at Florida International University Libraries. Accessed September 14, 2015. everglades.fiu.edu/reclaim/bios/ingraham.htm.

Walczak, Jared, Scott Drenkard and Joseph Henchman. "2017 State Business Tax Climate Index: Executive Summary." Tax Foundation, September 28, 2016. Accessed October 12, 2017. taxfoundation.org/2017-state-business-tax-climate-index.

Walker, Bruce. "Cuba Before Castro." *American Thinker*, December 22, 2014. Accessed October 23, 2015. www.americanthinker.com/articles/2014/12/cuba_before_castro.html.

Walt Disney Company. *EPCOT.* YouTube video, 25:48 from Walt Disney Company works containing the original presentation. Originally presented 1967. Posted by "TheOriginalEpcot," September 22, 2013. www.youtube.com/watch?v=sLCHg9mUBag.

Walters, Lori (University of Central Florida assistant professor of history), in discussion with coauthor, February 2016.

Watters, Pat. Excerpt of "The Publix Story: George Jenkin's 50 Years of Pleasure." Published in *The Ledger*, July 6, 1980. Accessed February 25, 2017. news.google.com/newspapers?nid=1346&dat=19800706&id=4PEvAAAAIBAJ&sjid=H_sDAAAAIBAJ&pg=3639,1678730.

Weingroff, Richard R. "The Lincoln Highway." U.S. Department of Transportation Federal Highway Administration website, November 18, 2015. Accessed February 16, 2017. www.fhwa.dot.gov/infrastructure/lincoln.cfm.

Weiss, Werner. "Is that Really Walt's Plane at Disney's Hollywood Studios?" Yesterland.com, December 24, 2010. Accessed September 28, 2015. www.yesterland.com/waltsplane.html.

West, Brian S. (media and communications manager for Publix Super Markets), e-mail message to coauthor, August 22 and August 25, 2016.

Wickman, Patricia Riles. *Warriors without War.* Tuscaloosa: University of Alabama Press, 2012. Kindle edition.

Wilson, Amy. "AutoNation Revives Its Used-Only Stores: Dealership Group Charts Brand Extension." *Automotive News*, October 31, 2016. Accessed August 23, 2017. www.autonews.com/article/20161031/RETAIL07/310319943/autonation-revives-its-used-only-stores.

Wilson, Mark R. "Waste Management Inc." *Encyclopedia of Chicago, Dictionary of Leading Chicago Businesses (1820–2000)*, 2005. Chicago Historical Society. Accessed August 29, 2017. www.encyclopedia.chicagohistory.org/pages/2898.html.

World Bank. "Gross Domestic Product 2016." Accessed October 18, 2017. databank.worldbank.org/data/download/GDP.pdf.

Wyatt, Dustin. "Bethune Helped Clear Path for Jackie Robinson's Historic Breakthrough." *Daytona Beach News-Journal*, March 16, 2016. Accessed January 8, 2017. www.news-journalonline.com/news/20160316/bethune-helped-clear-path-for-jackie-robinsons-historic-breakthrough.

Yad Vashem, the Holocaust Martyrs and Heroes Remembrance Authority. "The Holocaust: The Final Stages of the War and the Aftermath." Accessed October 16, 2015. www.yadvashem.org/yv/en/holocaust/about/10/aftermath.asp.

Yoo, Ariel S. "The Mariel Boatlift." *Washington Post*, December 1998. Accessed October 15, 2015. www.washingtonpost.com/wp-srv/inatl/longterm/cuba/mariel_port.htm.

Zucco, Tom. "Grand Hotel Checkout." *Tampa Bay Times*, December 5, 2004. Accessed December 18, 2015. www.sptimes.com/2004/12/05/Tampabay/Grand_hotel_checkout.shtml.

INDEX

V

W

Y

Z

ABOUT THE AUTHORS

George S. LeMieux is a native Floridian who has enjoyed a career in both the public and private sectors. George served as Florida's thirty-fourth United States senator in the 111th Congress. In the Senate, he served on the Commerce, Science and Transportation Committee; the Armed Services Committee; and the Special Committee on Aging. George also worked as Florida's deputy attorney general, managing more than four hundred attorneys and appearing before appellate courts on behalf of the State of Florida, including the United States Supreme Court. As the governor's chief of staff, he oversaw all state agencies and operations. In that role, he negotiated a gaming compact with the Seminole Tribe of Florida.

George is a practicing attorney and currently serves as the chairman of the board of Gunster, a Florida-based law firm. He is the founder of the LeMieux Center for Public Policy at Palm Beach Atlantic University. He lives in Fort Lauderdale, Florida, and is the proud father of four children.

Laura E. Mize is a freelance journalist and former reporter for the *Palm Beach Post*. She has written extensively about Florida business, culture, food and dining and agriculture. She also has worked as a health and medical sciences writer for organizations such as the University of Florida and Mayo Clinic, as well as the nationally syndicated radio show *Health in a Heartbeat*.

Laura's work has appeared in newspapers across the country and in *The Local Palate* magazine. She lives in Naples, Florida, with her husband and daughter.